D1297403

Velázquez

Velázquez

JOSEPH-ÉMILE MULLER

THAMES AND HUDSON

LONDON

Translated from the French
by Jane Brenton

Any copy of this book issued by the publisher as a paperback
is sold subject to the condition that it shall not,
by way of trade or otherwise, be lent, re-sold, hired out or
otherwise circulated, without the publisher's prior consent,
in any form of binding or cover other than that in which it is
published, and without a similar condition including these words
being imposed on a subsequent purchaser.

First published in Great Britain in 1976 by
Thames and Hudson Ltd, London

This edition © 1976 Thames and Hudson Ltd, London
© Editions A. Somogy, Paris 1974

All Rights Reserved. No part of this publication
may be reproduced or transmitted in any form or
by any means, electronic or mechanical, including
photocopy, recording or any information storage
and retrieval system, without permission in writing
from the publisher.

Filmset by Keyspools Limited, Golborne, Lancashire
Printed and bound in Spain by Printer SA, Barcelona

Contents

Introduction

'Le peintre des peintres' was how Manet described Velázquez after a visit to the Prado.[1] 'I was not so much astonished by him', he went on, 'as overwhelmed.' It is a pertinent comment from an artist well qualified to pass judgment, and it aptly sums up the effect produced by Velázquez. Neither his themes nor the emotions he expresses nor (usually) his vision are in any way astonishing. One might say that he sees the world through the eyes of the ordinary man, except that he regards it with an attention and a gravity of which few men are capable. Many painters are bent on communicating ideas or conveying their dreams or emotions, whether exaltation, fears or inward rebellion, but he is most true to himself when he represents the evidence of his remorselessly observant eyes. Velázquez is the painter of visible reality – which is not at all the same as saying that he creates merely a duplicate of that reality.

His themes are not numerous nor are they very varied, and his output seems never to have been large. Although some canvases have certainly been lost over the years (there is documentary evidence for this, as also for a number of studio copies of lost originals), everything tends to suggest that the 120 or so paintings now recognized as his do constitute the main body of his work. He was never particularly interested in experimenting with black and white, and we do not possess a single Velázquez engraving. Even the few drawings with which his name has been associated are usually no more than sketches, studies of figures or animals intended for later use in the paintings. It would seem that his drawings were practically never intended to be works of art in their own right: a complete contrast to his contemporary Rembrandt, who was as active as a draughtsman and engraver as he was as a painter.

In his personal life too Velázquez differed totally from Rembrandt. For him there was no period of decline, no heartbreak, no old age clouded by poverty, no repeated bereavement. Instead he enjoyed an

uninterrupted rise to a position of eminence, and honours in more than sufficient quantity to satisfy his aspirations as a man, even if they did not always come to him as the result of his activities as an artist.

That at least is our impression today. The truth is that we know very little about his life, and what little information we have relates to purely factual matters. It is not possible to do more than make an educated guess as to how he reacted in private to the public events of his life. No one was more sparing in his confidences than Velázquez – I mean by that, spoken or written confidences, or drawings, which might shed some light on the biographical details, for an artist always reveals himself in his art. Through his work we can discover him more completely than through any anecdote. The dating of some of his paintings is uncertain, but it is still possible to trace his development and establish his changing concerns, and in this way to understand both the nature of his sensibility and the resources of his genius. His works may not reveal how he lived, but they do tell us why he survives.

Pupil of Pachecho

Velázquez was born in Seville in 1599, probably shortly before 6 June, the date of his baptism according to the register of the Church of San Pedro. The name he has made famous was actually that of his mother, Jerónima Velázquez; his father was Juan Rodríguez de Silva. Although not wealthy, both his parents seem to have belonged to the minor aristocracy, his mother descended from a Sevillian family, his father of Portuguese origin.

Their child was christened Diego. At first he attended a school where he learned Latin, literature and philosophy, but he quickly discovered painting was more to his taste and apparently, like many other artists, used his exercise books to make sketches. At the age of eleven he was apprenticed to a painter. He may have had his earliest lessons from Francisco Herrera the Elder, a man with a reputation for being so violent and quarrelsome that even his wife and children were forced to run away. If he did he cannot have stayed with him for long. According to a contract signed in 1611 between his father and Francisco Pachecho, he entered the latter's studio at the end of 1610. In 1617, having served his apprenticeship, he was examined by Pachecho and the artist Juan de Uceda; this entitled him to become a member of the Guild of Saint Luke and to set up a workshop as an artist in his own right. The following year, on 23 April 1618, he married his master's daughter, Juana de Miranda. He was no more than an adolescent but she was still just a child – not quite sixteen at the time of their marriage. There is very little we can say about their life together. We know only that they had two children, Francisca, born in 1619, and Ignacia, born in 1621 (who must have died quite young as Francisca is referred to as Velázquez' only daughter in a text dating from 1634).

Pachecho never had occasion to regret his acceptance of Velázquez as a son-in-law and later declared that he had given the match his blessing because of 'Velázquez' youth and purity, for his innate qualities as well

as the expectations aroused by the nature of his great genius'.[2] Subsequently he was even more proud of his reputation as Velázquez' master, and when he learned that someone else (presumably Herrera the Elder) claimed that distinction for himself, he launched an attack on 'the man who has the presumptiousness to lay claim to such an honour and tries to rob [him] of the crowning glory of his last years'.[3] We may wonder what he taught his pupil. His paintings do not look as though they would have appealed to Velázquez as models for his own work. The style is flat, timid and conscientious, and lacks warmth. The expressions of the faces are conventional, the poses awkward and uninspiring.

Happily Pachecho was not only a painter. Born in Sanlúcar in 1564, he studied in Seville, probably prompted by his uncle, a canon, whose protégé he was. He became a cultivated man with wide interests – poetry, archeology, artistic theory and the orthodoxy of religious images. In 1616 the Inquisition appointed him to advise on the latter, and he made various pronouncements on questions of iconography. Not only did he know many of the writers and poets of Seville, entertaining them frequently at his house, he also produced a book of biographies and portrait drawings of the distinguished personalities of his native town (churchmen, men of letters, painters, musicians, etc.). He called it *El libro de descripción de verdaderos retratos de illustres y memorables varones*. Although most of it was written by the year 1600, he did not complete it until the end of his life (1644) and never saw it published; this did not happen until 1870, and then only in an edited version.

Pachecho also wrote a long work entitled *Arte de la pintura*, again published posthumously (in 1649) although the major part was already written by 1622. This text is still in use today, partly because of the information it contains about the life of Velázquez, partly because of the light it throws on the emergent tendencies and concepts of Spanish art at that time. Pachecho was a scholar, well versed in the various treatises on art published by his predecessors, not only the Italian Renaissance artists (Leonardo da Vinci, Alberti), but also Dürer, van Mander and others. And he was well informed about the artistic activity of his own day, taking sides in the various controversies. The book illustrates too his concern to prevent 'errors' and 'wrong interpretations' in religious art. He states his case with conviction, but he cannot

be said to be one of those fanatical Catholics, always smelling out a heresy; he admired Dürer, a Lutheran, considering him a great artist second only to Michelangelo and Raphael.

His reverence for these three masters explains the importance he attached to drawing. He saw it as 'the life and soul of painting'.[4] Nothing, in his view, was more fraught with difficulty than contour. 'It is in this that courage and steadfastness are called for,' he wrote. 'It is in this that the giants themselves must struggle throughout their careers, unable to lay down their arms even for a second.'[5] He also maintained that in the works of the masters (he includes Titian and Correggio among them) one finds 'the opposite of what the vulgar painters of today are seeking to achieve'[6] – he means slapdash artists like Herrera the Elder. Apart from drawing, the things the masters considered to be important were reflection and tact, spiritual depth, science and anatomy, perfection and fidelity as to musculature, a strongly differentiated treatment of various types of cloth, beauty and variety of faces, art in foreshortening and perspective, and ingenuity in adapting the scene and light to the setting of the action.

Pachecho claimed that he himself was always guided by nature. 'So much the better if I were able to consult nature continually and for every detail.'[7] On the other hand he emphasizes the importance of relief. 'The image should leap out of the frame, it should seem alive both from close to and from a distance and should give the impression of movement. The force and rotundity of relief exert such a powerful influence that it can even compensate for the absence of such important things as beauty [of proportions] and a harmonious palette.' Which is why he agrees with Alberti and Leonardo da Vinci in regarding it as the noblest element of art.[8]

There can be little doubt that Velázquez was in general agreement with these ideas. In fact the theories on relief are better exemplified in his own pictures than in the work of his master. Perhaps Velázquez put the ideas into Pachecho's head in the first place. If he did, how did he come by them? Did he have occasion to see authoritative examples of the use of relief? Today we can supply the answer to that question. Caravaggio, the great innovator of the turn of the century whose realism and expressive use of chiaroscuro influenced so many painters, and not only Italians, was already known in Seville by 1610, either

through copies or the originals. In addition the Sevillians were familiar with the works of Jusepe Ribera (Il Spagnoletto), who had lived in Naples as a young man and enjoyed the patronage of the Spanish viceroy. In his early works, influenced by Caravaggio, he too was a convinced believer in realism and the strong opposition of light and shade.

In fact the Spanish school as a whole tends to lay emphasis on the real world and to introduce images from it even in religious paintings. Artists belonging to the same generation as Pachecho – Juan de las Roelas and Francisco Herrera the Elder in Seville, Francisco Ribalta in Valencia and Juan Sánchez Cotán, initially in the monastery of Paular in Castille and later in Granada – all leaned towards a style of painting in which realistic elements played an important part. All were proponents too of Tenebrism, which was already established in Spain well before the influence of Caravaggio could have been felt. In fact this tradition can be traced back some thirty or forty years, to Juan Fernández de Navarrete who worked at the Escorial in 1579, and to El Greco who moved to Toledo in 1577. It exists most notably in the works of Luis Tristán, a disciple of El Greco who is in some respects reminiscent of Caravaggio. Palomino, Velázquez' earliest biographer,[9] says that Velázquez felt an affinity with Tristán 'whose direction corresponded to his own inclinations, by reason of the strangeness of his ideas and the animation of his motifs. . . . He therefore abandoned the style of his master [Pachecho], for he had rapidly come to realize that such insipid painting and drawing, whatever its erudition, was not to his taste; they did not suit his lofty temperament and love of grandeur.'[10] However Velázquez would not have had the opportunity to see Tristán's work before he went to Toledo, that is not before 1622, and by this time Tristán could have done no more than confirm what he already believed.

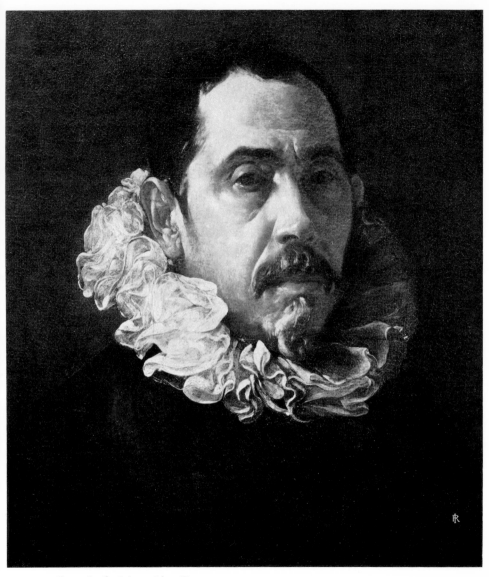

1 *Portrait of a Man with a Goatee* 1620

Between realism and pure painting

Most of Velázquez' early works cannot be dated with any precision; usually they are allotted to the period of 1618–22. They may be divided by theme into three categories – secular subjects, religious subjects and portraits – but the distinction between them is frequently somewhat arbitrary, where for instance portraiture or secular elements coexist with religious scenes.

In his choice of such subjects as the *Musical Trio* (Berlin, Staatliche *2, 3* Museen), *Three Men at Table* (Leningrad, Hermitage) or *A Girl and Two Men at Table* (Budapest, Szépmüvészeti Múzeum), Velázquez is very much in the Caravaggesque tradition. Yet in respect of style and mood he reveals a very different sort of temperament.

When certain of Caravaggio's admirers in Italy and, in particular, Holland painted scenes of everyday life, they deliberately set out to show that, following the example of their 'master', they were in revolt against everything pretty, elegant, affected or artificial in the work of their predecessors, the Mannerists. Rowdiness, indecency and vulgarity would all be included. Their street musicians and their soldiers playing at dice in some den, or courting far from reticent girls, are usually full of animation. They bustle, gesticulate, quarrel and wave their fists, while the women laugh flirtatiously or give vent to guttural cries. The atmosphere is one of crudity. Nothing at all like the work of Velázquez.

Pachecho tells us that when Velázquez was still no more than a boy, he drew numerous charcoals of heads, using as his model a young peasant lad whom he paid to adopt various poses, make this or that gesture, laugh or cry.[11] His paintings show few traces of these activities. There are few gestures and they are always restrained; no one cries; the only people who laugh are two boys, though it is true that their manner of doing so is quite different. The boy in the *Musical Trio* smiles tentatively, while a beaming grin is spread across the face of the boy holding up the carafe in *Three Men at Table*. Both face towards us and force us to

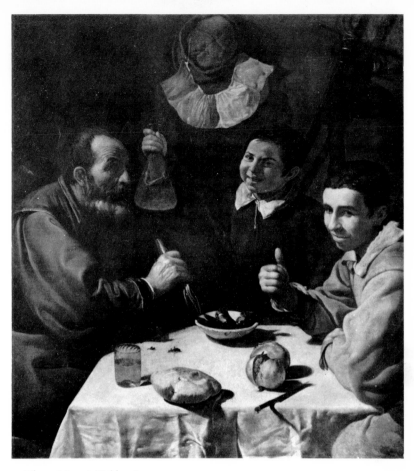

2 *Three Men at Table* 1620

meet their looks of complicity: they invite us to be their witnesses and
to take part in the scene before us. In the *Three Men at Table* we are also 2
addressed by the young man on the right. It is as though each of them
is trying to arouse a different response. Velázquez could be using this
device because he wants to make the scenes more alive, more capable of
engaging us in an immediate way. Or he may simply be making use of
the studies of the peasant lad mentioned by Pachecho. Judging by the

boy in the *Musical Trio*, this is the more likely explanation. His expression and pose do not fit in at all with those of the other two figures, serious men who might almost be in a state of trance. The one who is seen full-face would not be out of place in a religious scene, possibly as a monk transfixed by some fleeting vision. I would be tempted to call these three stock figures; Velázquez puts them side by side but his picture is not really a psychological unity. He always had difficulty, as we will see, in telling a story convincingly, no doubt because he was far more interested in the single figure, the individual, than in groups, where each person is deprived of a part of his individuality.

In choosing to make these boys conscious of their audience, Velázquez is pretending a familiarity that was not in his nature. The pictures are not typical of him. In the early works the figures are normally oblivious of any observer; they exist only for themselves and the people alongside
3 them. In *A Girl and Two Men at Table*, for example, the laughing boy of the *Three Men at Table* is replaced by a girl. Where he holds up the carafe of wine for us to see, she concentrates on pouring the wine into a glass, taking absolutely no notice of us. The old man with the beard (the same as in the *Three Men at Table*) and the young man opposite him are entirely unaware of any observer; their conversation engages all their attention. The result is an image with more unity and a more natural air than the other two. It is also altogether more serious and therefore more characteristic of the rest of Velázquez' work.

Velázquez' canvases are in general of marked seriousness and sobriety. Approaching life in a contemplative spirit, he treated secular subjects in much the same way as his colleagues treated religious subjects. There is little real difference, in terms of mental approach, between his *A Girl and Two Men at Table* and, say, Caravaggio's *The Disciples at Emmaus* (London, National Gallery).
4 One of Velázquez' earliest pictures is the *Old Woman Frying Eggs* (Edinburgh, National Gallery); it has recently been cleaned and the date 1618 has been uncovered. Standing opposite the old woman is a boy with a melon in his right hand and a carafe of wine in his left. The place in which the action is set is barely indicated at all. But for the few objects hanging on the wall at the back, notably a basket with a grey cloth, one would never believe that the two figures were surrounded by the obscurity of a dark kitchen and not standing out sharply against a

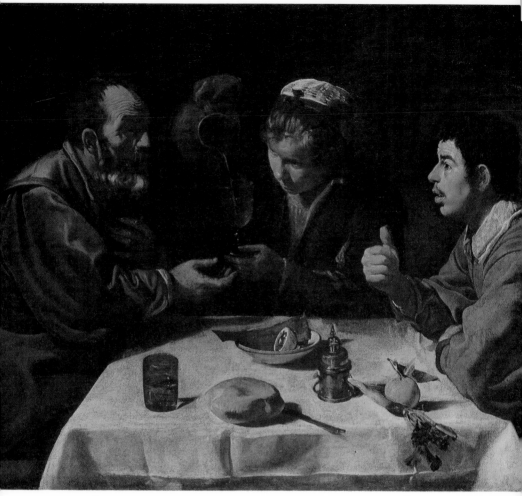

3 *A Girl and Two Men at Table* 1620

screen in a shallow relief. By filling nearly half his canvas with shadows
of varying degrees of opacity, Velázquez not only makes the objects
that are fully lit more prominent; he also divests them of all banality
and lends them an air of sober ritual splendour. For him, light and shade
are not methods of eroding and dematerializing forms, the dialogue
between them does not take on an autonomy that in the end determines

17

the whole significance of the picture. They are there purely to serve the objects. The woman's profile is as sharply etched as the head on a coin, and the modelling of her face is as well defined as the boy's. A twisting curved line unites the two figures; starting at the boy's head, it brushes past his hand, down to the cook's wrist, and rises up to her forehead. The juxtaposition of the two hands is highly expressive: because they are directly above the dish they act as a focus and help to draw the eyes to this important section of the canvas.

The inanimate objects in the picture are quite as important as the human figures. They are not there simply to fill up the canvas, balance its construction and help in gauging distances: they have a distinct life of their own. Because the pots, the mortar, the dish and the plate are viewed from above, they seem to be turned towards us so as to reveal their nature, their internal and external form, and in some cases their contents as well. It is almost as though, before he painted them, Velázquez physically created the objects, or at least ran his fingers over their curves, weighed them in his hand, felt their texture. The image he creates of each separate thing could not be more life-like; nothing could be a better illustration of his powers of observation.

It was by no means uncommon in Spanish painting to give this degree of emphasis to quite ordinary objects. Velázquez' most important predecessor in this respect was the Carthusian Cotán who, as well as painting compositions inspired by the Gospels and the history of his Order, also executed still-lifes of great spareness and expressive power. There is an astonishing immediacy about a few vegetables – a melon, a cabbage, an edible thistle, a cucumber and some carrots – set in a niche against a dark background. One need only compare his still-lifes with those by such Dutch artists as Pieter Claesz or Willem Claesz Heda, who also captured on their canvases the intense reality of objects, to be conscious of the even greater starkness and objectivity of Cotán. Not that it was a cold objectivity: it did not stem from the effacement of the artist's personality but from the passionate humility with which he regarded the objects he painted.

Much the same is true of Velázquez. Although he did not paint still-lifes as such, the inanimate objects in many of his compositions are imbued with a life no less intense than human life. But to illuminate the reality of things was not his only concern, he also saw them as having a

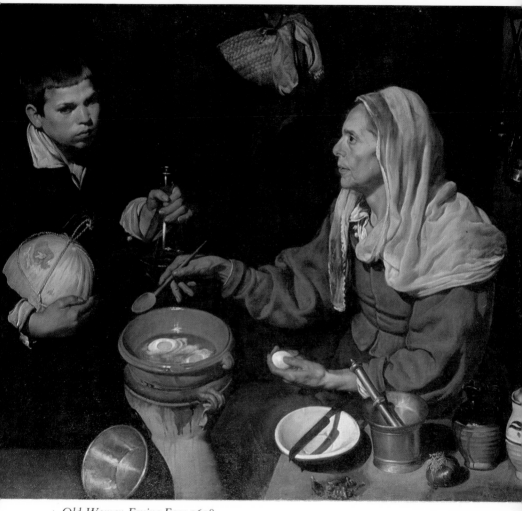

4 *Old Woman Frying Eggs* 1618

purely pictorial value. It would be going too far to say that he treats them exactly like a modern painter, a Cubist say, who sees them simply as forms and colours, but the deployment of some of the utensils in the *Old Woman Frying Eggs* is too meaningful, in terms of form, to be unintended.

Most revealing is the section of the picture to the woman's left, where each object appears in a kind of isolation. Three rounded and fully enclosed forms (the melon and carafe held by the boy and the egg in the woman's hand) are opposed to four objects which, in different ways, are open (the spoon, the dish containing the eggs, the copper pot and the plate). In addition, the egg is small and white while the melon is large and yellow; the spoon is the colour of wood and the dish the colour of brick; and the gold shininess of the copper pot is juxtaposed with the greyish white of the plate. Where two objects are similar in colour, they provide a contrast in terms of their forms.

Here Velázquez shows his taste for realism as well as his love of pure painting, two fundamental aspects of his character. But it is important to note that the realism of the details does not extend to the picture as a whole: the boy and the old woman are juxtaposed rather than engaged in a single action.

5, 6 *The Waterseller* (London, Wellington Museum) contains three figures: the waterseller himself, the boy to whom he is offering a glass of water and, behind them, a man drinking. Nevertheless, the power of the picture is nothing to do with its ability to tell a story: it resides in the presentation of an attitude and a gesture, so that they seem frozen there for all eternity. Nearly all the human figures Velázquez painted in Seville have something sculptural about them, but none is more monumental than this waterseller, who impresses us at once with his superb aplomb. His girth is accentuated by the huge jar whose vigorous curves project from the front of the picture. The man's garment is brown, and tints of brown lend a discreet touch of warmth to the grey tones of the vessel. The two objects are sufficiently different for each to affirm its individuality, yet they have enough in common to complement each other. Other elements are linked by their colours: the big jar and the pitcher on the table; the boy's collar and the waterseller's shirt; and of course the hands and faces. Once again there is a dark ground to emphasize the relief of figures and objects and to focus attention on them. And once again too Velázquez shows how he delights in expressing tangible physical reality. Whether he is dealing with animate or inanimate objects he brings out all their inherent qualities, and at the same time gives them a rocklike immutability of his own. They are not merely impressive to the eye, they demand to be touched as well.

5 *The Waterseller*
Details of ill. 6

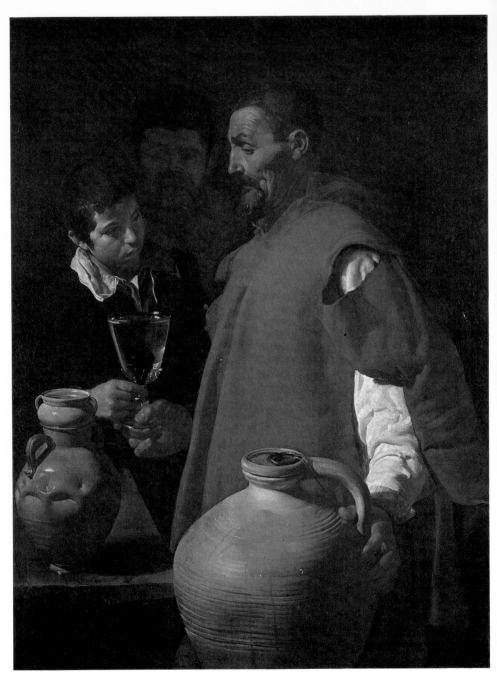

6 *The Waterseller* 1620

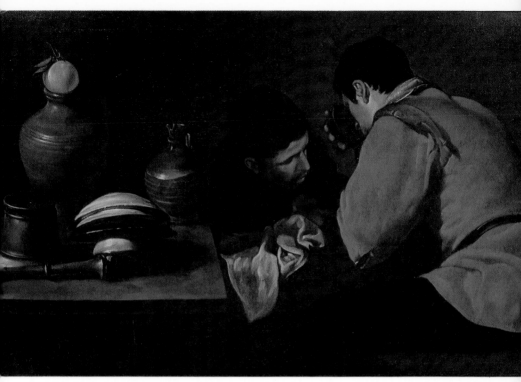

7 *Two Young Men at Table* 1618?

While Velázquez was in Seville he painted a few other pictures which are equally remarkable for the objects they contain. In *The Servant* (Chicago, Art Institute), a maid is leaning over a table placed parallel with the edge of the canvas. Her head forms the apex of a triangle whose bottom corners are defined by a number of kitchen utensils. The positioning of the basket high in the right-hand corner is a tiny detail, but it shows how Velázquez, who never lost sight of the exigencies of composition, avoids making the triangle too crudely obvious or the overall schema too simplistic. The pale cloth poking out of the basket attracts the eye away from the maidservant; at the same time it enriches the composition and invites the observer to explore it more fully. As the canvas is almost twice as wide as it is high, it is not a particularly favourable format for a painting of a single figure. But Velázquez is

able to turn the odd shape to good account by scattering the objects over the surface of the table and making the maid lean forward in a manner which is perfectly indicative of her condition and occupation.

7 The format of *Two Young Men at Table* (London, Wellington Museum) is similar to that of the previous picture. Once again the shoulders are hunched over – if the men sat up straight they would be out of the frame. Here too the device is apt, contriving to reinforce the impression that the two men are in a place where they cannot relax and take their time over their meal. In other words, they are in a kitchen. And the picture is therefore in the tradition of what the Spanish call *bodegones*, the term used to describe both kitchen interiors and still-lifes. At first sight nothing in the painting looks contrived, yet a more detailed examination reveals a very skilful arrangement, whereby each thing has precisely the form, colour, light, weight and position necessary to animate and balance the different parts of the whole. Notably, there are correspondances of form between the orange resting on the brown pitcher to the left and the head of the young man in the ochre-coloured jacket on the right. There are other links achieved by the use of colour: on its own, the brown of the pitcher is not sufficient to counterbalance the rather large surface area of the jacket, it is too dark and sombre; so Velázquez introduces the orange fruit, small in area but shrill enough in intensity to supply the necessary counterweight.

As well as these tensions between opposite points, there is a distribution of the light tones along a line leading from left to right of the picture, from the base of the mortar on to the pile of plates, the crumpled napkin and the young man's collar. The eye is distracted occasionally, so that the path does not seem too direct, by the dull shine of the two pitchers and the highlights on the faces. The greys in the painting shade into white on the plates, become darker on the collar, and acquire a blueish tinge on the napkin. There is nothing at all monotonous about them. Nor about the curves of the composition, deployed no less subtly than the colours. Veering from left to right, up or down, they offer either strict regularity (in the crockery) or sinuous irregularity (in the cloth). Of all the canvases Velázquez painted in Seville one might say that this one, though far from being the most spectacular or the most monumental, is nevertheless the most successful and subtly orchestrated as a composition.

24

Religious painting

It comes as no surprise to learn that Velázquez also painted religious subjects. What is surprising is that he painted so few, given that in Spain at that time the Church and monasteries were the chief patrons of the painters. Pachecho supplied the Convent of the Mercy with a suite of compositions inspired by the life of Saint Peter Nolasque, and a painter of Velázquez' generation, Zurbarán, produced the major part of his œuvre in the service of the religious orders. They had flourished in Seville, as they had elsewhere, and since the early seventeenth century had been an inexhaustible source of commissions, wanting illustrations of episodes in their history, portraits of their founders and martyrs, and images of the miracles that were of particular significance to them.

It was therefore in the normal course of events that the Carmelite Order of Seville approached Velázquez, in 1618, to paint an *Immaculate Conception* and *Saint John Writing the Apocalypse* (London, National Gallery). His approach to these commissions is revealing. Although he chose to represent Saint John seated in a landscape, and the Virgin suspended against a cloud-filled sky, both figures are treated more like statues than living people. The torsions and abrupt breaks in the numerous folds of the garments, the hard edges, the pools of gathering shadow, the vigorous modelling, everything in fact, are sculptural in treatment. The explanation is no doubt that sculpture was as highly regarded in Seville at that time as it had been in Florence two centuries before. The best exponent of the art, Juan Martínez Montañés, was a friend of Pachecho and used on occasion to ask for his assistance in the application of gold or coloured pigment to his sculptures. Velázquez therefore knew him through his visits to his master's house, and probably went to his studio as well; in certain respects at least he must have modelled himself on him.

The landscapes in these two works are shrouded in darkness. The clouds behind the Virgin are massed against a night sky; the earthly world is no more than a dark strip on which a few buildings and the

8

25

blurred outlines of trees can just be distinguished. Scarcely easier to discern are the eagle on one side of Saint John and the trunk of the old tree on the other. There is just one patch of bright light, top left, the apparition of the woman who is described in the Apocalypse as being clothed in sunlight. But it is a detail and not enough to distract attention from the Evangelist – his body rather than his face, as the gaping mouth and upturned eyes gazing at the apparition give him a very uninspired and unmoving expression. The sober tints of the backgrounds act as a foil to the colours of the figures: the dark blue and grey-violet of the robes of the Virgin, the blue-grey and violet of those worn by Saint John. The colour scheme does not lack beauty. What is missing from the pictures is not skill, it is any trace of feeling or warmth.

9, 10 *The Adoration of the Magi* (Madrid, Prado), which is inscribed with the date 1619, carries much more conviction. The Virgin has been seen as a portrait of Velázquez' wife, Juana Pachecho, who bore his first daughter in that year. Whether or not she is the model, there can be no doubt that Velázquez regarded this attractive face with some emotion; its regular features are still not very expressive but they have a soft glow of maternal feeling. He took equal pains with the child (perhaps because he was thinking of his own), making him look serious as well as wide-eyed as he sits on his mother's knee, her strong hands helping to support him. The Magi have strongly individualized features (once again it has been suggested that these may be portraits, although the identity of the models is not known). Their air of distinction contrasts with the rather homely appearance of Joseph and Mary. Velázquez demonstrates in the *bodegones* his skill in painting ordinary people; here he proves that he can convey the essence of men of nobility equally well. He also seems at ease with the composition. Again there is a sombre background. The Holy Family is set in front of a dark wall, and behind the Kings can be seen a landscape from which the shadows have not yet been dispelled by the pale dawn light. By contrast, the Virgin and Child are brilliantly lit. Its many folds impose on her robe an undulating, sometimes zigzagging pattern. The volumes are firmly defined and, in spite of the many muted tones, the palette is in general of a higher key and warmer tonality than before.

 The other religious pictures Velázquez painted in Seville are a series
11 of *Apostles*, most of which have been lost, and *Christ at Emmaus* (New

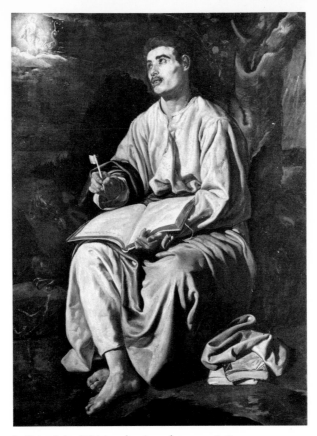

8 *Saint John Writing the Apocalypse c.* 1618

York, Metropolitan Museum), an unexpected work to come from this artist. Although the two disciples are no more than down-to-earth peasants, they express their amazement in extravagant gestures, and the face of Christ is as insipid as it is conventional. Certainly the work does not indicate any particular talent for religious painting. Perhaps Velázquez was aware of this. It certainly seems likely, as it was at about this time that he painted two canvases in which the religious theme is combined with a secular scene, and relegated to a secondary importance.

The first of these (Blessington, near Dublin, Beit Collection) was for a long time thought to be a second version of *The Servant*. But when the

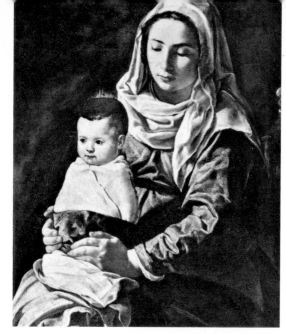

9 *The Adoration
of the Magi*
Details

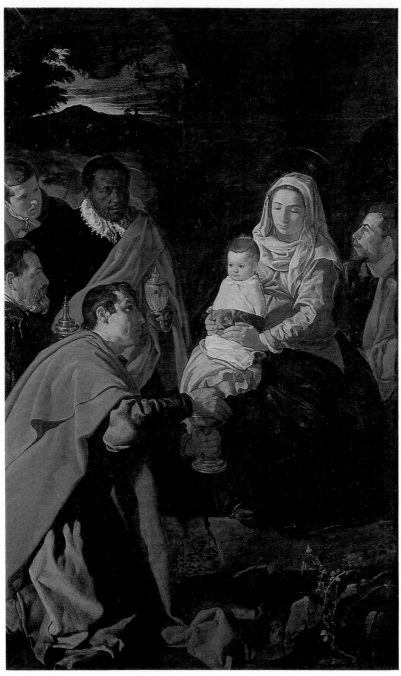

10 *The Adoration of the Magi* 1619

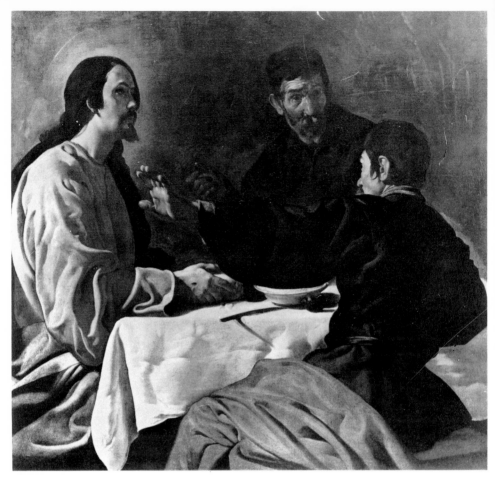

11 *Christ at Emmaus* 1620

picture was cleaned in 1933, the motif of *Christ at Emmaus* was revealed in the top left-hand corner, showing Christ flanked by his two disciples. (Only the forearm remains of the one at the very edge of the picture, the rest of the canvas has been cut away.) Tiny in proportion to the maid, the biblical characters are sitting through an embrasure, in another room.

An analogous solution has been adopted for the second of these paintings. In the foreground, by a kitchen table, an old woman is talking to a servant girl busy pounding something in a mortar; in the upper right-hand corner an opening in the wall gives on to another room where a man is talking with two women: this represents *Christ in the House of Martha and Mary* (London, National Gallery). The question arises, is one in fact dealing here with an opening in the wall? Are Christ and the two sisters as real and tangible as the other two figures? Some art historians suspect they are not, an understandable doubt as Veláz quez does not resolve the ambiguity one way or another.

Two hypotheses have been advanced, but both agree on one point, that there is no aperture in the wall. One theory is that the scene appears in a painting, the other that it is reflected in a mirror. In other words, Christ and the two sisters are either no more than a painted image or they are reflections, in which case they are not in the main picture at all but in front of it. The latter explanation is favoured by López-Rey,[12] his evidence being that Christ is raising his left hand, and Mary too is resting her chin on her left hand. In the Spain of Velázquez, López-Rey goes on to explain, left-handed people were regarded as evil or in some way possessed by the devil.[13] If one accepts this interpretation, and at first sight it seems attractive, it would account for the look on the servant girl's face. Certainly one can imagine the girl gazing curiously at the people in front of her, then hearing a remark from the old woman at her side and turning away, which might account for her sulky expression.

But this is not the only explanation possible. We have already en-countered in Velázquez' work examples of people staring out of the canvas straight into the eyes of the observer. And it is also true that Christ is not necessarily left-handed even if it happens to be his left hand he is raising here. Can we not think of other figures in Spanish seven-teenth-century painting who are raising their left arms – and in circumstances where the explanation put forward by López-Rey can-not possibly apply? In fact it is not difficult to find examples in the work of Montañés, Ribera, Zurbarán and Alonso Cano, including some studies of Christ and the Saints. Even in Vélazquez' *Christ at Emmaus*, in the Metropolitan Museum of New York, one of the disciples seems to have no hesitation about making a gesture with his left hand.

Instead of searching for ingenious explanations it might be preferable to accept that Christ and the two sisters really are situated in a room adjoining the kitchen. Allan Braham, who supports this view,[14] compares the picture with an engraving by Jacob Matham after a composition by Pieter Aertsen, which may have been known to Velázquez. There are a number of points of similarity: kitchen table and figures in the foreground; religious scene at the back, in a room which appears to be some kind of recess. The proportions too are rather similar. But there is one essential difference: in the Flemish painting there is not the slightest reason for doubting the physical relationship between the sacred and the secular scenes. The regular organization of space enables the eye to move freely between the two without confusion. But in Velázquez' picture one is brought up short by the wall immediately behind the two servants; this deflects the gaze back out of the picture, the more effectively as the wall is dark in colour. There is very little space between it and the table above which the embrasure and the religious scene appear, yet Christ and the two women facing him are so small in scale that they seem far away. There is no transition between the foreground and the scene at the back, nothing that helps us to estimate the distances. We are confronted, quite abruptly, with two arbitrarily juxtaposed scenes, each of which is situated in its own area of space.

The resulting hiatus and lack of cohesion are too marked for Velázquez to have been unaware of them. If he chooses to present us with this image, with all its questions left unanswered, it is presumably because he is content to leave us uncertain as to the reality of what is before our eyes. In fact, as we will see later, there are many occasions on which he declines to resolve the ambiguities of a picture or to offer us the reassurance of an undeviating fidelity to life. I have already remarked that he shows his love of realism more in respect of details than in the picture as a whole. And in order to do full justice to the details he has no hesitation whatsoever in sacrificing narrative coherence and clarity.

This being the case, we will not embark on a discussion of the identity of the two women in the kitchen or the justification for including them in a religious picture. Suffice it to say that they, like the still-life, are traditional elements of the *bodegón*, and it is pointless to ascribe to them any other significance. In that role they are superb, so why seek to give them any other? They are so life-like that they leave an indelible

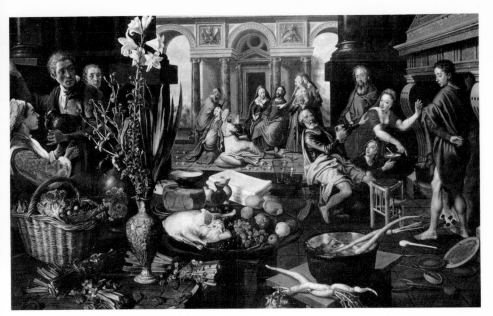

12 PIETER AERTSEN *Christ at Emmaus*

impression on the mind. Velázquez shows here that he is as much at home with the wrinkled face and intelligent expression of the old woman as with the almost insolently pouting features and sulky air of the raw young girl. The objects on the table are strongly characterized and constitute one of the finest still-lifes he ever painted.

As a composition the work may not be as fluent or assured as *Two Young Men at Table*; there are fewer curves, more straight lines, verticals, horizontals and diagonals. Yet it is a very attractive picture, and also a very revealing one. By relegating the religious scene to one corner of the canvas and devoting the rest to everyday life, warts and all, Velázquez tells us a great deal – not about his religious faith exactly, but about his artistic temperament. In effect he declares a preference for expressing what he sees rather than what he is forced to imagine, his gift of observation being far greater than his imaginative powers. In a Velázquez, the most humble contemporary scene is never banal; it acquires mystery and poetry. The most ordinary people engaged in

33

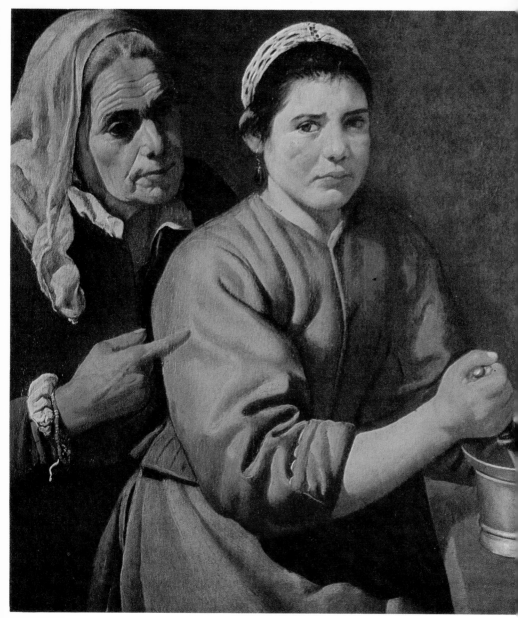

13 *Christ in the House of Martha and Mary c.* 1620

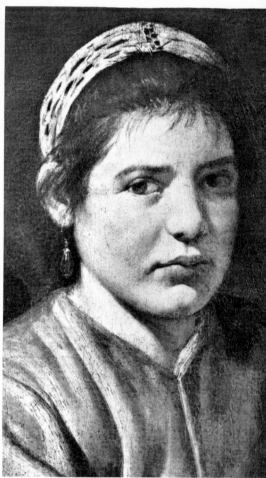

14 *Christ in the House of Martha and Mary* Details of ill. 13

menial tasks are touched by something that marks them off from their surroundings. They may be of low station in life but low behaviour is foreign to them, they have an air of distinction which comes from the rapt intensity of the artist's gaze.

15 In 1623 Velázquez painted *Saint Ildefonso Receiving the Chasuble* (Seville, Provincial Museum), a work quite different from any we have

previously encountered. Here the terrestrial and heavenly worlds are not separated, even though the Saint is kneeling on the ground and the Virgin, who is giving him the chasuble, is shown enthroned in the clouds. But the clouds come low down in the sky so that the two worlds meet and intermingle, and the Virgin and her two handmaidens do not really look at all like heavenly beings – no one would have been surprised to meet them in the streets of Seville. They belong to the stock of common humanity on which Velázquez drew for his characters. All that makes them special is the light striking them and glancing over their pretty, plump features; but they are only illuminated in part, large areas being left in shadow so that the volumes are not in such pronounced relief as in the other Sevillian paintings. (That at least is the impression one has looking at the picture today; it has in fact deteriorated considerably and has been extensively restored.) Saint Ildefonso himself has a bony, angular face, consumed by asceticism.

What then is the origin of this new masculine type and the changed manner? In the previous year, 1622, Velázquez had seen some of the works of El Greco. He certainly visited the Escorial, and one would assume that he also went to Toledo – Pachecho had been there in 1611 and must have talked to him about this master whose paintings had sometimes roused him to a pitch of enthusiasm, and sometimes appalled him; he had also been shocked by El Greco's comment that 'Michelangelo was a good man but could not paint', and this may have been another reason why Velázquez was anxious to see the paintings for himself. El Greco, who had died in 1614, had certainly been influenced by living in Toledo, but he had never truly become a Spanish painter. It was not his ardent mysticism that was unusual in Spain, it was his lack of interest in realism, his drive towards expressionistic statements, making him seek to convey emotions and visions by dematerializing bodies, stretching them, contorting them, banishing from the faces all trace of sensuality so that the burning ardour of the soul could pierce directly through the bloodless skin. Foreign as all this was to Velázquez' nature, he seems to have been fascinated by this artist's masterly handling of religious subjects. He himself experienced the greatest difficulty in fulfilling this type of commission. What could be more natural than to follow the example of the one painter who excelled in the form? Hence the spiritualized features of Saint Ildefonso, hence too the inter-

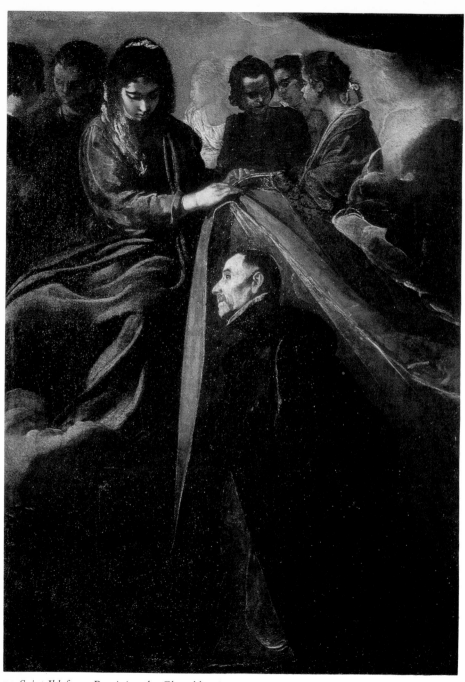

15 *Saint Ildefonso Receiving the Chasuble* 1623

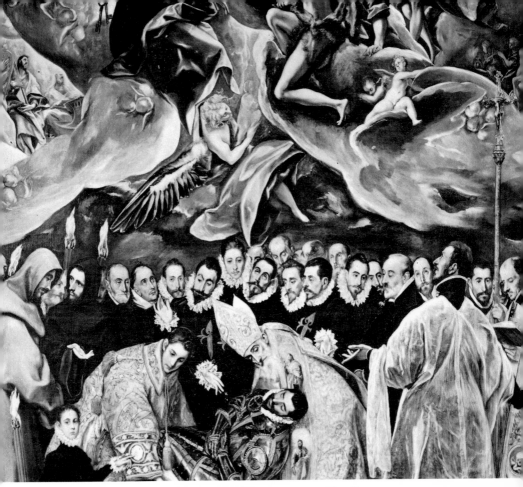

16 EL GRECO *The Burial of the Count of Orgaz* 1586–88 Detail

penetration of heaven and earth – echoing *The Burial of the Count of* *16*
Orgaz (Toledo, Santo Tomé) and *The Martyrdom of Saint Maurice*
(Escorial).

But the Toledan master's influence was not so great that it made
Velázquez abandon his own distinctive approach (witness the Virgin
and the two girls), nor did it have any lasting effect. It is worth recalling
here that Velázquez felt an affinity with the work of Luis Tristán who,

although a disciple of El Greco, was far less expressionistic and visionary, much more of a realist. However Velázquez did make one discovery of lasting consequence, namely, that he was not ultimately destined to work for churches or monasteries, or to become a painter of episodes from the Gospels or monastic legends. Probably his sheer skill would have enabled him to tackle all kinds of subjects satisfactorily, but for him it was not enough to paint coldly and academically, with mere application. Palomino tells us (with reference to the *bodegones*) that 'he was reproached for his failure to impart either sweetness or beauty to more serious subjects, in which he could well have rivalled Raphael'. To which Velázquez replied that he 'preferred to be supreme in the coarse genre rather than second-best in the refined genre'.[15] 'Not to be second-best' was surely his ambition in all his activities – especially as there was one sphere in which he knew he would be supreme, and that was portraiture.

The early portraits

Velázquez' ability as a portrait painter was evident right from the start, in subjects of all kinds. He always found his greatest inspiration in the things he could study from life. That is why his figures look as though they might be portraits even in the religious paintings, and it is what José Ortega y Gasset meant when he said that Velázquez showed he was a portraitist even when his subject was a pitcher or a glass.[16] But a portrait in the strict sense of the word presupposes a model, and usually a commission. It may be that Velázquez found these hard to come by in Seville. At all events he painted comparatively few during his time there. Apart from a *Head of a Young Man* (Leningrad, Hermitage), which appears to be a study for the young man in *A Girl and Two Men at Table*, there are only four known examples.

Three of these portraits are of male subjects and, of these, two (Madrid, Prado) have not been identified by name. Various possibilities have been suggested, such as Velázquez himself for the *Young Man* and Pachecho for *A Man with a Goatee*, but this is pure guesswork and cannot in any way be substantiated. Both are head-and-shoulders portraits, in three-quarters profile, nearly full-face. Presumably this pose appealed to Velázquez because it allowed him to take full advantage of the operation of chiaroscuro and bring the face into a powerful relief. The fine drawing and concise modelling of the forms enhance that sculptural quality which we have already had occasion to remark. In *A Man with a Goatee* in particular, it is as though one can actually detect where the chisel has chipped out a feature or defined a plane, forging a compact unity. The chromatic range is limited in the extreme – apart from the collar and the face, the dark tones are unrelieved. The style is uncompromisingly stark and severe, even allowing for the fluidity, verve, and perhaps fantasy, in the representation of the collar. The expressions of the faces too are forbidding. Neither the old man nor the young one make any effort to look agreeable. To say they do not encourage an

17

1

approach is hardly adequate; they actively repel any advances, clearly regarding this as a form of distraction which would be totally unacceptable to minds as severe and agonized as theirs. But the young man's face has an air of sadness, and he seems more vulnerable than his haughty expression would have us believe.

The third male portrait, dated 1620, is of *The Priest Cristóbal Suárez de Ribera* (Seville, Provincial Museum). It could not have been painted from life as he died in October 1618; also he was sixty-eight at the time of his death and looks far younger than this in the portrait. He is shown kneeling in a bare room from which a big bay looks out on to a clump of trees; the pale face is at the peak of the pyramidal mass of the cloak enveloping his body. The chiselled features, especially round the mouth, give a sharply individualized appearance to his face, accentuated by the way it stands out against the sober colours behind it. Even the landscape is dimly lit, the trees being no more than dark silhouettes under an olive sky.

18 The fourth portrait is even more daunting. It too dates from 1620, the model on this occasion being *Mother Doña Jerónima de la Fuente* (Madrid, Prado). There is not so much as a glimpse of the outside world to relieve the neutral grey of the background. Grey is also the dominant colour of the robe and cloak, whose ample folds both lend volume to the body and, through the repetition of abrupt vertical lines, emphasize the stiffness of the nun's bearing. At the time Velázquez painted her she was sixty-six. She had travelled from Toledo, and stayed in Seville for three weeks before going on to Manila in the Philippines, where she was to found the first Franciscan convent. There can be no doubt that she was an energetic and determined woman, marked by a long life. The ugliness of someone who has known more of renunciation than of pleasure, the face lined with wrinkles, the look of authority, the prominently veined hands – Velázquez paints these things in no spirit of cruelty, yet without in any way toning them down.

The source of the commissions for the first two portraits was very probably Pachecho, who we know was on good terms with the ecclesiastical authorities. Father Cristóbal Suárez de Ribera was godfather to Juana, Velázquez' wife. Given these circumstances, one wonders why there are not more portraits of this kind in Velázquez' œuvre, why he did not acquire a reputation, like Zurbarán, as a painter

17 *Portrait of a Young Man* 1623

of monks. Perhaps he was not attracted to this type of commission because the world of monasteries was alien to him. Or was it that he had other ambitions which he regarded as more important and more in keeping with his own inclinations? Everything tends to suggest that it was the second consideration that determined the course of his subsequent career.

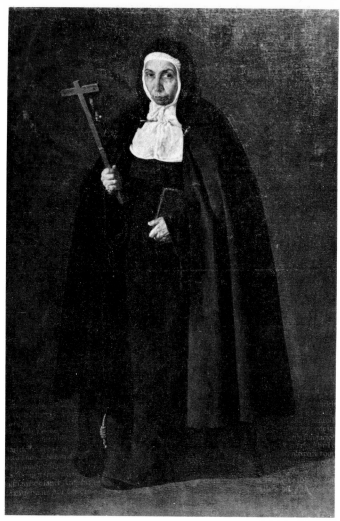

18 *Mother Doña Jerónima de la Fuente* 1620

In 1622, with Pachecho's blessing, Velázquez determined to go to
Madrid and try to obtain the post of court painter. The time seemed
propitious. Philip III had died in the previous year and the entourage of
the new sovereign, Philip IV, included a number of Sevillians who

might be expected to regard Pachecho favourably. The Prime Minister himself, the Count of Olivares, had lived in Seville for some years and was still in touch with his old friends and acquaintances. One of them was the poet Francisco de Rioja, who had been one of the witnesses at Velázquez' wedding, and must therefore have given him a particularly strong recommendation. He was also supported by another Sevillian,

19 *The Poet Don Luis de Góngora y Argote* 1622

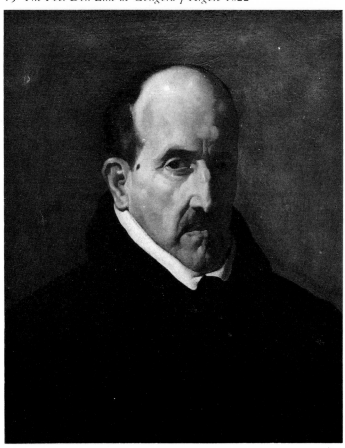

Don Juan de Fonseca y Figueroa, an ecclesiastic who had great influence at court. Velázquez took leave of his family in April 1623 and set out for the capital with high hopes of a chance to paint the King's portrait. But on this occasion he was unlucky. After visiting the Escorial, and probably Toledo, he was forced to return to Seville with his mission unaccomplished. The only portrait he painted at the court was of the poet *Luis de Góngora* (Boston, Museum of Fine Arts).

19

Here again chiaroscuro and line-drawing are used to stress the contour and relief, but the modelling seems freer and not as harsh as in the earlier pictures. The high bald domed forehead, the hollow cheeks covered by pouches of skin, the irregularly shaped nose, the dimpled jutting chin, the lips pursed as though in complaint, the wary intentness of the eyes – all these individual features add up to a face which is not merely serious but sullen and austere. The portrait is remarkable for its acute observation as well as its energetic style.

We should remember that when he painted this portrait Velázquez was barely twenty-three, and yet he had already created the large body of work we have so far discussed. His precocious skill is not in doubt. These canvases alone would have been enough to ensure him a place in the history of painting that would have been the envy of many other artists. But for him they were no more than a beginning, and when he went on to produce the most original and important part of his work he abandoned his old style completely.

First years at court

The unsuccessful attempt of 1622 proved no more than a temporary setback. In the spring of the following year Velázquez received through Fonseca an invitation from Olivares to return to Madrid, together with fifty ducats from the Count to defray his travelling expenses. Naturally the painter was delighted with this turn of events and accordingly set off shortly afterwards, in the summer, this time accompanied by Pachecho and his 'slave', the mulatto Juan de Pareja, who was also his pupil.

Fonseca received him into his own house and Velázquez wasted no time in painting his portrait. The picture, which apparently no longer exists, aroused such interest that it was immediately shown around the court and was admired by all, including the King. It was only a matter of time before Philip IV himself agreed to sit for him, and Pachecho tells us that Velázquez finished the portrait on 30 August 1623. Once again the painter won universal praise and acclaim. 'His Excellency the Count-Duke', notes his proud father-in-law, 'spoke with him for the first time, invoked the honour of his native province, and promised that henceforth he alone should paint His Majesty; all other portraits would be taken down. He commanded him to take up residence in Madrid.'[17] At the beginning of October Velázquez was officially taken into the King's service as court painter; he was granted a salary and various other privileges; a studio was placed at his disposal in the palace, also a house in the town, where he installed himself with his family.

The high esteem in which he was from the first held at court is further attested by his portrait (a sketch in colour, according to Pachecho) of the Prince of Wales, the future King Charles I of England, who spent six months in Madrid in 1623 in a futile attempt to negotiate his marriage to the Infanta María, sister of Philip IV. Like the portrait of Philip IV of 30 August, this painting has disappeared. So has another of the King on horseback in a landscape setting. But apparently this latter picture pleased the sovereign so much that he ordered it to be

47

20 TITIAN *Philip II in Armour* 1551

publicly exhibited in Madrid, in the Calle Mayor, opposite the Church of San Felipe. The enthusiastic populace queued to see it and poets celebrated it in verse.

Velázquez was of course not the first outstanding artist the Spanish court could claim the distinction of employing. Titian had already

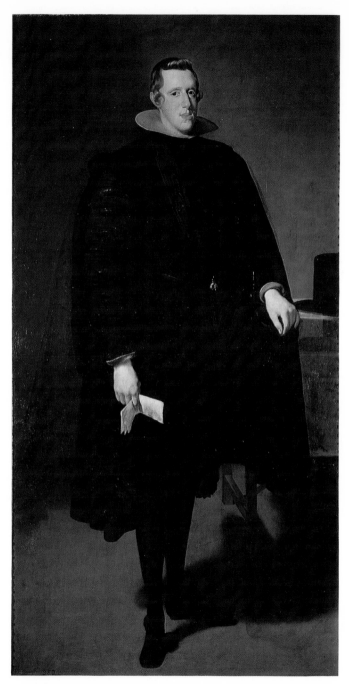

21 *Philip IV* 1626–28

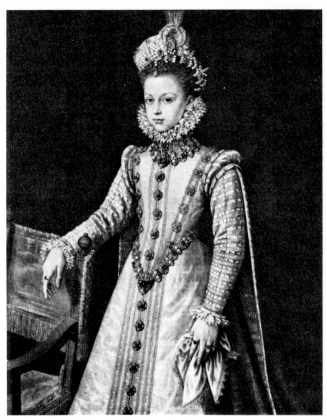

22 ALONSO SÁNCHEZ COELLO *The Infanta Isabella, Daughter of Philip II*

worked there, and his portraits of Charles V, Isabella of Portugal and
20 Philip II are some of the most dazzling he ever painted. Their easy
majesty and richness of colouring can be admired today in the Prado.
The features are delicately drawn while the noble splendour of the
garments, the quality of the cloth and the armour, gave the artist the
opportunity to produce some gems of painting that are full of delight
and variety. Velázquez saw these works at the palace or in the Escorial
and there is no doubt that he must have admired them greatly and
studied them with close attention.

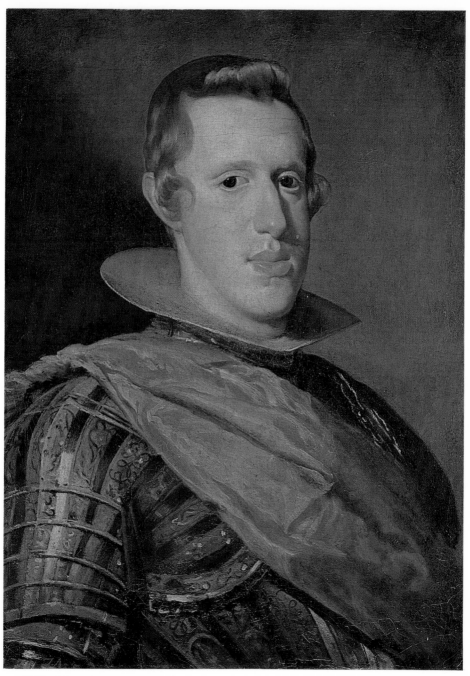

23 *Philip IV in Armour* 1626–28

He also knew the portraits of Anthonis Mor, the cosmopolitan Utrecht artist known to the Spaniards as Antonio Moro, who had been court painter to Charles V and Philip II. He was a penetrating observer, less given to idealization than Titian and employing a much bolder and harder line. His feeling for colour was less sensual but his works have an attractive and sustained sobriety which never becomes arid. He never allowed the painstaking care with which he painted costumes and uniforms to interfere with the simple outline of the forms, which gives them a certain monumentality. And he did not restrict himself to portraits of kings and nobles, men of normal physique – his models included jesters and dwarfs as well. In the Prado is his *Portrait of Pejeron*, in which the man's ugliness and deformity are shown with quite straightforward frankness.

22 Alonso Sánchez Coello, a Spanish portrait painter at the court of Philip II, is in many ways similar to Moro and was certainly influenced by him, although his line-drawing is less incisive and the pale, often morose faces of his models are less full of character. But these elements are of secondary importance to the costumes, which are minutely portrayed down to the last detail, with all their ornamentation and jewelled embellishments.

There are considerable points of similarity too between Sánchez Coello and his successor Juan Panteja de la Cruz, who was active towards the end of the reign of Philip II and at the start of the reign of Philip III. The faces have the same set expression but – reflecting the taste for luxury – the women's garments are even more elaborate and more richly decorated.

It is unlikely that Velázquez was enthusiastic about the work of the two Spaniards or of Bartolomé Gonzales, who was still employed at the court when he arrived there. The unexpressive faces, unnatural postures and concentration on garments weighed down with embroidery and trimmings cannot have been at all to his taste.

Of all the many portraits of Philip IV that emerged from his studio, the earliest that still survives dates from 1623 or 1624 (New York, Wildenstein Galleries). It is a head-and-shoulders portrait of the King as a young man of eighteen or nineteen. The head is turned slightly to the left (of the subject), as in nearly all Velázquez' portraits of the King, and the oval face has still not lost its adolescent fullness; the thick neck

barely rises above the collar; the fleshy lips are set between a large nose and heavy chin. His features suggest that he is slightly wary, but the look in his eyes is frank and proud. The physiognomy is the same in the full-length portrait of *Philip IV* (New York, Metropolitan Museum), a rather better example of the manner in which Velázquez acquitted his duties as court painter. Dressed in black, Philip IV is standing against a grey ground, and his upright stance and the simplicity of his costume give the silhouette an appearance, not of splendour, but of noble gravity. Of course it was not the artist who dictated the simple costume, that was the fashion of the day, or more precisely it was the result of an edict of 1623 condemning the extravagance of clothing so favoured by the previous epoch. But such sobriety corresponded to Velázquez own taste, and he has turned it to excellent account.

Contemporaries of Philip IV tell us he was of average height;[18] here he looks tall because he occupies the whole height of the canvas (which is almost twice as long as it is wide: 199.2 × 102.8 cm.). When painting a single standing figure Velázquez liked to use canvases of this shape as they enabled him not only to give an impression of tallness, but also to keep to a minimum any objects shown beside the model and so make him the sole focus of attention.

Philip IV holds a sheet of paper in his right hand, as he does in several other pictures. No doubt this was meant to show that he devoted himself to affairs of state, reading all the reports of his councillors, the despatches of his ambassadors and petitions from his subjects. And it is true that he did read them, or at least he said he did, but not because he had any intention of governing the country. His father had been dominated by his Prime Minister, the Duke of Lerma, for some twenty years, and Philip IV likewise had handed over all his powers to the Count of Olivares, who acted on his behalf for a similar length of time. He himself was simply not in a position to influence events or take decisions.

In any case he was less interested in politics than he was in hunting, the theatre, painting and the arts in general – as well as in amorous exploits. His thick swollen-looking lips betray the sensual nature to the promptings of which he was always ready to succumb, in spite of the remorse he experienced afterwards. A writer of a previous century says he was credited with thirty-two natural children, of whom he

acknowledged eight.[19] His love of the theatre led him to take part in improvised plays, and apparently he wrote some dramatic pieces himself. He was also said to have executed a number of paintings and drawings, although none of these has come to light. The painter who gave him lessons was supposedly the Dominican monk Juan Bautista Mayno. Contemporary writers noted too that Philip IV was a good judge of a painting, something for which Velázquez had cause to be grateful.

21 Somewhere between 1626 and 1628 Velázquez painted another full-length portrait of the King (Madrid, Prado), which in certain important respects differs from that of 1624. The face has lost its heaviness, the chin is now smaller and more pointed; the line joining it to the ear has lengthened; and the neck seems less stocky. In addition, the legs are closer together and the outline of the cloak against the right arm is less clear-cut. The result is that the vertical, from the right foot to the head, is given greater prominence, and the silhouette as a whole is more taut and compact. Furthermore the blacks of the costume are unrelieved even by the patch of colour provided by the Order of the Golden Fleece which, in the New York portrait, hangs from a chain curving down from the shoulder to the belt. The second of the two pictures has an austerity tempered only by a single touch of discreet warmth, the purplish red of the cloth on the plain table beside the King.

This table has another role to play: the position of its feet corresponds to the position of the King's feet, and as both are set obliquely they direct attention towards the back of the picture. The result is to give an impression of space. But it is only an impression; Velázquez guards against using lines that would define it precisely. He eliminates the horizontal that would normally be there to mark the division between the floor and the back wall, so that distances and depth are conveyed solely by the placing of the objects and the direction of the light.

X-rays have shown that this portrait conceals another which is quite different from the visible picture. The fall of the cloak, position of the hands and design of the cuffs are much closer to the 1624 portrait in the Metropolitan Museum, New York. And, more important, Philip IV has the broad, rounded chin and thick neck that he has both in the 1624 picture and in the head-and-shoulders portrait of 1623–24. López-Rey, who prints a reproduction of the X-ray,[20] draws the conclusion that

what we see here is the very first portrait of Philip IV painted by Velázquez, the one that is mentioned by Pachecho. He suggests that the artist had obliterated it because he was not satisfied and felt that he had done no more than reproduce the physical appearance of the King instead of illuminating his quasi-divine nature.[21] But it is hard to see how the lengthening of the face and a marginal refinement of the features could possibly give a man an aura of divinity. However, the face has been altered, and we must ask ourselves why. We have frequently said that Velázquez aimed at objectivity. Is it possible that he has suddenly changed his mind and now wants to idealize his subject? This seems unlikely. It would probably be more accurate to say that he has corrected certain of the King's physical peculiarities, not in order to make him more attractive or divine, but to give him an added air of nobility.

Whatever the reasons, the various modifications the portrait has undergone point to a conclusion that holds true in all circumstances. Velázquez is an artist who frequently abandons his first ideas on a subject. He looks critically at the work he is planning (or has painted) and then goes back to it, making the changes suggested by his reappraisal. Many of his canvases show the traces of his experiments and reveal a desire for perfection that can be detected without the assistance of X-rays.

The King's face in *Philip IV in Armour* (Madrid, Prado) is similar to that of the previous picture and probably dates from the same period. Once again X-rays[22] have been used to show that the present painting has underneath it a head drawn in the earlier manner. The sash and breastplate, no doubt painted later, introduce more colour than in the other portraits: the crimson sash occupies a large surface area and the elaborately worked breastplate is striped with broad bands of ochre and olive green. *23*

A further work from the period 1626–28 is the portrait of the *Infante Don Carlos*. He was a brother of the King and two years his junior. This picture (Madrid, Prado) is reminiscent of certain of the portraits of Philip IV; the position of the legs and the gold chain across the chest recall those of the picture in the Metropolitan Museum of New York, while the rest is closer to the Prado painting. Yet the portraits are quite distinct, and in ways that correspond to the distinctive qualities of their *24, 25*

subjects. The outline of the silhouette, for example, is less severe and stiff in the case of the Infante. There is one particularly revealing detail: in his right hand Don Carlos holds, not a sheet of paper, but the finger of a glove which dangles beside his leg. This casual gesture seems to betray a desire to cast aside etiquette, to be granted a measure of eccentricity, or at least of freedom. If the Infante did feel like this (he died in 1632 at the age of twenty-four) it would be quite understandable, for Olivares was for ever telling him what to do. In 1621, following the death of Archduke Albert, Governor of the Spanish Netherlands, the Prince was meant to go to Belgium to be of assistance to the dead man's widow, his aunt Isabella, and to make preparations to succeed to the post. The project came to nothing simply because the Count was opposed to the idea. According to contemporary documentary evidence, Don Carlos was 'so reserved in his speech and shows such submissiveness to his brother, being never more than a step away from him, that one has no idea what his own inclinations may be. The gentlemen-in-waiting who spend one week in the service of the King spend the next in the service of the Infante. He takes his meals with His Majesty and follows him everywhere like a shadow. He leaves the King only when he is reading documents or working with the Count-Duke. In short, he lives in permanent captivity.'[23]

We need only look at the Infante's face to see that this way of life was not at all to his liking: he appears depressed, anxious and resigned. Possibly his state of mind was the reason Velázquez chose to place him against a brownish background in an empty room lit only by dim daylight. This shadowy portrait, in which there is nothing to distract attention from the central figure, gives one the strong impression of being in the presence of a destiny that is at once privileged and tragically without point.

According to a document bearing Velázquez' signature, the *Philip IV* that is in the Metropolitan Museum was paid for by Doña Antonia de Ipeñarrieta, the widow of Don Garcia Pérez de Araciel, a former professor at the University of Salamanca. He had close ties with Olivares, and it seems that during that year (1624) his widow received two other portraits from Velázquez: one of her deceased husband, the other of Olivares. About the first we know nothing; the second is today in the possession of the Museo de Arte, São Paulo.

Born in Rome in 1587, when his father was ambassador to the Vatican, Don Gaspar Guzmán, the Count of Olivares, was originally destined for a career in the Church. But the death of his elder brother in 1604 cleared the way for him, and he had no hesitation in changing course. From then on he lived mostly in Seville, where he was conspicuous for his extravagant life-style as well as his activities as a patron, which brought him into contact with scholars, poets and painters. (Pachecho painted his portrait in 1610.) Shortly after his father's death he married Doña Inés de Zúñiga, his cousin, who although ugly was a lady-in-waiting to the Queen. Olivares hoped this marriage would lead to his nomination as a grandee of Spain. In this he was mistaken, but in 1615 the Prime Minister, Lerma, invited him to the court as one of the Gentlemen of the Bedchamber to the Heir Apparent, the future Philip IV. The appointment proved to be a mixed blessing. At first the Prince was wary of him, and Lerma tried to get rid of him on more than one occasion, sensing a potential rival. Nonetheless Olivares managed to strengthen his position and it was not long after the accession of Philip IV that he was named Prime Minister, which made him the most powerful man in the land. He remained in power for twenty-two years, time enough to demonstrate all the facets of his personality, his strengths as well as his weaknesses and shortcomings. All of which have been assiduously noted down by contemporary observers and historians of a later age.

To sum up: he was said to behave unctuously towards the King while being haughty and rude, even at times coarse, in his treatment of the nobles, who hated him as a result. He was judged to be intelligent and courageous but evidently lacking in stability, oscillating between the over-excitement that went with his natural vitality and the depressions of precarious mental health. In addition he was obstinate, touchy, suspicious, vindictive and underhand. He loved power, less from any urge to use it than from a desire to appear important, not merely to be the equal of the grandees of Spain (an honour his father had longed for in vain) but to be set above them and dominate them all. Hence his love of blatant ostentation and his taste for careless display of wealth. Hence too his habit of organizing spectacular celebrations at crazy expense.

When Velázquez painted his portrait in 1624, Olivares was at the beginning of his career. He had not yet revealed himself in his full

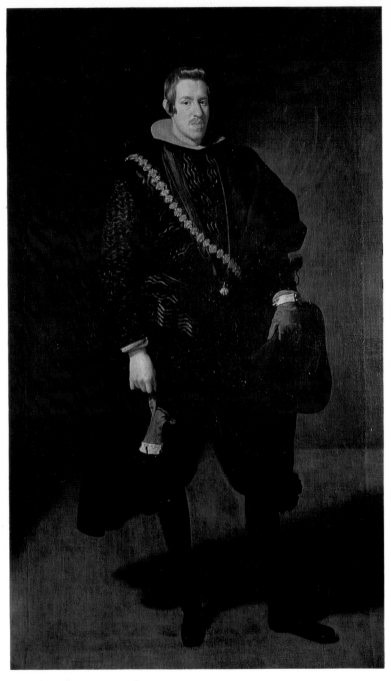

24 *The Infante Don Carlos* 1626–28

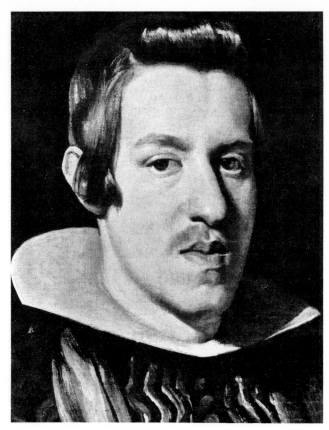

25 *The Infante Don Carlos* Detail

colours. Certainly Velázquez himself had no cause to complain of the man to whom he owed his position at court and who, moreover, continued to lend him his support. There was therefore no reason why he should choose to represent him in an unfavourable light. But there was no reason either why he should choose to flatter him.

According to Siri, the Venetian ambassador, Olivares 'is of little more than average height, and his body is of a size that would be considered fat in a country where the people are generally of slight build; his shoulders are so rounded that he has, quite wrongly, been described as a hunchback; his face is broad, his hair black, and he has a

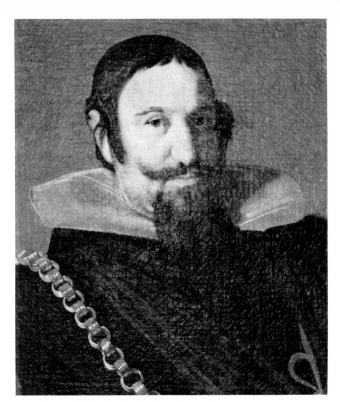

26 *The Count-Duke of Olivares* Detail

rather deep-set mouth and very pronounced chin; the eyes and nose are neither ugly nor especially handsome; he has a large head that leans slightly forward, a vast forehead, yellowy skin, and a menacing and sly look in his eyes. Overall, a distinctly unappetizing appearance.'[24]

Another contemporary says that 'the look in his eyes is a mixture of dark humour and irascibility, from which the physiognomists deduce a profound hypocrisy and a lack of sincerity'.[25]

26, 27 What trace is there of all this in Velázquez' portrait? Although Olivares fills the canvas in much the same way as Philip IV in the Metropolitan Museum picture, he does not have the same natural dignity or serenity. He practically seems to be bursting out of the frame

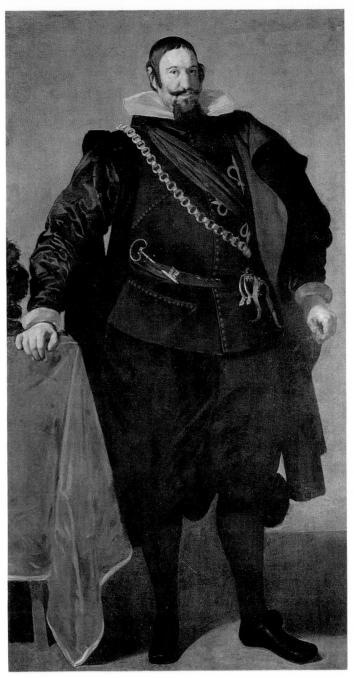

27 *The Count-Duke of Olivares* 1624

and looks impatient for the sitting to be over, as though he has placed himself at the artist's disposal only for a brief period in between two more important engagements. In the royal portrait the silhouette is drawn with a simple, direct and uncluttered line; here the line is full of angularities and jerky curves, denoting activity. The body faces squarely to the front and looks broad and heavy; if Olivares appears to be tall it is once again because of the proportions of the canvas. He wears a wig and his head is set low on his shoulders. A wide moustache, topped by a big hooked nose, gives the face a theatrically warlike air, while the position of the arms reminds one of nothing so much as a fairground wrestler showing off his strength in the parade. Everything bespeaks the man who views his situation with some complacency and has a vulgar desire to attract attention to his person.

Velázquez conveys this effect without the least degree of exaggeration. There is no hint whatsoever of caricature. The palette is restricted, with only a few bright tones to relieve the dark costume – the streaks of red (the embroidered insignia of the Order of Calatrava), and of yellow (the key of the Grand Chamberlain and the knight's golden chain and spurs). Next to Olivares is a table covered with a red cloth, as in the portraits of Philip IV; he is leaning heavily on it with one hand. It is the only warm surface in the picture.

28 In 1625 Velázquez painted a second portrait of the Count, who by then had acquired the additional title of Duke of San Lucar (New York, The Hispanic Society of America). This is a rather bigger painting than the one now in São Paulo and is much wider in proportion to its height. Olivares does not seem so close to the observer and there is a bigger gap between the top of his head and the frame. He appears in three-quarters profile, the right leg partly hidden by the left, and seems far less massive and clumsy. Although his face is no more agreeable than before, he does look a trifle less pleased with himself. Everything is designed to emphasize his importance. His insignia of office are prominently displayed (the green cross of the Order of Alcántara having replaced the red cross of the Order of Calatrava). And the position of the sword is significant. Held horizontally, it lifts up the cloak and makes it balloon out in a way that adds to the stature of the Count-Duke. The two patches of the red tablecloth seen to the right and left of the legs act in much the same way. Together with the red curtain draped across the top left-hand corner of

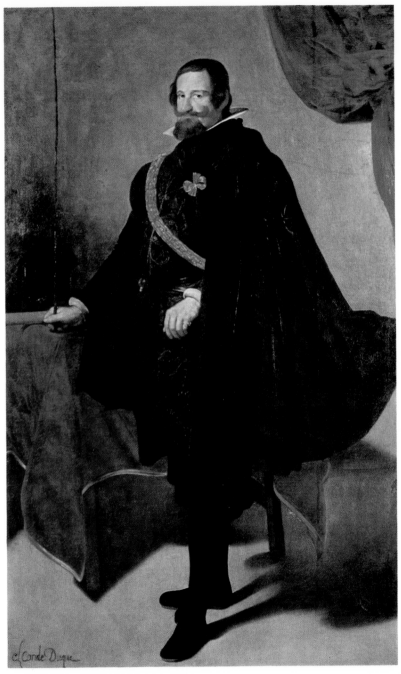

28 *The Count-Duke of Olivares* 1625

the picture, they form a frame around Olivares, reinforcing the formality of the picture. The sort of diamond shape in which the figure is enclosed emphasizes both its verticality and its breadth. The play of light and shade, and the shading-off of tints in the background, help to create a spatial 'environment' which is absent from the previous portrait. To say that Olivares is enclosed in an 'envelope' of space is to repeat a phrase that is often used in connection with Velázquez, yet it is an apt description and one which is difficult to better.

A contest, a victory and a stimulating encounter

When Velázquez began his career at the court in Madrid there were already three artists in residence as painters to the King: Bartolomé Gonzales, Vicente Carducho and Eugenio Caxesi. The first was Spanish, the other two Italians, Carducho being a Florentine and Caxesi, although born in Madrid, the son of a painter from Arezzo who had gone to Spain to work on the Escorial. The Italians received many commissions from the monasteries; they were highly regarded and thought this was no more than their due. Velázquez' privileged position with the King annoyed them and made them jealous. To them he was more than a rival, he was an usurper. They disliked his work, regarding it as contrary to the tradition of Michelangelo, Raphael and the Mannerists, from which they themselves claimed to be descended.

In 1633 Carducho's book *Diálogos de la pintura* was published. In it he set out his ideas on art and launched a violent attack against the school of Naturalism inspired by Caravaggio, declaring that he was 'a false prophet whose arrival can without doubt be seen as the start of the decline and fall of painting'.[26] Comparing him to Antichrist, Carducho described him as 'an Anti-Michelangelo' who had diverted many from the path of immortality, for 'with his superficial imitation and prodigious vivacity, he has made them believe that it is he who represents fine painting'.[27] In the circumstances it is hardly surprising that Carducho hated above all the *bodegones*, pictures with everday themes, of drunkards, cheats, saucy rogues and licentious women (these being approximately the terms he employed). Even the genre of portraiture was not at all to his liking. 'No great painter, no artist of eminence, has ever been a portrait painter,' he proclaimed.[28] And he went on to explain that the portraitist, not being in a position to correct nature by means of knowledge and reason, was forced to be subservient to his model, whether he be good or bad; he was obliged to put aside his intelligence and stop thinking. Of course, as court painter, Carducho

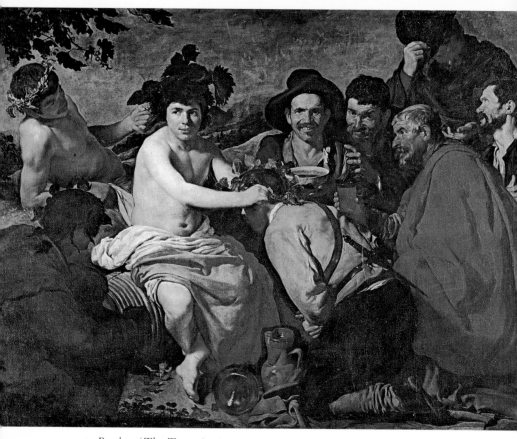

29 *Bacchus (The Topers)* 1628

could not dismiss portraiture out of hand. He therefore maintained that it should be restricted to important rulers, benefactors of humanity, and the Saints.

In his book he does not explicitly state that his attacks are really meant for Velázquez, but no one could fail to guess whom he has in mind. And in any case Carducho felt so strongly on the subject that writing it all down was not enough, he also discussed his views in public well before his book was published, feeling no need whatsoever, in conversation, to conceal the identity of his principal target. Of course

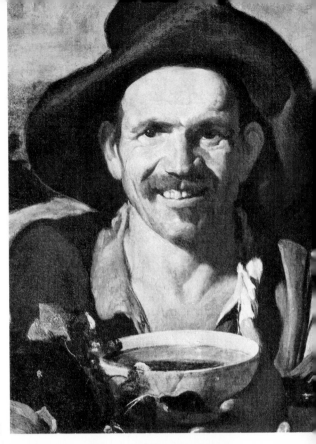

30 *Bacchus (The Topers)* Detail

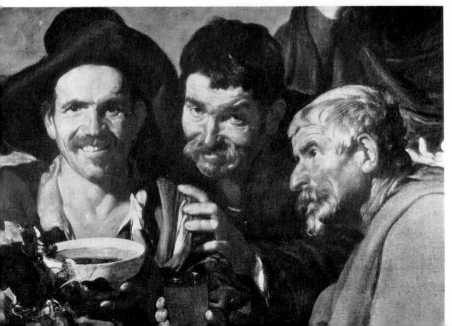

his words eventually reached the King's ears, and he at some point told Velázquez that he was under criticism for being incapable of painting anything but portraits. To this the artist replied that it was not a criticism but a compliment for, he went on: 'For my part I know of no one capable of painting a portrait well.'[29]

Apart from illustrating the bitterness with which Velázquez' rapid rise was greeted by some of his colleagues, and no doubt among the ranks of the courtesans as well, the story also demonstrates that the young artist was perfectly confident of his own ability and worth. And his detractors obviously had little effect on the King, who continued to hold him in high esteem and frequently used to visit him in his studio and watch him at work.

Presumably it was to silence Velázquez' critics, or at least to give the painter the opportunity to confound his enemies, that Philip IV decided in 1627 to hold a contest between the various painters, each being asked to paint a canvas of similar size on the same historical theme. The subject chosen was *Philip III and the Expulsion of the 'Moriscos' from Spain*. This had occurred in 1609 when Lerma, at the instigation of the Archbishop of Valencia, persuaded Philip III to order that all the Moriscos in the Valencia region should leave Spain within the space of three days. The forced exodus was only the first of many which took place in the other provinces during 1610 and 1611, causing hundreds of thousands of people to flee their homes. It mattered little to those who made the deportation orders, and those who supported them, that they deprived Spain of a large part of her farmers and labourers, with disastrous consequences for the economy. The fanatics and purists in political and religious circles rejoiced; in their eyes nothing was more important than that the country should be purged of the infidel.

The fact that Philip IV chose the expulsion as the subject for the competition shows that he too believed it had benefited the kingdom. And what of the painters? How did they acquit themselves? We have no knowledge of the pictures by Carducho, Caxesi or Angelo Nardi, a newcomer to the ranks of the court painters (Bartolomé Gonzales having died in 1627). Velázquez' painting has also disappeared, but there is a description of it by Palomino.[30] Philip III is shown dressed in white and wearing a breastplate, standing right in the centre of the canvas. To his right, seated on a throne set in front of a building, is an

allegorical figure representing Hispania, dressed in Roman style with ears of grain in her left hand, lance and shield in the right. The King is pointing his field-marshal's baton in the general direction of the coast, towards which the soldiers are conducting Moorish men, women and children, many of them in tears. In the background the embarcation is already under way.

From these few sentences it is obviously impossible to have any very clear idea of the picture, which was apparently destroyed in 1734 when the royal palace was gutted by fire. We do at least know the result of the contest. The winner was Velázquez; the verdict was given by a jury consisting of one Spaniard, the Dominican monk Mayno, and an Italian, the court architect Giovanni Battista Crescenzi. Naturally enough Carducho continued to hate Velázquez and, as his book later showed, defeat only sharpened his resentment. But to the King and his entourage the superiority of Velázquez was established beyond doubt. Wanting to reward his favourite artist with some mark of public esteem, Philip IV appointed him to the post of Usher of the Royal Bedchamber.

The year following this victory was a significant one for Velázquez for a quite different reason: Rubens came to Madrid, and stayed there for nine months. Aged fifty-one, the Antwerp artist had long since achieved fame throughout the length and breadth of Europe. At the start of his career he had been in Italy, working for the Duke of Mantua and the Spínola family in Genoa. In 1605 he had visited Spain for the first time and painted an equestrian portrait of the Duke of Lerma and an *Adoration of the Magi* for the royal palace. In 1622 Marie de Médicis commissioned from him a cycle of twenty or so paintings representing in legend and allegory the major events in her life. There were admirers of his work in Germany, and even Poland. And although, superficially, he would seem to be very much a painter of the Catholic world, of the Counter-Reformation and the Jesuits, he was in fact admired even in the Protestant countries, Holland and England. In Flanders he received numerous commissions from churches and religious orders, also from the municipal authorities of the town of Antwerp and from Archduke Albert and Archduchess Isabella, whose official painter he was.

To the Archduchess he was much more than a painter; she used to consult with him about political matters and even entrusted him with

31 *The Forge of Vulcan* 1630

diplomatic missions. She and Rubens were both much preoccupied by the state of war existing between Holland and Spain. It had lasted for tens of years and its effects were felt even in the Spanish Netherlands. A twelve-year truce had been made in 1609, but fighting had resumed in 1621 and no end to the hostilities seemed in sight. Spain continued to fight because she hoped to win back her lost territories in Holland, while the Dutch had everything to lose by yielding as they had grown steadily in wealth and power since they had achieved independence.

Because of the alliance between Holland and England, with England by far the stronger of the two, Rubens determined to open peace nego-

tiations between London and Madrid, hoping that a treaty between the two major powers would have repercussions on relations between Holland and Spain. In Paris he met the Duke of Buckingham, favourite of two English Kings, James I and Charles I, and he gave the idea his blessing. The Archduchess, as Governor of the Spanish Netherlands, decided to send him on an embassy to her nephew Philip IV. It is interesting to note that, in spite of the King's love of painting and sponsorship of Velázquez, he (or Olivares?) were not at all enthusiastic about receiving such an ambassador. He wrote to the Archduchess Isabella: 'I feel I must say that I was most displeased that a painter should have been chosen as emissary in such an important matter. It will be seen as a very grave slight to our monarchy, for inevitably reputation must suffer when a man of such low rank is the minister whom the ambassadors must visit and who advances propositions of such far-reaching significance.'[31] The Archduchess had to reassure the King by explaining that the Duke of Buckingham in person had asked Rubens to undertake the mission, and that the artist would do no more than open negotiations, which would of course be pursued by persons of greater consequence.

Rubens was allowed to come, but on Philip IV's orders he travelled at speed and passed through France without visiting any of his friends in Paris. It was sometime in mid-September when he reached Madrid. Shortly after his arrival he was invited by Olivares to communicate his business and opinions to the Council of State. He seems to have had little difficulty in winning their confidence, for in April 1629 he was actually appointed as Ambassador Extraordinary to the Court of Madrid and sent to London to try to obtain a truce. Even before that, according to Pachecho, Philip IV had named him 'Secretary of the Privy Council to the Court of Brussels. This position, which was his for his lifetime and would then pass to his son Albert, brought with it the sum of one thousand ducats a year. And when his mission was concluded and he took his leave of His Majesty, the Count-Duke gave him in the King's name a ring of the value of two thousand ducats.'[32] It is outside the scope of this book to follow the progress of the Flemish artist's negotiations through to their conclusion, and eventual failure. All that is relevant here is to explain the reason for his journey to Madrid and the circumstances in which he arrived. And in any case it is

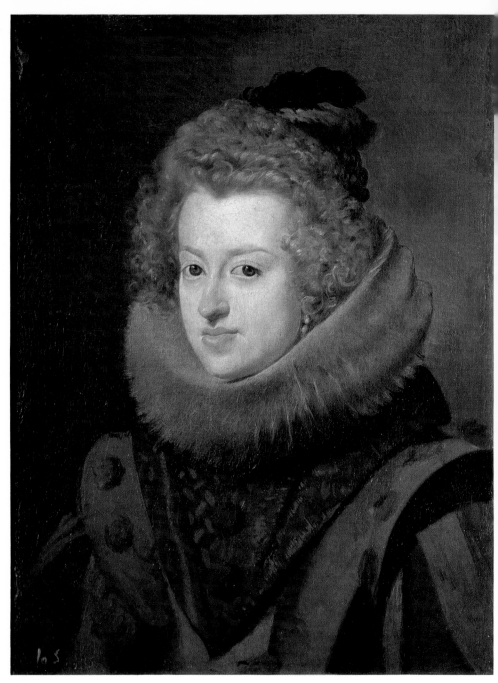

32 *The Infanta Doña María* 1630

of far greater interest to learn what he did there as a painter and above all what impression his presence and his work produced on Velázquez.

Pachecho can supply us with some of the answers. Firstly, he notes that Rubens brought eight canvases with him as a gift for the King, all on different themes and of different sizes. And later he mentions with astonishment the Flemish artist's intense artistic activity while in Madrid – painting not merely a dozen portraits of the King, the Queen, the Infante or private citizens, as well as an *Immaculate Conception* and a *Saint John the Evangelist* for other clients, but also retouching the *Adoration of the Magi*, which he had executed on the occasion of his first visit to Madrid, and copying all the Titians in the royal collection as well as some from elsewhere.

In a letter he sent in December 1628 to his friend Peiresc, Rubens mentions that he lived in the palace itself and was visited nearly every day by the King. Given his preference for art over politics, the King no doubt had reason to be grateful that it was a great artist who had undertaken the role of diplomat, since it gave him the additional pleasure of seeing him at work in Madrid itself.

As for the relationship between Rubens and Velázquez, Pachecho notes that the Flemish master 'had little contact with the other painters. He became friendly only with my son-in-law (with whom he had previously exchanged letters) and pronounced very favourably on his works, especially praising his modesty. They went together to visit the Escorial.'[33]

Reading this, one cannot help but be surprised at the phrase 'especially praising his modesty'. Was it, as Justi has suggested,[34] that Velázquez compared his own work with the work of Rubens and found that it did not stand up to the comparison? And did he then tell Rubens of his reactions? Perhaps. But it would be better not to jump too hastily to this conclusion. Velázquez might well have been impressed with the sheer brio of Rubens' painting and the facility with which he handled all kinds of subjects, and dazzled too, no doubt, by the gleaming colours of his pictures. But it is surely improbable that this would have had any profound or lasting effect on him, to the point of making him lose confidence in himself and want to change his own style. The two painters are very different in temperament. There is no exuberant sexuality in Velázquez, no use of rhetoric. Nor does he possess those

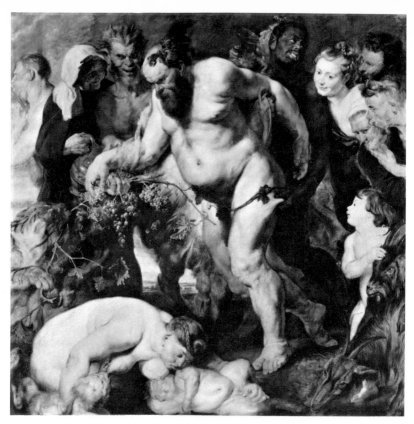

33 PETER PAUL RUBENS *Drunken Silenus c.* 1618

resources of the imagination which enabled Rubens to conceive his
grandiose set-pieces and to deal as freely with the gods of legend as the
heroes of history.

In fact, if proof of his consistency were needed, Velázquez provided
it while the Flemish master was still in Madrid. It was then that he
29, 30 painted his *Bacchus* or *The Topers* (Madrid, Prado), which shows the
mythological character Bacchus surrounded by drinkers. One need
33 only compare this with Rubens' *Drunken Silenus* (Munich, Alte Pina-
kothek) to see the vast difference between the two painters. Even
superficially, there is on the one hand the heavy plump flesh of the old

74

satyr, sagging and even bloated in places, and on the other a body
which, though stout, is still youthful and relatively fit. More signifi-
cantly, there is the contrast between a noisy, laughing throng and a
group of people who make no gestures and say very little, whose faces,
with two exceptions, are serious and attentive, almost reserved. Ac-
companied by a heterogeneous cortège, Silenus totters forward at an
angle, as though about to fall over. Bacchus however, like most of
those around him, is seated; with an air of detachment he is crowning
with vine leaves the man kneeling in front of him. In the foreground of

34 CARAVAGGIO *Bacchus c.* 1590

the Rubens there is a ribald detail typical of this artist's exuberant sense of life – that is, the nude bacchante leaning over to offer her full breasts to the two children sucking at them like greedy little pigs. There is nothing remotely like this in the Velázquez. One or two of his peasants may look vaguely like tramps, and two of them are laughing with that malicious humour often seen in a drunkard, yet none is without a certain dignity. The figure in the foreground, with the grey hair and beard, could be translated just as he is into some scene of the Adoration of the Shepherds – or even the Adoration of the Magi.

Even when Velázquez is painting drunkards he excludes rowdy behaviour and vulgarity. Yet he does not idealize his characters in any way – the figure of Bacchus has sometimes been regarded as a parody of the god. The same explanation has been put forward in the case of Caravaggio's *Bacchus* (Florence, Uffizi), which certainly has points of similarity with the Velázquez and may even have been a direct influence. But in the Italian painting the god appears alone, while here he is surrounded by a crowd of drunken rustics, placing him fairly and squarely in the context of ordinary everyday life. Perhaps there is some justice in Ortega y Gasset's remark, that in Velázquez myth is 'reversed': instead of having the power to transport us to an imaginary world, it is itself forced to become part of the domain of physical reality.[35] And of course it is quite true that this Bacchus is nothing more than a country lad, with only his naked torso to show that he is meant to be a mythological hero. The same holds true for the youth holding the goblet who is sitting behind him. But it is not the half-naked bodies that are the most interesting, it is the older figures of the drunkards themselves. It is in them that we rediscover the piercing realism of the pictures of the Sevillian period.

Yet the style has undergone several changes. The faces are less sharply defined, the volumes less sculptural. Velázquez evidently takes more account than he did before of pictorial interest. This might be put down to the influence of Rubens, except that the portraits he had already painted at court indicate a shift in this direction. Although the drunkards are shown in a landscape setting this cannot really be described as *plein air* painting. The light is not as frozen or as hard as in the Sevillian canvases, but it remains static, falling from left to right as though through the window of a studio. The landscape is really there to open

34

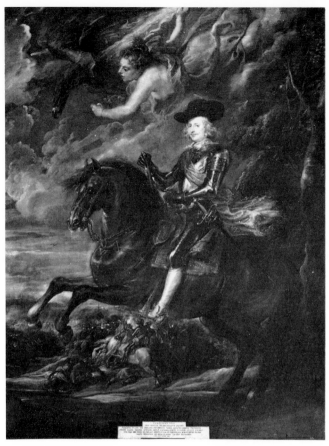

35 PETER PAUL RUBENS *The Cardinal-Infante Don Fernando at Nördlingen*

up a perspective in the composition, to carry the eye on beyond the group of men, who are certainly anything but fully integrated into the surrounding countryside. Nevertheless, the landscape is still something more than a backdrop.

The contrasts between Rubens and Velázquez are equally apparent in their portraits. As painted by Rubens, *Philip IV* (Leningrad, Hermitage) is a different man. He looks altogether more worldly. His uniform is richly ornamented, and he stands in front of the full sweep of a heavy

curtain. Which image is the more accurate? We know that Philip IV liked a life of pleasure and enjoyed flirtations, so Rubens is not giving a false impression of the man – he is simply expressing that portion of the truth to which his own temperament responds. And, essentially, Velázquez does exactly the same, except that it was not in his nature to represent indolence, debauchery or familiarity. He believed in decorum. And when he painted Philip IV he never forgot for one second that he was painting the King, a personage who ought to be dignified and remote if not actually majestic.

When Rubens wanted to lay emphasis on the royal blood of his model he employed allegory. Behind the figure of the King in *Philip II on Horseback* (Madrid, Prado), he introduces a winged woman holding a laurel wreath above the monarch's head. In the equestrian portrait of *The Cardinal-Infante Fernando at Nördlingen* (Madrid, Prado) a rather similar woman, with an eagle flying in front of her, is shown throwing a thunderbolt, helping the soldiers who are fighting at the rear of the picture. Such an approach is not without its attendant melodrama and cliché, neither of which is to be encountered in the work of Velázquez. And it hardly needs saying that the two painters are equally at variance in their use of colour. Velázquez was never interested in ostentation or aggressive display and always preferred restraint and sobriety to anything that smacked of theatrical effect.

It is clearly impossible to accept that Rubens influenced Velázquez in any substantial way. But certainly he may have increased his appreciation of the Titians which he had copied so energetically. And he no doubt sang the praises of Italy, where he himself had spent so many enjoyable years, fighting his first battles and winning his first victories. Velázquez must have been very willing to be persuaded, for Pachecho, a devotee of Italian painting, had certainly already awakened in him the desire to see the works of the great painters of Rome and Venice in their proper setting. It was a desire that became more and more insistent, and eventually Velázquez asked Philip IV for leave of absence in order that he might undertake the journey of which he dreamed.

The discovery of Italy

On 28 June 1629 Velázquez was given permission to go to Italy. Not only was he assured that he would continue to receive his salary, he was also given money by both the King and the Count-Duke. Olivares gave him in addition a medallion bearing the effigy of Philip IV and letters of introduction for Venice, Rome and the various Italian courts. On 10 August Velázquez boarded ship at Barcelona, and on 19 September arrived in Genoa. A Spaniard travelling to Italy at that time would have found in various parts of the country territories that were governed from or in some degree dependent on Madrid. Milan was the capital of a Duchy, Naples of a kingdom, but both were under Spanish rule; power was exercised in the name of Philip IV by a governor or viceroy. Other states were more or less effectively subject to the Spanish King (or, more accurately, to Olivares). Only the papal states, Venice and Savoy were outside his realm of influence.

At the time Velázquez was preparing to leave Madrid, Spain believed, quite correctly, that her interests were being threatened both to the east and west of the Duchy of Milan. The famous Italian general Ambrosio Spínola was sent to take command of the army; a few years earlier he had captured the town of Breda from the Dutch. It was in the company of this illustrious personage that Velázquez travelled to Italy. In the course of the few weeks he spent in his company he was able to observe him at leisure, a fact which has some importance as he was to include him in one of his compositions some five years later. But Velázquez' arrival side by side with the General, together with his position at court, also had more immediate consequences, for certain individuals began to speculate whether the study of Italian art was indeed the sole object of his journey. The Venetian ambassador in Spain was obliged to reassure the Senate that Velázquez was indeed coming there for the sole purpose of perfecting his art, while the ambassador from Parma maintained that this was no more than a pretext for his

true mission, which was espionage.[36] Local painters were even advised to watch what they said if they should happen to meet their Spanish colleague.

Velázquez himself seems to have had no other thought in his head but to look at pictures and paint them. He quickly left Genoa for Venice. There he lived in the house of the ambassador Don Cristóbal de Benavente y Benavides, and was no doubt surprised to discover that Spaniards were not popular at that time in the City of the Doges. When he went out he had to be accompanied by an escort, and of course he had come with the express purpose of going out as often as possible in order to see as many Titians, Tintorettos and Veroneses as he could find. He made many drawings after these masters – unfortunately none has survived – and also a number of studies of Tintoretto's *Crucifixion* in the Scuola di San Rocco, and a copy of a *Last Supper* by the same artist, which he later presented to Philip IV.

After spending several months in Venice – 'only the war prevented him from staying longer' Palomino tells us[37] – he set out for Rome. According to Pachecho, his journey took him by way of Ferrara, where he was entertained by Cardinal Sacchetti, former Papal Nuncio to Spain. After only two days there he continued his journey. He had letters of introduction to the Cardinals Ludovisi and Spada in Bologna but in the event did not visit the town. Nor did he go to Florence, although that had been part of his original plan. Rome was the magnet and he was in a hurry to get there. The nephew of Pope Urban VII, Cardinal Francesco Barberini, mindful of the splendid reception he had been given when he arrived in Madrid as Papal Nuncio in 1626, took personal charge of him and arranged for living quarters in the Vatican to be placed at his disposal. But Velázquez felt too isolated and did not stay there long. He was content to have access to the Vatican in order to make drawings of Michelangelo's *Last Judgment* or the works of Raphael. Again it is his father-in-law who supplied this information, adding that he often visited the Vatican and made excellent progress.

Pachecho also tells us that when Velázquez saw the Villa Medici he thought it would be an ideal spot to spend the summer in study. He mentioned his idea to the Spanish ambassador, the Count of Monterrey, a brother-in-law of Olivares, and he applied to the Duke of Florence for permission for Velázquez to take up residence. It appears that he

lived there for two months (May to July 1630) before a fever obliged him to move nearer to the Count of Monterrey's house. The Count had him looked after by his personal physician and at his own expense. He also sent him quantities of presents and ordered everything to be arranged to Velázquez' liking in his new dwelling.

Pachecho takes visible pleasure in recounting how well his son-in-law was treated, mentioning all the attentions and marks of consideration shown to him by each individual. He could only have done this on the basis of information supplied to him by Velázquez, so one must assume that the painter himself was appreciative of the welcome he received wherever he went – and which he no doubt thought was no more than was due to him as court painter of the King of Spain.

While in Rome Velázquez would have had ample opportunity to meet other artists, not just Italians but Flemish, Dutch, French and Lorrainers as well, for in Europe at that time there were literally hundreds of painters whose dearest wish was to work in the Eternal City. He might, for example, have met Le Valentin (de Boullogne), whose Caravaggesque works must have reminded him of his own Sevillian paintings, or Poussin who, like himself, had studied Raphael and Titian and in addition was known to Cardinal Francesco Barberini, who had commissioned a *Death of Germanicus* from him in 1626. Yet apparently Velázquez made no contacts with any of these artists – not at least in any significant sense. If he had he would certainly have told Pachecho and he, who has described the Italian journey in such detail, would not have failed to include the information in his book. Similarly, if there had been cause to do so, he would have mentioned that Velázquez had admired such and such a painting which he had seen in Rome. In fact all the indications are that the Spanish artist was more enthusiastic about sixteenth-century painting than about the works of his contemporaries.

Pachecho does report that while in Rome Velázquez painted a 'superb self-portrait', adding that it was 'in the manner of the great Titian' and by no means inferior to his portraits.[38] Unfortunately we are not in any position to judge for ourselves as the picture has disappeared. The same is true of the portrait of the Countess of Monterrey of approximately the same date. But there remain two canvases painted in 1630, one a biblical subject, *Joseph's Bloody Coat Brought to* 37, 38

81

Jacob (Escorial), the other a mythological subject, *The Forge of Vulcan* (Madrid, Prado). Both were purchased for Philip IV in 1643 by Olivares' secretary.

Although neither can be ranked among the artist's masterpieces, they deserve to be studied in some detail because they reveal how Velázquez reacted to the exposure to Italian painting. That he was fundamentally

31, 36 unchanged by it comes as no great surprise. *The Forge of Vulcan* is, like
29 *The Topers*, a scene of everyday reality. Apollo is breaking the news to Vulcan that his wife Venus has succumbed to the advances of the god Mars. Yet Vulcan is a perfectly ordinary blacksmith, his four helpers are like any other workmen, and they regard Apollo exactly as they would any chance visitor to the forge. As for Apollo himself, he has the well-covered body of the Bacchus in *The Topers*; only the laurel wreath that frames his features, the halo shining behind his head, and the long orange robe that leaves his torso and arms bare, distinguish him from the other characters. It is hardly enough to convince us that we are in the presence of the God of Light. The effect is more of someone playing the part in a theatre. This Apollo has no aura of majesty. He looks like a spoilt child, an adolescent who has run to fat. He could be the angel in some uninspired Annunciation. It is impossible to imagine a young man like that bringing Vulcan the news that his wife has deceived him.

Once again Velázquez shows that his talents did not lie in the direction of convincing narration, and that the myths inspired him less than practically anything else. One wonders why he chose the subject in the first place, whether it still mattered to him to prove that he was more than just a portrait painter, that themes from the myths were as accessible to him as to Rubens or Titian? But more probably he chose it because of the opportunity to paint semi-nudes and to demonstrate that he was as skilled in this as in anything else. Certainly he appears to be much preoccupied with anatomy in this composition. He rings the changes more or less at will, giving each person a different physique or pose.

Apollo's body is solid and well rounded, Vulcan's is thin, wasted and misshapen, those of the workmen powerful and muscular. One is shown facing to the front, the rest are in three-quarters profile, full profile or seen from the back. One stands upright, another is bent forward. One head is thrown back, another is on one side, another is

82

36 *The Forge of Vulcan* Details of ill. 31

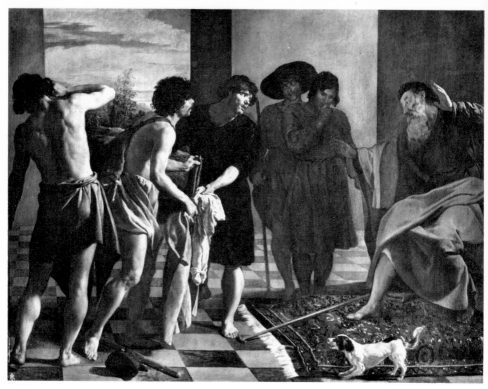

37 *Joseph's Bloody Coat Brought to Jacob* 1630

craning over. It is almost like looking at some sort of demonstration, and it makes the picture seem even more cold and academic.

Of course there are a number of passages of straightforward realism, for example Vulcan's twisted body, his face and the faces of his helpers. But the picture as a whole does not have the piquancy or visual sharpness of *The Topers*. The chiaroscuro is not very pronounced, and the hazy and subdued light that envelops skin, clothes and objects does not allow the shadows to be dark or opaque. No doubt Velázquez owes his characters to Italian painting, and to Raphael in particular. In all probability it was because of his influence that Velázquez used a different grouping from that of *The Topers*. There (in the right-hand section of

the picture particularly) the characters are crowded closely together, but here each one is free-standing in space, his position dictated by an overall design intended to be clear and rhythmic to the eye. Yet the picture painted before the Italian trip conveys far more emotion. As a composition it may be less subtle, but it is charged with a more honest and intense sense of life.

Joseph's Coat, which shows the brothers bringing Joseph's coat to *37, 38* their father Jacob, has certain points of resemblance with *The Forge of* *31, 36* *Vulcan*. The two canvases are the same height and were, apparently, originally of similar width (an early copy of *Joseph's Coat*, now lost, showed that the original must have been trimmed on both sides). In each work there is the same number of figures (six) and the same carefully plotted composition. And there are two partially nude male figures in *Joseph's Coat*, the one seen from the back being chiefly of interest as an anatomical study. The anatomical details are rather more carefully expressed than in *The Forge of Vulcan*: there seems to be

38 *Joseph's Bloody Coat Brought to Jacob* Detail

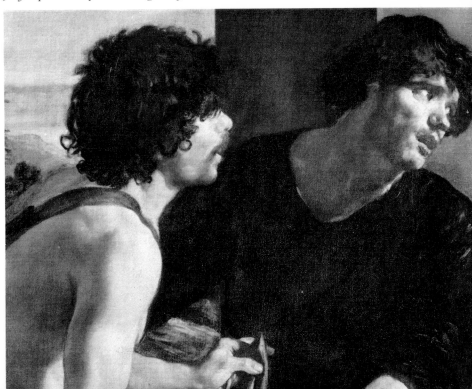

greater contrast in the modelling. Light and dark are altogether more resolutely opposed throughout the picture. Although there is a big window set in the rear wall of the room where the scene takes place, and presumably another somewhere behind the figure of Jacob, the room is bathed in transparent shadow. The light coming from the right picks out the contour of a hand, a fragment of face, a piece of arm, body or leg. Like the grouping of the figures, the light emphasizes the diagonal which leads across to Jacob. It also establishes an immediate rapport between him and the men bringing the coat, in other words, between the men announcing the death of Joseph and the man who is distraught at hearing their news. Justi notes that the two brothers are without doubt the most ruffianly Velázquez ever painted.[39] Their faces, torn between light and shadow, are full of insolence, villainy and uneasy treachery.

Narratively it is a more convincing picture than *The Forge of Vulcan*. Except in the case of the figure seen from the back (who, as we have said, is chiefly important as a nude study), both the expressions and the attitudes are more appropriate in terms of the roles the characters are playing and the emotions they are experiencing. And the colours of the garments and the big red carpet under Jacob's feet, and also the operation of the chiaroscuro, provide a far warmer and more varied chromatic range. The chiaroscuro also gives depth to the picture, although Velázquez makes use of another device rare in his work: the tiles on the floor, progressively decreasing in scale, give a sense of measurable receding space. This explicit reliance on linear perspective is no doubt a further influence of the Italian Renaissance.

Although Velázquez left Rome in the last months of 1630, he did not immediately return to Spain. At the request of Philip IV he went first to Naples to paint the portrait of the Infanta María, the same whose hand in marriage had once been sought by the Prince of Wales. In April 1629 she had finally married by proxy the King of Hungary and future Emperor of Germany, Ferdinand III; on her way to join him she passed through Naples and stayed there from 13 August to 18 December 1630. A few months earlier the Tuscan ambassador Michelangelo Baglioni, who had seen her in Barcelona, had written in a letter to the Grand Duke of Tuscany that she 'has the face of an angel'. He described her as 'one of the most beautiful women I have ever met: very white skin,

blond hair that is more white than gold, a truly royal appearance. She listened attentively to what I had to say and made a gracious reply, but in so low a voice that I had difficulty in understanding more than a few words.'⁴⁰ Other sources tell us that, although devout, she had a taste for the theatre and (like her brother) enjoyed playing the leading role. She also liked hunting and physical activity.

In the head-and-shoulders portrait of her by Velázquez (Madrid, Prado), which was in the artist's studio at the time of his death, she appears to correspond quite closely to the Tuscan ambassador's description. Her expression is, up to a point, angelic, but also somewhat distant. She has the same fleshy lower lip as Philip IV and the set of her mouth gives her a melancholy air; there is a hint of moodiness and frustration about her. From a purely technical point of view, the brushwork is now much lighter and more lively. The hair is merely indicated with many rapid strokes that do no more than suggest curls picked out by the light. The modelling is softer than in the early portraits and the shadows less dense, although the volumes are still firmly stated.

Another Spanish artist, Jusepe Ribera, had been working for many years at the court of the Viceroy of Naples, where Velázquez painted this picture. He had a studio in the palace at his disposal and the Viceroy used to consult him when he purchased works of art either for himself or for Philip IV. Eight years older than Velázquez, the Ribera of 1630 was no longer the enthusiastic devotee of Caravaggesque Tenebrism that he had once been. He had also abandoned the brutality of certain of the scenes of martyrdom on which a large part of his reputation rested. He and Velázquez must have been very much in sympathy as, by this time, both looked to sixteenth-century Italian art for inspiration. Five years previously, when asked by the painter Jusepe Martínez if he did not long to return to Rome to see again the works he had once studied, Ribera had replied: 'I would like not only to see them but to study them afresh. For they are works one must study and contemplate very often. True, other directions and practices are being pursued at the present, but art rushes to its ruin if it is not founded on this basis of study. For history paintings, those the immortal Raphael painted in the Vatican are our guide and our compass; he who studies them will become a true and consummate history painter.'⁴¹ Nothing could have been closer to Velázquez' own ideas at the time. And no doubt the

encounter between the two artists is the reason why so many of Ribera's works found their way to the palace at Madrid and to the Escorial.

Once the portrait of the Infanta María was finished, Velázquez had no reason to linger in Italy. He arrived back in Madrid in January 1631, having been away for one and a half years. 'He was very warmly welcomed by the Count-Duke', Pachecho tells us. 'At his instigation he went at once to kiss His Majesty's hand, and he thanked him profoundly for not having his portrait painted by any other. His Majesty was very happy to see him returned.'[42]

Further portraits

It is impossible to say whether it was in Italy or following his return to Spain that Velázquez painted his *Christ After the Flagellation Contem-* *40*
plated by the Christian Soul (London, National Gallery). Some passages appear to have been influenced by Italian works, others could well have been executed before he left. Dates suggested range between 1628 and 1632. It is not, as it at first appears, a realistic scene, but a vision. Christ has sunk to the ground after his flagellation, his hands tied by a rope to a column. He turns to look at the child and angel behind him. The child personifies the Christian soul whom the angel invites to sympathize with the pain of the tortured man. The expression Velázquez has given him could hardly be more affecting. Yet neither the body nor face of Christ show pain in any way that has the power to touch us. A few specks of blood here and there are hardly enough to make such a robust and well-covered nude emotionally moving. And the expression on his face, full of sentimentality, is pure melodrama. It has been inferred from this that Velázquez came under the influence of Guido Reni while in Italy. But the pronounced, rather harsh relief recalls Velázquez' Sevillian period, and this is why it has also been suggested that the picture predates the Italian trip.

A second religious painting, *Christ on the Cross* (Madrid, Prado), must *41*
be of slightly later date. It was commissioned by Philip IV for the nuns of the Benedictine convent of San Plácido in Madrid. By setting the cross against a dark background (made even blacker by the passage of time) Velázquez has obviously tried to convey an immediate sense of the complete isolation of the crucified man at his death. Yet the ivory body is quite without tension and shows no trace of suffering or agony. The tiny wound in the breast, trickling blood, and the bleeding of the hands and feet where they are nailed to the cross, cannot counteract the cold academicism of the nude body which, although harmoniously constructed, once again totally lacks any power to stir the feelings.

39 *Prince Baltasar Carlos* 1632

40 *Christ After the Flagellation Contemplated by the Christian Soul* 1628–32

It would of course be stupid to expect Velázquez to be a second Grünewald. But one cannot help remembering the crucifixions painted by his former friend Zurbarán at the same period. He did not resort to expressionistic distortions any more than Velázquez; yet he employs grey or brownish tints for the emaciated nude body, makes us feel physically the painful weight of the crucifixion on the muscles of the arms and torso, hollows out the stomach, contorts the drapery over the hips, and in these various ways makes his works acutely expressive in a manner that suits their theme, and which one looks for in vain in Velázquez.

41 *Christ on the Cross c.* 1630

Happily there were other tasks waiting for the painter on his return. An event of momentous significance had occurred at the court during his absence. On 17 October 1629 the Queen had given birth to a son and heir, Baltasar Carlos. Until then Philip IV and Queen Isabella of Bourbon had conceived girls only, and all of them had died.

No sooner was Velázquez back in Madrid than he was asked to paint 43 the young Infante. Even in the first picture of him (Boston, Museum of

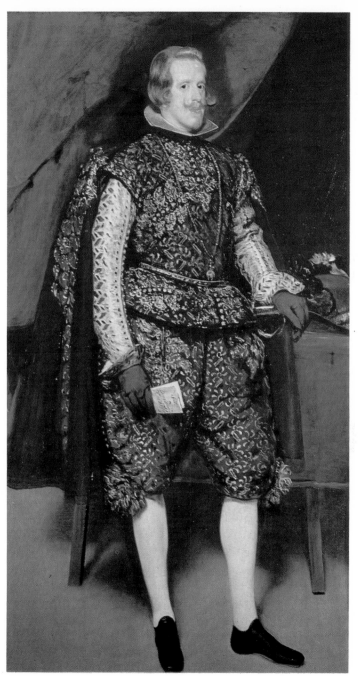

42 Philip IV 1635

Fine Arts) he is shown standing upright, a field-marshal's baton in one hand and the hilt of a sword in the other. The stiffness of his bearing is obviously meant to indicate the future sovereign he was (although his death fifteen years later prevented him from coming to the throne), but the unformed features, full plump cheeks and fine blond hair show that he was nevertheless a child. The ceremonial nature of the painting is emphasized by the reds of the sash, the hangings at the back, the carpet, and the cushion lying on the floor.

Baltasar Carlos could easily have been swamped by this expanse of warm tonality and made to look very fragile and doll-like. But Velázquez has avoided this danger by placing a young dwarf in front of him. Although his legs are hidden under his skirt, he seems to be moving forward, and the way he holds his head and the look he casts behind him seem to be encouraging the Prince to follow. There is a contrast between, on the one hand, the normal boy whose rank has to be stressed and who therefore looks as stiff as a dummy and, on the other hand, gestures and movements that are full of life but are marred and rendered grotesque by infirmities of mind and body. Of course, and this is something that will crop up again later when Velázquez chooses to paint a crippled dwarf, and one who to all appearances is mentally deficient as well, his intention is not to make people have pity on the unfortunates of this world. He is merely stating a fact: just as a child of today might have a dog or a cat or a wooden horse, Baltasar Carlos has a dwarf. What could be more natural than to show them together?

39 In the second portrait, of 1632 (London, Wallace Collection), the Prince stands alone in the middle of the picture in a rather similar pose to the first. But he is older and clearly has more control of his body, so his upright posture is less contrived. The red tones of the curtain behind him and the cushion at his feet are not as dominant as in the earlier portrait: they are muted in colour and far less conspicuous. They combine with the similarly muted tonality of the background to set off the figure of the Infante, who has exchanged his dark green robe embroidered with gold for one of grey embroidered with silver. It is less heavy and formal and rather more suited to a young child, though still anything but insipid. Luminous grey alternates with tones of dull grey and the pink of the sash adds a bright splash of colour; the effect is one of attractive nobility and variety.

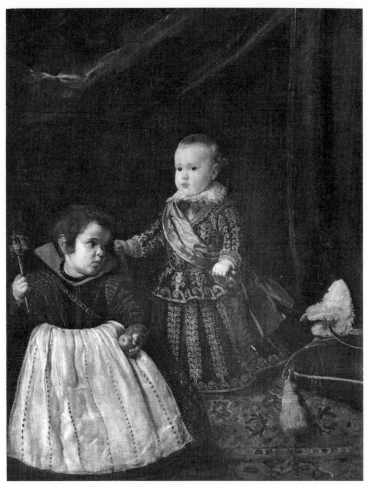

43 *Prince Baltasar Carlos with a Dwarf* 1631

It is the beauty of the costume that is the charm too of the portrait of 42
Philip IV (London, National Gallery) which must have been executed
shortly after that of Baltasar Carlos. Until then Velázquez had never
painted the King in anything but his habitual sober black. Here the
material is brown and decorated all over with silver embroidery. The
colour scheme may not have the ravishing subtlety of the young

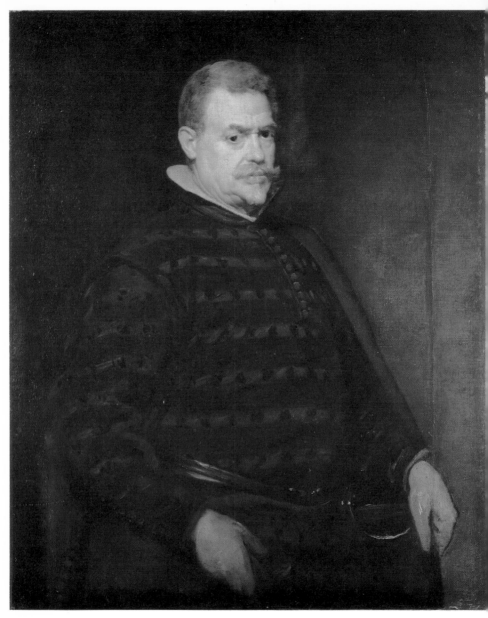

44 *Don Juan Mateos* 1632

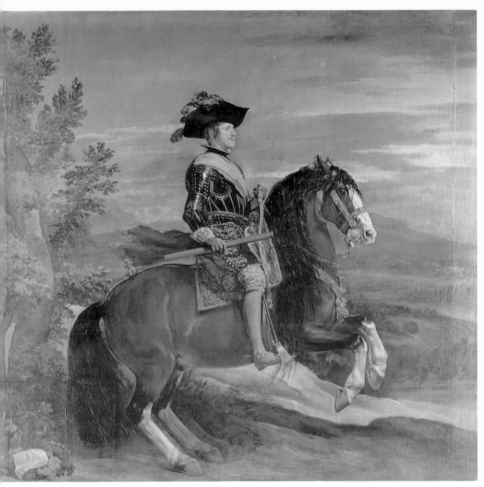

45 *Philip IV, Equestrian* 1635

Prince's robe, but it is equally attractive. More striking still is the
freedom of the brushwork. It was already remarkable in the portrait of
the child, but is particularly impressive here over a wider surface area.
Looked at closely, the complex embroidery is made up of blobs,
streaks and commas, meaningless unrelated scribbles. So that this rapid

and airy calligraphy (which is nevertheless totally accurate and sug-gestive) does not introduce too much animation into the picture, every-thing that surrounds the costume is calm, including the deep red curtain with its minimum of folds. Velázquez judiciously counterpoints activity with repose. The liveliness of his touch does not make him perfunctory, nor does the concept of a grand formal portrait lead him to lay too much stress on pomp and ceremony.

Although the face is clearly that of the same man, it has undergone certain changes since the earlier portraits. The head is turned to the side so that the left cheek appears less full, the chin is more pointed and jutting, and the face as a whole does not have the flabbiness or com-placently apathetic expression of the earlier pictures. The lips seem a shade less greedy, the mouth now betrays a hint of anxiety, and the King looks out of the corner of his eye as though hesitant to meet our gaze. The portrait differs from the preceding ones in respect of two other details – the hair falls down over the cheek, covering the ears, and the King wears a moustache with curled-up ends, a distinctive mark of royalty for the Spanish at that period.

The head too has certain stylistic peculiarities. Its lines are less accen-tuated than before and the shadows which suggest the modelling are far more delicate and transparent. But it is not treated in the same impressionistic manner as the costume, and this has inspired the suppo-sition that the two sections are not of the same date. Allan Braham thinks the head must date from 1631–32 and the costume from c. 1635.[43] He may well be right, although it should be borne in mind that Velázquez was always more 'respectful' in the way he portrayed the King's face than in the other sections of his royal portraits.

Velázquez must have been particularly proud of this canvas as, unusually for him, it is signed with his name. The sheet of paper Philip IV holds in his right hand bears the words: *Señor. Diego Velasqûz. Pintor de V. Mg.* (Painter to His Majesty).[44]

We have documentary evidence that in the autumn of 1632 portraits of Philip IV and Queen Isabella (Vienna, Kunsthistorisches Museum) were sent to the court of the Habsburgs. But today these pictures are attributed not to Velázquez but to his studio. Given the number of pictures he was asked to paint, it was necessary for him to have assistants working under his direction or copying his originals. The most

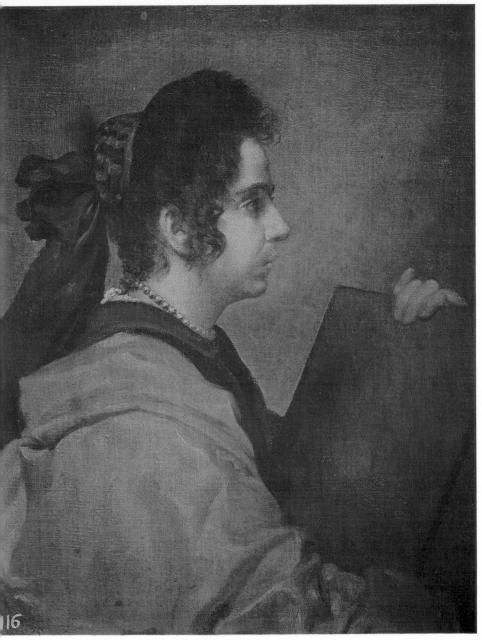

46 *A Woman as a Sibyl* 1632

interesting of them was Juan Bautista del Mazo, who in 1633 became his son-in-law, marrying his daughter Francisca.

A few portraits of private citizens also belong to the early 1630s: those of Philip IV's Master of the Hunt *Don Juan Mateos* (Gemälde-galerie, Dresden), of *Doña Antonia de Ipeñarrieta and her son*, and of that lady's second husband *Don Diego de Corral y Arellano* (Madrid, Prado). It was Doña Antonia who, in 1624, had paid Velázquez for three pictures, of Philip IV, Olivares and her deceased husband. Her first husband had been a professor of law, her second was a jurist. The portraits of the couple are very severe. The woman in her floor-length

47 *Doña Antonia de Ipeñarrieta y Galdós with One of Her Sons* 1631

48 *Don Diego del Corral
y Arellano* 1631

dark dress looks almost more strict than the man in his black gown. And the child is as stiff as a little wooden doll. In pictorial terms, he cannot be compared with the portrait of *Baltasar Carlos* in the Wallace Collection, and it is hard to conceive that this canvas was painted only a few months before. Several art historians have understandably declined to attribute the figure to Velázquez and have suggested it was added at a later date by another hand.

The identity of the model for *A Woman as a Sibyl* (Madrid, Prado) is 46 far from certain. The name of Juana Pachecho has been suggested, but

266

49 *Prince Baltasar Carlos, Equestrian* 1635

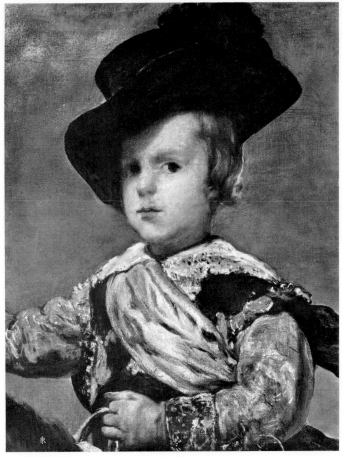

50 *Prince Baltasar Carlos, Equestrian* Detail

as no undisputed likeness of her exists it is impossible to be sure. Certainly if she is the model we have yet another example of the difference between Velázquez and Rubens, who took such pleasure in showing off the attractions of his two wives. Here there is no affection, no attempt to beautify, not the least hint of sensuality. Instead a serious, almost disapproving expression, a plain dress and drab colours, browns, greys and blacks.

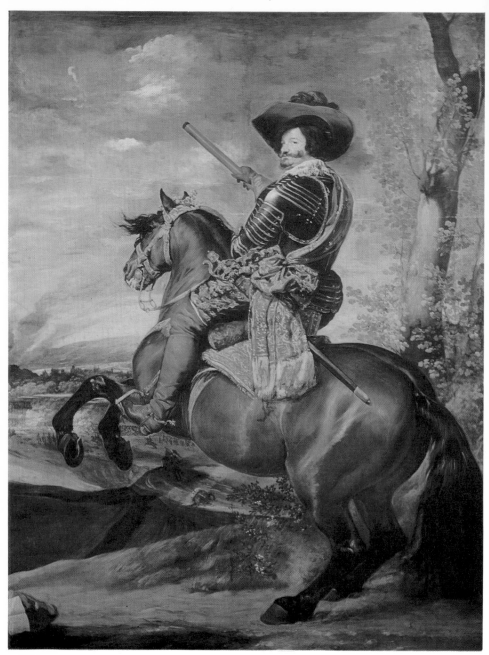

51 *Don Gaspar de Guzmán, Conde de Olivares, Duque de San Lúcar
La Mayor, Equestrian* 1634

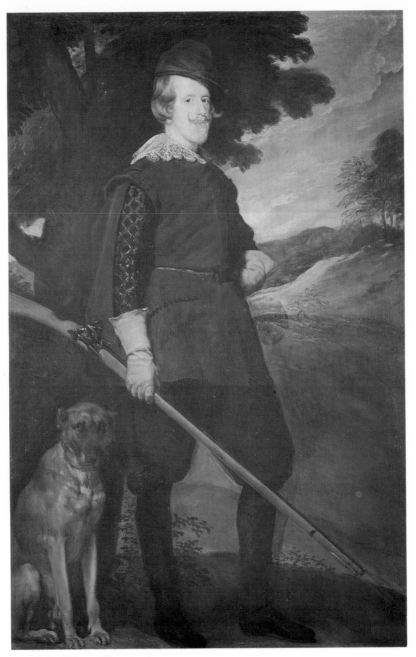

52 *Philip IV as a Hunter* 1632–35

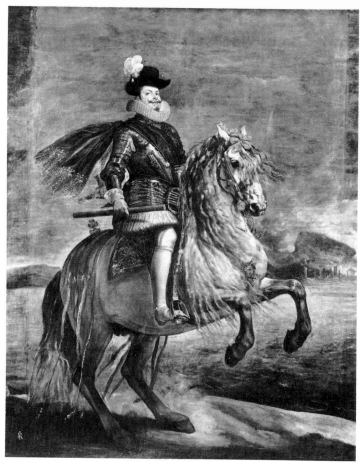

53 *Philip III, Equestrian* 1628–35

In about 1635 Velázquez was given another official commission, that of painting a number of equestrian portraits. There are six such pictures 45, 49 to be seen in the Prado, representing Philip IV, Baltasar Carlos, 51, 53, 58 Olivares, Queen Isabella, Philip III, and his wife Queen Margarita. There are no problems of attribution about the first three but the remainder are more problematical. As Philip III died in 1621 and Queen

Margarita in 1611, they could not possibly have sat for Velázquez. He might have painted them from existing portraits, but if so it seems unlikely that he would have adopted the style of his predecessors, the minutely detailed rendering of the costumes in particular. According to López-Rey,[45] it is generally accepted today that Velázquez started work on the portraits in 1628, before he went to Italy, and left them to be completed by someone else in his absence; he then retouched them in c. 1634–35. But there is no proof that this is what occurred. What is not in question is the difference in style between the two groups of portraits and, within the second group, between the passages which have been retouched (where the handling is very free) and those that have not (which are painted in the rather meticulous manner of the portraits of Pantoja de la Cruz or Bartolomé Gonzales).

The most heavily retouched picture is that of Queen Isabella. Her *58, 59*
dress and the caparisons of the horse are very much in the spirit of the portrait of Queen Margarita, but the face, earrings, collar and horse's head are by an altogether freer and more perceptive hand; the style is as allusive as it is in the likeness of the Infanta María painted in Naples. Rubens too had painted the Queen, in 1628 (Vienna, Kunsthistorisches *56*
Museum), although his interpretation of her does not correspond too well with what we know of her life. Her sweet expression and gleamingly healthy skin (one can almost see the blood flowing through the veins) seem hardly appropriate for a woman who lost four children, whose husband had countless love affairs, and who had been slighted and humiliated more than once by Olivares. An ambassador from Venice wrote the following in 1630: 'The Queen is much afflicted by the dissolute life led by her husband, who takes almost no account of her. She leads a miserable existence and the people of the court eye her askance.'[46] Shortly afterwards another ambassador staying in Madrid wrote that 'the Queen led a very melancholy existence. She was more preoccupied with medicine bottles than with festivities.'[47] Other accounts confirm that she had a weak constitution. Unlike Rubens, Velázquez does not attempt to conceal the reality. He does not dwell on the disillusions, illnesses and suffering that might have been expected to show in her face, but he does depict her as pale and reserved, very grave and a little anxious. He also makes her look more of an aristocrat than she does in the Rubens.

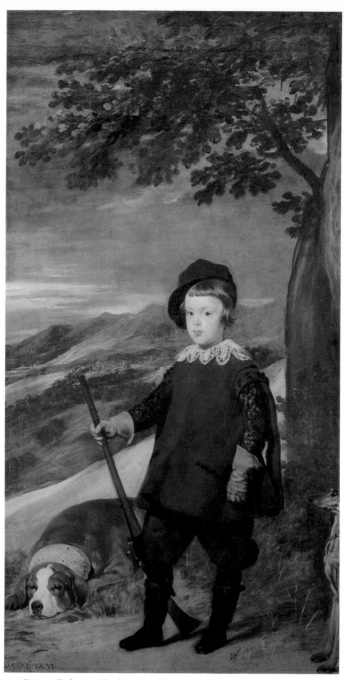

54 *Prince Baltasar Carlos as a Hunter* 1632–35

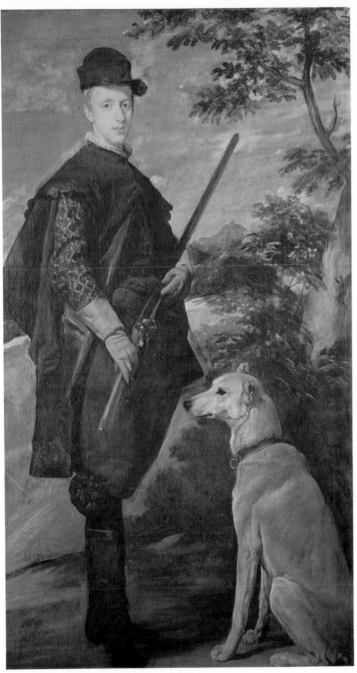

55 *The Infante Don Fernando as a Hunter* 1632

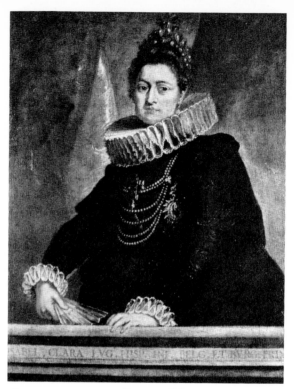

56 PETER PAUL RUBENS *Portrait of Queen Isabella c.* 1635

45 The equestrian portrait of *Philip IV* is exceptional in that it shows both the King and his horse in strict profile. In the other pictures of the series the rider is in three-quarters profile and, except in the portrait of Isabella, the horse too is seen from this angle. We know why the distinction was made. In 1634 Olivares decided to ask the Florentine sculptor Pietro Tacca to sculpt a bronze statue of Philip IV, similar to the one of the King's father made by him in 1613. He needed to send the sculptor a portrait of the King – thought to be a copy (today in the Pitti Palace, Florence) of the original under discussion here. So it would appear that the Prado portrait was painted specifically to serve as a

model for the equestrian statue that stands today in Madrid in the gardens opposite the royal palace. The horse is shown rearing up on its hind legs as though about to break into a gallop, just as it appears in the Velázquez. This position, known as the 'pesade', was specified to the sculptor, and hence to the painter as well. It marks a change from the monument of Philip III, where the horse is in a walking position, but had already been used in a portrait of the former King in the Prado. It was chosen presumably to glorify the monarch and make him appear more dashing and courageous.

57 *The Surrender of Breda* 1634–35

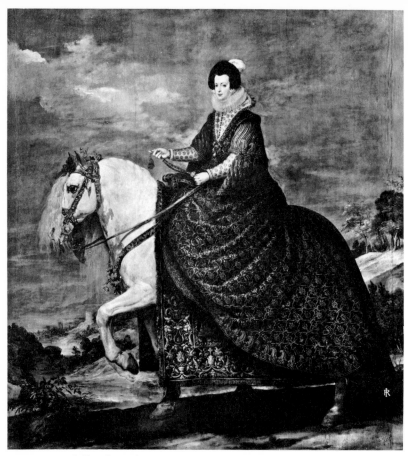

58 *Queen Isabella of Bourbon, Equestrian* 1628–35

Whether the desired effect is achieved is a different matter. One is far
from convinced that this horse is galloping – or even capable of it. Its
hind hooves look as though they are stuck to the ground and destined
to stay there. The animal appears transfixed, and the King too is as stiff
as can be. There is no such problem with Titian's equestrian portrait of
60 *Charles V* or the Rubens of the *Cardinal-Infante Fernando*. In both these
works (Madrid, Prado) the horse's position seems far more natural

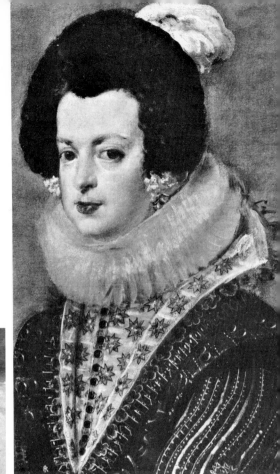

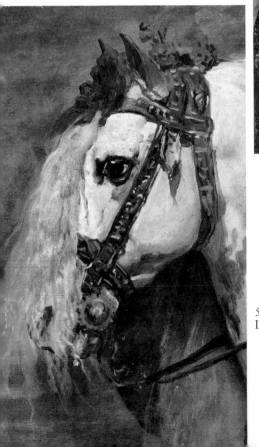

59 *Queen Isabella of Bourbon, Equestrian*
Details

because the rearing forequarters are set against a relatively light background, while the rest of the animal is still in shadow. One is less conscious of it in fact being immobilized in a picture. In the Velázquez, however, the animal's entire silhouette is drawn with uniform clarity; it provides a good illustration of Velázquez' limitations as an artist. The definition of his style permits him to convey to the full the intense life of a person or an object in repose, but it does not lend itself to expressing movement, which would demand a lack of precision and the employment of such subterfuges as sashes, manes and tails streaming in the wind.

That said, Philip IV does in fact wear a sash. But it is the only thing in the picture which seems to be blown by the wind and as a result looks merely odd, not evocative. The King and his mount (even if it does look rather more like a rocking horse) nevertheless have many attractive features. The same is true of the landscape. Flooded with a misty light, it is redolent of peace and freshness. The blues and greens, which predominate in the sky as well as the landscape itself, discreetly emphasize the warmer tonalities of the King's figure and the horse.

49, 50 There is a rather similar landscape background to the portrait of Baltasar Carlos. The eye looks down from a sort of vantage point, out over valleys, wooded slopes and snow-capped mountains. Obviously these are not features of landscape that Velázquez imagined, but what he saw on the outskirts of Madrid, looking out over the Sierra de Guadarrama. In the portrait of Philip IV the clouds in the sky are static and arranged in such a way as to echo the outline of the horse. Here they are ragged and in movement, following the silhouette of the child and his mount. Velázquez manages to make each work a harmonious sum of its parts, but he does not announce the fact; the evident realism of the picture tends to conceal its art.

Here again the horse is rearing up on its hind legs, and all four legs are fully extended to launch its body forward. But in spite of the movement in the tail and mane, the creature appears to be incapable of budging from the spot. Seen in three-quarters profile and from below, at an angle which makes its swollen belly seem more like a barrel, it looks positively grotesque. Yet the head is finely drawn and the breast well-proportioned. The Prince himself could not be more dignified and charming. The face glows with luminosity, the modelling is lovingly

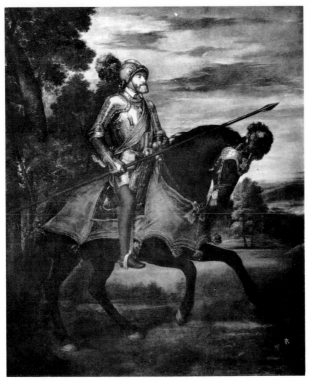

60 TITIAN *Charles V, Equestrian* 1548

done, with light brush-strokes, and it manages to be grave and graceful at the same time. Delicate tints of colour abound in the costume, pinks, yellows and dark blues being combined in a most attractive colour scheme. If the tonalities are fresher than in the portrait of Philip IV, it is presumably because Velázquez wants to give us an immediate sense of the youthfulness of the figure he places before us. Compositionally, the picture is based on two intersecting diagonals which contradict each other, one suggested by the horse, the other by the strip of wooded land.

The second acts as a brake so that the rider does not appear to leap clean out of the frame.

51 The horse ridden by Olivares is also in three-quarters profile but is turned to face the back of the picture and therefore looks rather more normal; it is also far less wooden-looking than either the King's or the Prince's mount. The landscape on this occasion includes a battle scene, a Spanish victory for which Olivares regarded himself as responsible. Anyone seeing him here giving the signal to attack would think he had commanded the victorious cavalry, although in reality he had never held a military command and never once took part in a battle. Velázquez is illustrating a legend which Olivares was pleased to foster, not a historical event. But while lending credence to an official lie he also expresses certain truths, and even emphasizes them. Olivares' love of display, his bragging nature, his inelegant physique, which even a handsome uniform cannot disguise, are at once apparent. As worn by Philip IV, the red sash plays a purely secondary role, here it is boldly displayed, with a big elaborate bow following through the curve of the back, and a long yellow fringe to emphasize its theatrical splendour. Not that this is anything to complain about. The colours are beautiful, even if the historian or the moralist might take exception to what they symbolize. Leaving aside the antipathy aroused by the subject, as a painting the whole thing is admirable. Horse and rider are better related to the landscape than in the portrait of Philip IV. The sky and land are animated by the lively play of light and shade. As in the other two pictures, the form and colouring of the clouds echo the character of the model, but only discreetly; the external world has its own life. The leafy trunk of the oak tree behind the horse's hindquarters does not merely serve to repeat the Count-Duke's silhouette; it exists in its own right, asserts itself absolutely as a tree, its bark subtly caressed by the diffuse outdoor light.

Velázquez' equestrian portraits were intended for a specific location, the new royal palace of Buen Retiro, which Olivares had ordered to be built in 1630. The Alcázar was in the western quarter of Madrid but the new palace was built on the east side, near the present-day Prado and the Retiro Park. One of its principal features was a large room known as the Hall of Realms (the only part of the palace which has survived; it is now used as the Army Museum). The equestrian portraits were to form

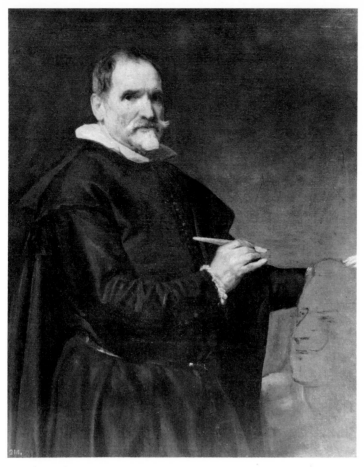

61 *The Sculptor Martínez Montañés at Work* 1635

part of the decoration scheme for the hall. This of course explains both their size and the way the subjects and their horses are presented. So that the pictures could be arranged symmetrically, the two Kings face to the right and the two Queens to the left. The curious angle of the portrait

of Baltasar Carlos was dictated by its intended position: because it was to be hung high on the wall the horse was painted as it would appear from below.

Another Velázquez which would appear to be connected with the equestrian portrait of Philip IV is his painting of *The Sculptor Juan Martínez Montañés at Work* (Madrid, Prado). When Pietro Tacca was commissioned to execute his big equestrian statue, he asked for a bronze bust of the King to be sent to him in Florence, as well as the oil portrait. It was Montañés whom the court invited to supply the bust. He lived in Seville and therefore came and stayed in Madrid for seven months (from June 1635 to January 1636). Velázquez must have painted him sometime during that period, as he shows him standing beside a clay bust of Philip IV. But even though the sculptor is holding the model with his left hand and has a tool in his right hand, he is still very much a subject striking a pose rather than an artist engaged in his work. The impression is reinforced by the rather formal flowing black robe and the stiffness of his bearing. Velázquez has done no more than indicate the bust in a few quick lines, as though he wanted all our attention to be concentrated on the sculptor himself, savouring his sobriety and sincerity.

It was not only the Buen Retiro that had to be furnished with pictures. In the Forest of Pardo to the north of Madrid, Philip IV had converted into a hunting-lodge a tower built by Charles V, the Torre de la Parada. Velázquez could not take on the responsibility for all the pictures required, particularly as there were a dozen or so rooms to fill and the King wanted the work finished quickly. His requirements included about forty canvases on mythological themes, and for these it was decided to approach Rubens, whose stay in Madrid had not been forgotten. He accepted the commission, drawing the sketches himself and leaving it to younger artists to paint the actual pictures. Ten or more painters were involved in the project, among them Jordaens, Cornelis de Vos, Cossiers, Willeboirts Bosschaerts and Erasmus Quellin. Their works are now all in the Prado. As well as themes from mythology and from Ovid's *Metamorphoses*, the decoration scheme for the Torre de la Parada naturally included a number of pictures of animals (by Frans Snyders and Paul de Vos) and hunting scenes, notably by Peeter Snayers.

61

Portraits of the King were also required, and of the Cardinal-Infante 52, 55 and Baltasar Carlos, in hunting costume. These of course were painted 54 by Velázquez, probably between 1632 and 1635. In the eighteenth century these three paintings were transferred to the royal palace and, being too large for their new location, were trimmed at the edges; various dogs have disappeared, either wholly or in part.

As in the equestrian portraits, each figure is in profile against a landscape setting, but here there is a stronger relationship between the figure and the surrounding nature because there is less contrast in colour between the costumes and the terrain, plants and clouds. Philip IV, dressed in brown, is only just distinguishable from the tree behind him; the brown tones are picked up in the ground and even in the sky.

Although the men, dogs and backgrounds are as realistic as we have come to expect from Velázquez, each figure stands in front of an area of landscape which is of a striking fluidity. Why this sudden lack of precision? As it would be absurd to think that Velázquez was incapable of representing the scenes with greater definition, we must assume it was the result of a deliberate decision on his part. If too much detail were shown, these areas of countryside would become too prominent and the hunters themselves would not have the same importance. They were the *raison d'être* for the pictures, so the rest had to be subordinated to them.

It is interesting to note that the postures, although more relaxed (these being scenes on the outskirts of a forest, not interiors) are nevertheless dignified. Each pose is different. So are the guns and the way they are held, and the dogs, who have clearly not been artificially posed, as some of the horses must have been in earlier pictures. They are simply given the appearance that corresponds to their breed and temperament. Though the fat hound lying at the feet of Baltasar Carlos is somewhat reminiscent of the young Prince's horse and has the same bloated look about it, its heavy, shapeless, somnolent mass seems to be there chiefly to emphasize the youthfulness and wide-awake air of the Prince. It also provides a contrast to the slender greyhound, whose alert head and tensed front legs can just be seen at the edge of the canvas, and which is the perfect match for its young master.

In each portrait there is a relationship between the hunter and his dog or dogs. Although it was presumably not Velázquez who decided that

the King should be accompanied by a mastiff and the Cardinal-Infante by a sort of greyhound, it was up to him to decide how the animals should be represented. Certainly the mastiff with its puffy features is an excellent accompaniment to Philip IV, and the intelligent profile of the greyhound picks up the expression on the Infante Fernando's face. The latter left Madrid in 1632 to become Governor of the Spanish Netherlands, and his portrait shows him as he was before his departure. His rather long face indicates the distinction and open-mindedness with which he has been credited by the historians.

History painter

The Hall of Realms at the Buen Retiro palace was to be decorated with history paintings as well as portraits. The idea came from Olivares, inspired no doubt by a desire to flatter the King and at the same time enhance his own position. Through these paintings, illustrating what were judged to be the most memorable events of contemporary history, Philip IV, whose actual political power was nil, would be provided with tangible proof, so to speak, that many significant things had been accomplished and great victories won since his accession to the throne. Naturally he would come to realize that this was due to the efforts of his Prime Minister.

Thirteen paintings were planned. Because of the number, and no doubt because of the subject matter as well, it was decided that Velázquez should not be the only artist involved. Probably he did not object to the decision and may well have been relieved. He could even have made the suggestion himself as he and Mayno had overall artistic responsibility for the project. But it was the Count-Duke who chose the subjects – battles, conquests or reconquests of towns and raising of sieges, both in Europe and the colonies. Eight artists shared the work – Mayno, Velázquez, Zurbarán, Carducho, Caxesi, José Leonardo, Antonio Pereda and Felix Castello – which meant that some of them painted two or even three out of the total of thirteen scenes. Most of these canvases are still in existence and can be seen today in the Prado. Few of them could be said to be masterpieces. Usually the military commander is shown with a few members of his entourage in the foreground, while the battle that is the subject of the picture takes place behind them somewhere in the distance. The composition is divided into two areas with little or nothing to link them together. Everything at the back is shown in miniature, while the front stage is held by tall figures strutting about or striking heroic poses. Their attitudes and gestures belong to the theatre and not to real life.

Mayno's *The Deliverance of Bahia* (a town in Brazil) is something of an exception. The foreground is more extensive and is better related to the rest of the picture. It is also interesting to note that the artist chooses to emphasize the casualties of war: a wounded man is being tended by men and women who are expressing pity and weeping. The admiral and the victorious troops occupy the middle ground. Right at the extreme edge of the canvas, they are either standing or kneeling in front of a tapestry which depicts Philip IV being crowned by Minerva and Olivares. Light shades of colour predominate throughout the picture – ochres, greens and blues – and the palette has a cohesion that is lacking in most of the other paintings of the series.

Zurbarán lived in Seville and painted mostly religious subjects, so there was no obvious reason why he should have been invited to the court. If Velázquez had not met him in the past, no one would have thought of summoning him to Madrid. But friendship and esteem led Velázquez to commission from him not only two history paintings (one of which survives) but also works on the theme of *The Labours of Hercules* (Madrid, Prado), which were similarly intended for the Hall of Realms (they were later hung beneath the windows). As was only to be expected, historical and mythological themes did not give Zurbarán the scope for the emotional power of his religious paintings. The series of *The Labours of Hercules* contains a number of rather laboured nude studies, and his *Defence of Cadiz* is far from original in terms of composition. Here too the picture is divided into two unrelated sections. Seated on a chair in the foreground, with a half dozen of his officers at his side, is the stiff-jointed old governor of the town (who had to be carried there in order to direct operations). Behind the platform on which the men are standing is the sea, the shore and the fighting. But the governor and his officers would look much as they do here if they were in a room, perhaps assembled for some sort of meeting. If we did not know in advance, we would never guess that the outcome of the battle depended on their commands. We would quite likely assume that they were not even aware of its existence for, although the governor is pointing his field-marshal's baton in the general direction of the fighting, his face is turned towards us. He appears to be sitting for his portrait, and the same is true of most of the men with him. But although it lacks conviction it is a much more powerful work

62

than the paintings supplied by Carducho, Caxesi and José Leonardo. The postures are full of nobility and the colours of the uniforms are beautiful and unusual – purple reds, olive browns and bluey greys.

62 FRANCISCO ZURBARÁN *The Defence of Cadiz* 1634?

63 *The Surrender of Breda* Details

63, 64 Velázquez' subject was *The Surrender of Breda* (Madrid, Prado), easily the most famous of all the historical events chosen and of the greatest interest to Velázquez' contemporaries. The town of Breda is in the south of Holland, somewhat to the north of Antwerp, and at that time was as important to the Dutch as it was to the Spanish. The Spaniards considered it was in a position to threaten or protect their hegemony in Flanders, while Holland saw it as the key to her independence, the point at which an invasion would either succeed or be halted. Breda was also the place where two great commanders met in battle, Justin de Nassau defending the fortress and Spínola trying to take it by force of arms. Victory was finally won by Spínola after a siege lasting several months, which ended only when the besieged forces ran

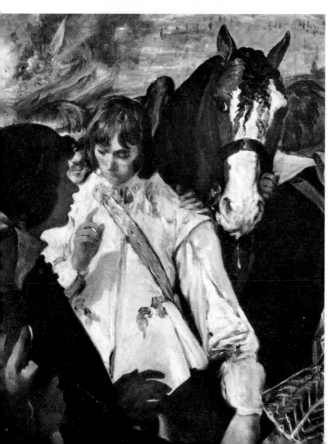

64 *The Surrender of Breda*
Details

out of provisions and were forced to concede. The surrender was signed on 2 June 1625, the commander of the Spanish army granting particularly honourable terms to the defeated troops: because of their heroism, Justin de Nassau and all his officers and men were permitted to leave Breda in full battle array, with their weapons and standards, the infantry to the accompaniment of beating drums and the cavalry to the sound of trumpets. The keys of the town were handed over on 5 June, and this ceremony is the theme of Velázquez' painting (executed in 1634–35).

Velázquez had not witnessed the scene, nor had he ever been anywhere near Breda or encountered Justin de Nassau and his army. The only one he had met was Spínola, whom he had the opportunity to observe at first hand, as we mentioned before, some five years previously on the boat sailing to Italy. This meant that he had to rely largely on written accounts and other sources. For example, he discovered an engraving executed by Callot shortly after the battle, giving an exact plan of the fortress (though it would seem that all he has retained of this is the image of a plain rising towards the skyline). In fact this device of the 'vertical' landscape was commonly employed when it was desired to give a more or less cartographic representation of a site. It is seen in the work of Peeter Snayers, painter to the Archduke Albert and Archduchess Isabella (and the master of van der Meulen), who produced a series of paintings of towns under siege or at the point of capture (Madrid, Prado). (The series in fact includes one of Breda, but it was not painted until 1650.) This device of lifting the horizon and reducing the area of the sky was not otherwise characteristic of Dutch artists, who habitually painted a deep expanse of sky, copying the effect of their own flat landscape.

According to eye-witness accounts, Spínola had awaited Justin de Nassau with an escort of nobles and officers, and embraced him, praising the gallantry shown in the defence of the town. Velázquez does not show this embrace. Spínola merely inclines towards his adversary and places a hand on his shoulder, while Justin de Nassau, his knees slightly bent, reaches forward to give him the key. He looks not in the least dispirited, and Spínola seems positively amiable, full of nobility and warmth. A victor can rarely have been depicted with such a total absence of arrogance. And the men assembled behind him have

not a hint of triumph or scorn in their expressions. They merely look serious. A few may be indicating compassion, but impassivity is the general rule. Much the same can be said of the Dutchmen accompanying Justin. Very few of them appear to be aware of exactly what is going on between the two commanders. It is hardly surprising that Mérimée has described this picture as 'a series of portraits'. As he points out: 'Each character is thinking more of the spectator than of the action in which he is supposed to be participating.'[48] Attempts have even been made to identify the various figures, but nothing very positive has emerged. What one can say is that the men in each group are strongly individualized, as well as having the features that are appropriate to their nationality and station.

There has been considerable speculation as to what other works Velázquez might have consulted, either in respect of details or for the composition as a whole. A wood engraving by Bertrand Salomon of *Melchisadek and Abraham*[49] has been mentioned, also Rubens' *The Meeting of the Cardinal-Infante Fernando and the King of Hungary at Nördlingen* (Vienna, Kunsthistorisches Museum), and *Christ and the Centurion* by Veronese (Madrid, Prado). El Greco's *El Espolio* (Toledo Cathedral) has also been cited for the representation of the heads in the Spanish group – and of course Paulo Uccello and Piero della Francesca for the lances. But if one attempts to look objectively at all these different works in relation to *The Surrender of Breda*, then one is forced to conclude that more than one of the parallels are strained or at any rate of little significance. In any case, Velázquez's contribution is far greater than anything he might conceivably have borrowed from another source. Whatever resemblances with this or that painting are read into the picture, the profound originality of the work is not in question. That is all that is really important or worth a fuller examination.

It would patently be false to say that *The Surrender of Breda* has absolutely nothing in common with the other compositions destined for the Hall of Realms. It has, for a start, the same division of the canvas into two zones. But the strip of land where the principal scene is being enacted is not as narrow, and we are less aware of the distinction between foreground and background. There are none of those wide gaps that the other painters thought it necessary to introduce at the side of or

behind their heroes, in order to show precisely and in detail the principal subject matter of the picture. Of course Velázquez does not neglect to show the countryside outside Breda and some of the incidents of the battle (for example, the aftermath of the flood caused by the besiegers), and he shows the soldiers, the flags, fires and spiralling smoke in the background, but he joins the landscape with the sky so as to create the kind of backdrop he particularly favoured, to set off the profiled figures of the generals and their men. The only space between the two groups is small in size. It comes directly between the bodies of the two military commanders, and is barred by the arm of Justin de Nassau, so that it in no way resembles those other gaping holes which distract the eye from what is going on. In fact this opening permits no more than a cursory glance, allowing one to catch sight of a line of soldiers but not to dwell on it. And the light colours of the uniforms (the airy blues in particular) give the effect of back-lighting playing on the arms of the two pro-tagonists; instead of drawing the eye on into the background, they direct attention forward on to the hands, allowing the principal action of the picture to be etched on the pale surface.

The unity of the picture is reinforced by the lighting, general atmosphere and colour scheme. The light flows evenly and undramatic-ally but plays over the landscape and the sky, creating effects of con-siderable freedom and complexity. Blueish greens predominate, and these cold, rather fresh colours contrast with the light and dark browns of the Dutch and Spanish parties. If we did not know this lighting and these colours were invented by Velázquez, we might well describe them as objective. Certainly they are not used to create an especially heroic or emotional impact. The traces of the siege, the ravaged countryside, appear almost as a reminder of the past, and the calm sky has already forgotten all that has occurred.

The men in the picture are, in this respect, at one with nature. They make few gestures and their expressions reveal little. In fact there is so little emotion and such a lack of formality in the picture that, were it not for the noble bearing of Spínola, one might think the painting was some sort of 'slice of life'. By comparison, Uccello's *Battle of San Romano* is a ballet (albeit a beautiful one) and Rubens' *The Meeting of the Cardinal-Infante Fernando and the King of Hungary at Nördlingen* is a sumptuous scene from an opera.

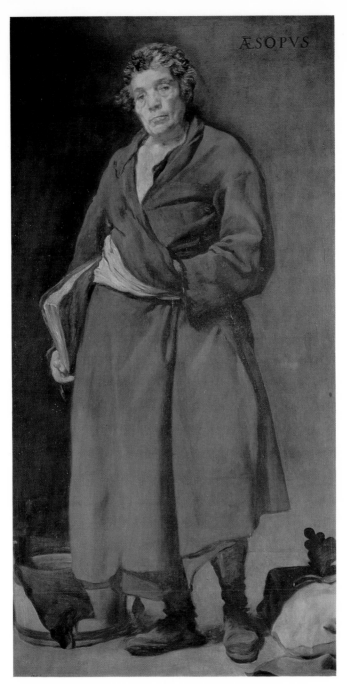

ÆSOPVS

65 *Aesop c.* 1640

Velázquez' painting has the mood and feel of a documentary record. Without the least hint of exaggeration it tells a true story, makes us believe that things happened more or less as they are shown here. One could not possibly feel that with the Rubens. Not just because of the two eagles crowned with laurel wreaths, flying above the heads of the King and the Cardinal-Infante, but because the encounter between the protagonists takes place in the background (although on raised ground), the foreground being occupied by three large allegorical figures: an old man with a beard (the god of the River Danube) and two women (Germania and a nymph). These three figures immediately dictate the mood, making the historical event appear to be part of a fable.

We have already noted that the characters in *The Topers* occupy a compact space. The same is true in *The Surrender of Breda*, but here, although each group is huddled together, this has the curious effect of making it look larger than it actually is. One can count only fifteen or so heads behind Spínola, but it looks as though there is an army assembled there. The impression is strengthened by the bulky mass of the horse which partially conceals the Spaniards' bodies and gives the group an imposing weight. That feeling is reinforced by the obstinately repeated parallels of the long lances, which form an impassable barrier, a rigid, imperious fighting machine which is in marked contrast to the three smaller lances and two halberds on the Dutch side, derisory equipment for an army. They suggest an armoury that is improvised, or heavily depleted at the very least.

The horse has another function too. The prominence accorded to its large rump and massive belly, rather than its head, gives it an unceremonious air – adding to the deliberately informal mood of the scene. Then too, Velázquez is representing an action which takes no more than a few seconds to perform. Many of the figures look as though they are frozen there for all eternity, and the horse helps to single out a particular moment of time. Its legs are in a walking position. Conceivably it has just arrived on the scene, or it may be about to depart. In fact, as it is Spínola's mount, neither explanation is plausible. But it is there to indicate movement and give a sense of instantaneity. The same feeling is conveyed by two of the young men. One, standing behind the horse, turns to look at Spínola, the second, a Dutchman wearing a light-coloured doublet, is pausing to explain something to his neighbours.

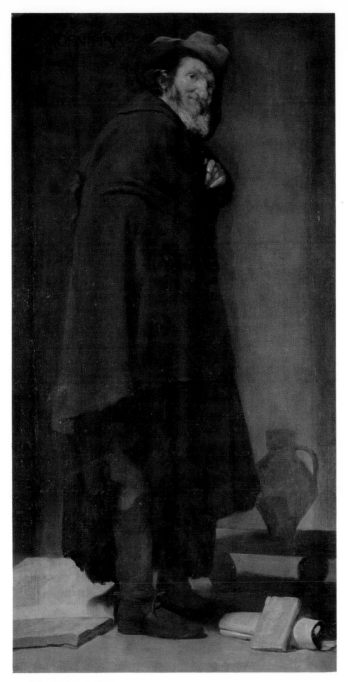

66 *Menippus c.* 1640

To sum up: an analysis of *The Surrender of Breda* indicates that even though a subject of this type had its difficulties for someone as poorly endowed with imagination as Velázquez, it did nevertheless spur him on to discover ingenious ways of acquitting himself of his task. Once again the story, and therefore the picture as a whole, does not carry conviction, but the truthfulness of the individual details is utterly convincing. This is a canvas which includes some fine passages of painting, gems of artistry. Among them must certainly be included the two protagonists, and also the young man in the light-coloured shirt (in spite of his undistinguished features), the head of the horse standing behind him, and the big horse in the foreground. The background too. In fact, it is a picture full of delights.

Jesters and clowns

A few years after he painted *The Surrender of Breda*, in 1640 or thereabouts, Velázquez produced three further pictures which are thought to have been intended for the Torre de la Parada. They are of three single figures, *Mars, Aesop* and *Menippus* (Madrid, Prado), and were meant to be companion pieces to the *Philosophers* sent by Rubens for the same building.

To say the least, Velázquez has not treated Mars, God of War, with any great respect. Seated before us is a man with a well-developed, furrowed body. He has a moustache, and looks rather like some sort of disgruntled German soldier, thoroughly fed up and totally mindless. This is a further instance of Velázquez' habit of bringing the gods of Olympus down to earth, and cutting the heroes of mythology down to the size of ordinary mortals. No one would want to criticize Velázquez on the grounds of deflating a myth, but all the same it is an embarrassment to see him produce such a picture – not because the man is a vulgar character but because the painting is so cold, not because Velázquez is ridiculing a god but because, once again, he has painted a nude in such an academic style. Even the colours are unappetizing. The piece of cloth around Mars' body is forget-me-not blue, and he is seated on a purplish-red drapery – which reflects a ruddy glow on his skin, turning it a bright shrimp pink. In both the *Aesop* and the *Menippus* the body is concealed by a dark-coloured garment. The former wears a kind of brown dressing gown, the latter a dark grey cape. But in spite of the drab colours they are more appealing pictures than the *Mars* and have an authentic quiver of life. Each bears, in Velázquez' writing, the name of the figure who is represented. Probably Velázquez was aware that, if he did not take this precaution, no one would ever believe that one was a philosopher and the other a writer of Greek fables – even though the author is holding a large volume in his hand, and his philosopher friend has two books and a scroll on the ground at his feet. When he was

69

65, 66, 70

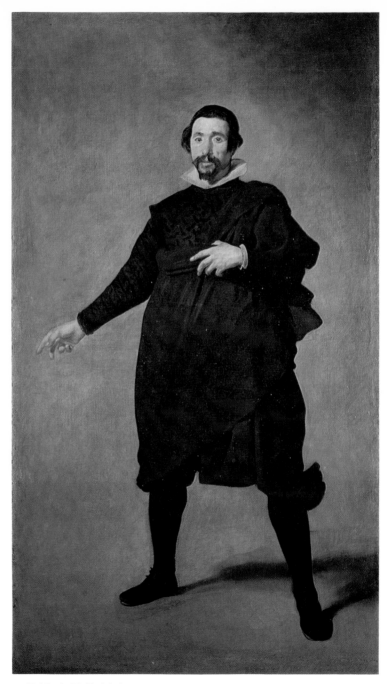

67 Pablo de Valladolid 1632

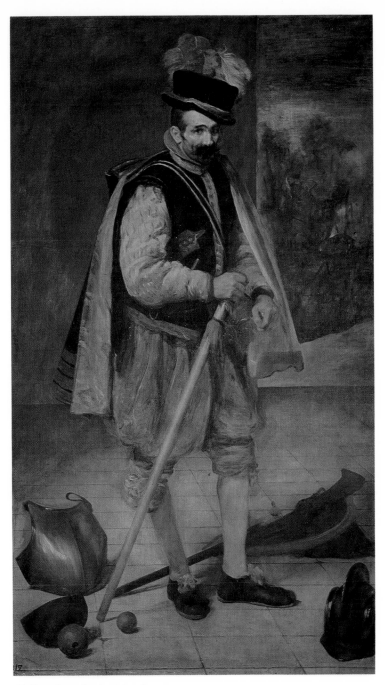

68 *Don Juan de Austria* 1632–35

69 *Mars c.* 1640

in Seville Velázquez tried to give the fabric and relief of each object an intense life of its own; here he reduces the objects to silhouettes and dabs of colour which are obliquely evocative only. It is the human figures who are important, and these he treats in a similarly free style.

The ancients described Aesop as ugly, hunch-backed and a stutterer. *65, 70*
Here he looks like a labourer, his face lined by toil and wasted by
privation. No one could call him handsome, but he is not so ugly as to
lack the dignity appropriate to his ethical pronouncements, however
disenchanted. Menippus looks like a tramp. His smile is mocking and *66*
uneasy, conspiratorial yet wary; his back is slightly rounded and his
whole attitude betrays a lack of self-assurance. One senses immediately

70 *Aesop* Detail of ill. 65

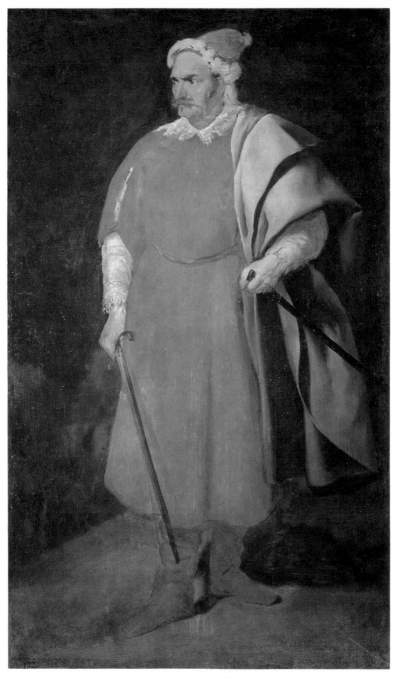

71 *Don Cristóbal de Castañeda y Pernia* or *Barbarroja c.* 1635

a person who has repeatedly been rebuffed and finds his revenge through cynical remarks and derisive laughter. In the last analysis it does not matter very much that the two characters are inspired by history and legend. Velázquez has invested them with a humanity of such eternal validity that they do not belong specifically even to the century in which they were painted. They belong to our time and to all time. We can forget their names and concentrate on the human destinies they embody. It is also gratifying to note that, although Velázquez' position at court meant he had to concentrate on portraits of persons of rank and privilege, he has not lost his earlier interest in ordinary people whose lives give them little cause for rejoicing.

That he retained this interest is confirmed by the large number of pictures he painted, either for the Buen Retiro or for the Alcázar, of jesters, dwarfs and fools. Of course it was not only at the Spanish court that such characters were to be encountered, but they were present in large numbers and enjoyed particular favour, especially under the reign of Philip IV. Their task was to entertain and provide distraction, and this they did in a number of different ways: first of all by the simple fact of their existence – they were freaks of nature, the spoiled products who enhanced the perfection of the rest. By offering a spectacle of physical malformation or mental derangement to people with normal minds and bodies, they provoked a sense of self-satisfaction, inviting the others to congratulate themselves that they were not like that. Looked at dispassionately, as they were at that time, they introduced an element of fun into life, they were like caricatures or grotesque counterfeits, and they made people laugh. The more so as many of them were very witty and were permitted a considerable degree of licence, even impertinence. Justi comments aptly: 'They exemplified freedom of speech in its most humiliating guise.'[50] They were objects of curiosity rather than pity; no one was sorry for them, but on the other hand no one despised them. They received a salary, and as employees of the court they were certainly better off than if they spent their lives trailing through the streets of Madrid.

It would be unrealistic to expect Velázquez to regard them any differently from his contemporaries. We have already observed that, when he paints a dwarf with a defective mind, his intention is not to enlist our pity. He simply shows him for what he is. He looks at the

72 *Calabazas c.* 1639

3 *Sebastián de Morra* 1644

mad and the unfortunate in the same spirit as he looks at a king or a prince – with seriousness and sensitivity, but without the least trace of sentimentality.

75 It is possible to include in the series of jesters Velázquez' painting of a man who looks towards us with a sneering laugh, pointing his crooked index finger at a little globe of the world (Rouen, Musée des Beaux-Arts). It has been called variously *The Man with the Globe*, *The Geographer* and *Democritus*, indicating uncertainty as to its icono-graphical derivation. It is not as free in style as the *Aesop* or *Menippus*, and so is likely to have been painted before Velázquez went to Italy.

The same is probably true of the first portrait of Juan Calabazas, the so-called *Calabacillas* (Cleveland, Ohio, Museum of Art). He is de-picted standing in front of a wall in which the architectural details are clearly shown (possibly by the use of over-painting), and his silhouette is made to stand out from it with particular clarity by the contrast of the pale background with the dark costume. He is standing, and holds a miniature in his right hand and a little weathervane on a stick in his left. He has something of the supple elegance of a dancer, except that this initial impression is contradicted by the slightly unsteady placing of the feet. Behind him is a screen; that too is precisely drawn. In the later works neither the objects, figures nor locations are as clearly delineated; the human figure is much more closely integrated with his surround-ings, and his face is a more direct expression of the disturbance in his mind.

67 In the portrait of *Pablo de Valladolid* (Madrid, Prado) the yellowy-grey of the backdrop again allows the black-costumed clown to stand out in stark isolation. But on this occasion the exact nature of the back-ground is left vague. There is nothing to indicate that it is meant to be a wall or an exterior. The shadow cast by the legs gives only the slightest impression of the horizontality of the ground on which he stands, and there is no line to indicate where it ends. It moves from the horizontal to the vertical without any visible frontier between the two. In other words, space is conceived in purely pictorial terms, as it is in the works of certain modern artists.

In *Les Maîtres de la peinture espagnole*, Eugène Dabit points out that Manet used the same effect for *The Fifer* (Paris, Jeu de Paume).[51] This is not surprising as the Manet dates from 1866, only one year after the

142

74 *Don Diego de Acedo, 'El Primo'* 1644

artist's visit to Madrid. What is more noteworthy is that he employed the same device eleven years later in *The Actor Faure in the Role of Hamlet* or *The Tragic Actor* (Essen, Folkwang Museum). In some ways the later painting is even closer to the Velázquez (*The Fifer* also reflects the influence of the Japanese print) as it represents an actor, and Pablo de Valladolid has about him very much the air of an actor giving a performance.

Legs apart, left foot pointing in a different direction from the right hand, the clown seems uncertain of the role he is meant to be playing, what gestures are appropriate and what lines he has to say. The expression on his face is one of vague discomfort, as though he has suffered a lapse of memory. This is the most direct indication of the man's mental state, for he seems only dimly aware of the situation in which he finds himself. The outline of the figure reveals his condition with equal force. In places the silhouette seems hesitant, not because the painter felt any uncertainty but because a line that moves forward then back, bends and fragments, is an accurate reflection of the man's instability of mind and inner turmoil.

As with so many other of Velázquez' works, we do not know the date of this portrait, although it is assumed to be sometime between 1632 and 1635. It was probably painted at roughly the same time as *Don Juan de Austria* (Madrid, Prado), although he is a very different character from Pablo de Valladolid. Don Juan stands in a room which is sufficiently defined this time to show the tiled floor, the back wall and the big window embrasure through which the sea can be seen. One can make out a burning ship and smoke filling the blue sky – an allusion to the Battle of Lepanto and its victor, whose name the clown bears. It was the fashion in the Spanish court at that time to regard the clowns as doubles or caricatures of historical characters. Sometimes they were so strongly identified with their namesakes that their own identities disappeared altogether. This was the case here, Juan de Austria being the only name by which the buffoon is known. His role is the explanation for the costume he wears and the objects at his feet – the breastplate, helmet, arquebus and cannon balls. The humour resides in the contrast between all this and the pathetic bowed legs, the weary old ruffian's face, the bleary gaze and bent shoulders. The costume is done in particularly rich colours; the purplish pink and iridescent greys of the

68

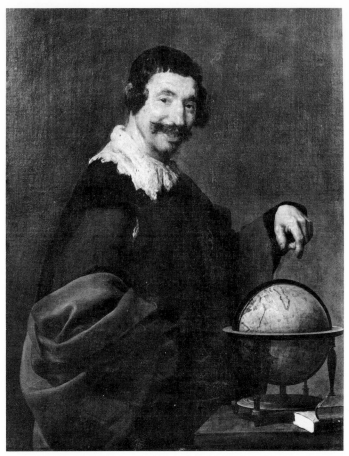

75 *Democritus* or *The Geographer* c. 1628

silk, the black velvet, constitute a particularly striking ensemble – which of course only enhances the sad insignificance of the wearer.

Don Cristóbal de Castañeda y Pernia was another clown who repre- *71* sented an historical personage (Madrid, Prado). His adopted name of *Barbarroja*, or Barbarossa, belonged originally to the pirate Khayr ad-Din, a sixteenth-century admiral of Selim I, who had launched attacks against Spain from Algeria before the Battle of Lepanto. The

76 *Francisco Lezcano* or *The Boy of Vallecas* 1637

77 *Francesco II d' Este, Duke of Modena* 1638

clown wears a long red robe and pale grey cloak and looks very like a Turk, adopting an aggressive stance and threatening attitude. Overall he looks less of a caricature than Don Juan de Austria, though he overdoes the air of intimidation. The background of the canvas (which again must date from *c.* 1635) is unfinished, but the various shades of brown set off the bright-coloured expanse of the costume.

72, 78 A few years later, in 1639 or thereabouts, Velázquez painted a second portrait of *Calabazas* (Madrid, Prado) which differs in all respects from the first. He is seated this time on a very low stool, which quite removes any pretensions to elegance. His right leg is drawn up, and he holds his hands clasped, accompanying this childish gesture with a foolish grimace of a smile. The face is as contorted as the light that flickers over it, reflecting the turbulence of an unhinged mind. On the ground beside him are some calabashes, or water-bottles, obviously a pun on his name but also an echo of his empty brain. The palette is sombre and restricted. The costume is of dark grey and brown, and brown is also used in the ground and background. Although, on the right-hand side, these two zones are demarcated by lines indicating the corner of a room, on the left side the distinction is not even suggested. Add to all that the grey of the collar and cuffs, the rapidity of the brushwork, the jerky application of paint and the dramatic chiaroscuro, and it will at once be evident that we are in the presence of a work that, although sober, is powerfully expressive – a sort of premonition of the black paintings of Goya some 180 years later.

In or around 1644, Velázquez painted his three pictures of dwarfs (Madrid, Prado).[52] They are all shown in a sitting position and, although one might think this would be confusing, in fact their stunted growth is immediately apparent.

74, 80 One of the dwarfs, *Don Diego de Acedo* (although the picture is popularly known as *El Primo*), reminds one of a writer or scholar. A number of books and an ink-well are on the ground beside him and he is leafing through an imposing volume resting on his knees – or, more accurately, has looked up from his book to direct his pained and weary gaze in our direction. His rather gloomy expression is in contrast to his upright torso, and the small scale of his body, his frail legs and tiny hands, are at variance with the formality of the large hat and velvet costume. These are both black and the landscape at the back is grey, so

78 *Calabazas* Detail of ill. 72

the picture has an air of dignity about it, but it is a dignity that is purely assumed, not inherent.

In the portrait of the dwarf *Sebastián de Morra*, the black is replaced by dark green and purplish red, emboldened by touches of gold and white, but once again the clothes have an air of fake splendour – the more so as they encase a squat little body whose breadth merely accentuates its freakish nature. The pose adopted by this unlovely creature could not

73

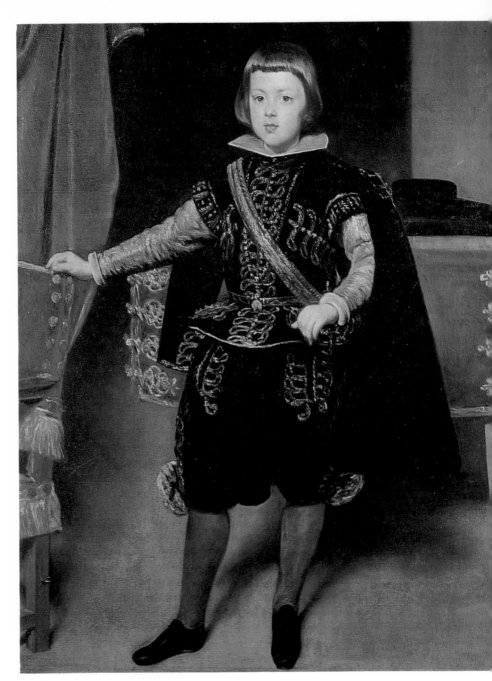

79 *Prince Baltasar Carlos c.* 1640

80 *Don Diego de Acedo, 'El Primo'* Detail

have been better chosen. The frontal presentation; the foreshortening
of the legs, which immediately attracts attention to the miniscule feet,
more suited to a child; the hands which look like stumps; the arms
whose position recalls that of a wrestler; the cunning fixed gaze of the
eyes in a face overshadowed by the dark brown of the moustache and
beard: all these characteristics are the direct expression of the man's
mutilation. He tries to put on an air of energy and determination, but it
is clearly artificial, a pathetic attempt to disguise the truth.

The most striking work of all the series is the portrait of *Francisco* *76, 82*
Lezcano, known as *The Boy of Vallecas.* He is a little hydrocephalic
child, clearly an idiot, his partially paralysed face lit by stabs of light, the
lips parted in an effort to emit some plaintive mumble. The heavy head
lolls backwards, the eyes are vague, the legs suggest a halting gait. The
two hands are clasped loosely round some object whose significance
escapes us, just as it seems to escape the feeble child.

Although most of the dwarfs are shown in a room, which is usually
not precisely delineated, *The Boy of Vallecas* and *El Primo* have a land-
scape setting. In the second picture this is no more than hinted at, with *74*

81 *The Coronation of the Virgin* 1641–42

82 *Francisco Lezcano* Detail of ill. 76

stripes of various shades of brown which have no parallel in the
external world, but in *The Boy of Vallecas* it is more explicitly stated. 76
Or it is in part of the picture at least, as the child is depicted seated on a
bank in front of a rock which has the same function as Velázquez' usual
backdrop. But to one side of the rock a deep perspective opens up of the
land sloping down to a woodland area and meeting a range of moun-
tains in the far distance. The presence of these distant objects, inacces-
sible to the young invalid, emphasizes again the desperate nature of the

child's affliction. It also stresses his solitude, making us painfully conscious that the unfortunate creature is abandoned in the midst of alien nature.

Here again the palette is restricted: various shades of green, brown and grey, often dark, muted and intense all at once. Only the face, hands and neckcloth introduce lighter and warmer notes of colour. The light which flickers on the child's face also spreads its gloom over the landscape. The sky in particular has a bleak and mournful air.

Gentleman of the Royal Bedchamber

Velázquez, we should bear in mind, was not only a court painter. He was also a court official, holding a succession of posts at the palace. We have already noted that in 1627 he was made an Usher of the Royal Bedchamber. Seven years later he was granted permission to hand these duties over to his son-in-law Mazo, and in 1636 he himself was named Ayudo de guardaropa (Gentleman of the Wardrobe), which meant that he was responsible for the furnishings and works of art in the various rooms of the palace. In 1643, Philip IV conferred on him a title normally held only by nobles, that of Ayudo de cámera sin ejercicio (Gentleman of the Royal Bedchamber, without official duties). In the same year he became Superintendante de Obras Reales, or Superintendent of the Works of the Palace. In 1646 he was promoted to Ayudo de cámera son oficio, a post which carried with it a certain precedence in official ceremonies. The following year he was entrusted with the duties of Veedor y contador de Obras de la Pieza ochavada de palacio (Inspector and Treasurer for Works undertaken in the Octagonal Room). Special payments and increases in salary went with these positions, and there are documents in existence which refer to the number of ducats and reals paid to Velázquez – or rather, that he was forced to ask for when payment was overlooked. In 1647 he was obliged to ask for the money owing to him for the past two years, and in 1648 he claimed he had still not received his salary as court painter for the years 1630–34, or payment for pictures delivered between 1628 and 1640.[53]

Velázquez was not the only person in the palace who had to wait for his money. According to a text of 1624, quoted by Justi, no one was paid regularly, and even the members of the royal guard were still waiting for their wages for the previous three years.[54] This of course is an indication of the country's far from comfortable economic situation at that time. In spite of the ships that arrived laden with riches from America, Spain's revenues decreased year by year. Hundreds of

thousands of the population categorically refused to work, and after the expulsion of the Moriscos large stretches of land were left uncultivated and yielded absolutely nothing. Meanwhile Olivares committed the nation to military involvements both overseas and in Europe, and these were a continuing financial drain that weakened the country still further. At first his generals won victories, notably those commemorated in the paintings for the Hall of Realms in the Buen Retiro, but after the Battle of Nördlingen, where the Cardinal-Infante defeated the Swedish in 1634, victories were few and far between, and after 1636 defeat followed defeat – in the confrontations with the Protestant armies in Germany, with Richelieu's troops in France, in Italy, and in the sea battles of the Armada against the Dutch fleet. Even within Spain itself uprisings were taking place; the country was beginning to fall apart.

One of Olivares' aims was to introduce strong centralized government. He persuaded Philip IV that it was not enough to be King of Portugal, Aragon and Valencia, Count of Barcelona, etc., but that he should attempt to unite the various provinces of which Spain consisted and make them adopt the laws and political institutions of Castille. In 1640 Barcelona rebelled and proclaimed the deposition of Philip IV. Towards the end of the year Portugal expelled the Viceroy and announced its secession. Madrid naturally attempted to deal with the insurrections, but without success, as the rebellions were supported by foreign powers. In 1642 the French took Perpignan, moved south and entered Catalonia. The situation became more and more alarming, not to say catastrophic, until it ultimately shook the foundations of Olivares' power. Early in 1643 Philip IV, prompted by the Queen among others, decided to abandon the minister who for so long had directed the politics of the kingdom. Exiled from Madrid and humiliated, the Count-Duke survived only a little more than two years and spent his last days in a state of madness.

As for Velázquez, he had been Olivares' protégé before he won the King's favour. Did he regret Olivares' sudden departure or feel grief at his death in despair and delirium? Such a question is impossible to answer. Nor do we know if the painter was troubled by the military reverses and political setbacks that afflicted his country. All we can be sure of is that Olivares' fall from grace did not affect his own position:

he continued to enjoy the King's complete confidence, he carried out his official duties as before, and he painted portraits.

His last portrait of the Count-Duke (Leningrad, Hermitage) of course dates from the period before his disgrace and, judging by the physical appearance of the sitter, it must have been executed in 1638 or thereabouts. Showing only the head and shoulders, it has none of the magnificence of the equestrian portrait. The face, turned almost fully to the front, is even more bloated. The flesh is flabbier and, if there is the merest gleam of kindliness to be detected in his eyes and features, it stems not from a genuine cordiality but from the weariness attributable to old age. However, we should be careful not to conclude from this that Velázquez too, in the end, came to dislike the blundering despot. It is more to the point to recall that even in 1625 he had refrained from idealizing him, and had in fact never attempted to disguise the essential truth of what he saw.

There are two other head-and-shoulders portraits which belong to this period, one of *Francesco II d'Este, Duke of Modena* (Modena, 77 Pinacoteca), the other a *Portrait of a Bearded Man* (London, Wellington 83 Museum). The former in all probability dates from 1638 and was painted during the autumn when the Duke visited Madrid. The red expanse of sash that partially covers the breastplate makes this a more brightly-coloured painting than the second of the portraits, with its costume of unrelieved black. It has not been possible to establish the identity of the subject, but it is clear that he was a proud and fiery man with an imperious and sensitive nature; the signs are there in the face with its hollow cheeks and wide, upturned moustache. Light and shade intermingle in passages of the utmost delicacy to reveal the bone structure beneath the skin, which is suggested without the use of a single hard line. Yet the expression is forthright and the style direct. The softly drawn volumes of the face, and the few folds which orchestrate the blacks of the costume, are separated by the thin white line of the collar, an extremely fine but incisive lightning stroke.

At the time when the Duke of Modena arrived in Madrid a new Princess had just been born. She was christened María Teresa and, wanting to flatter the Duke (presumably for political reasons), Philip IV asked him to be godfather. Velázquez painted the Infanta, as he painted all the other members of the royal family, but not until she was a little

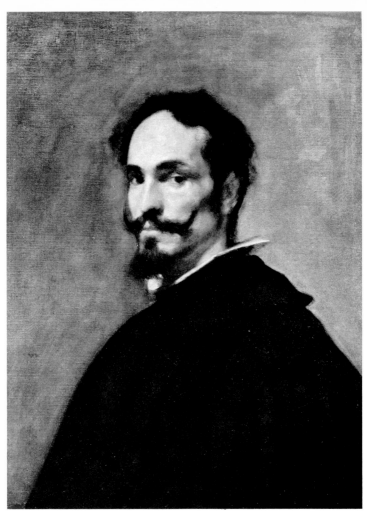

83 *Portrait of a Bearded Man* 1638

79 older. In about 1640, however, a new portrait of Baltasar Carlos was
requested. It was to be sent to the court of Vienna, as a match was
planned between the Prince and his cousin Mariana, daughter of the
Emperor Ferdinand and María, the sister of Philip IV. The Infante's

features in this portrait (Vienna, Kunsthistorisches Museum) are regular and attractive. His dark eyes look at us enquiringly and rather shyly. His face has a porcelain purity and the skin is fragile and delicate. The costume is of black velvet, set off by the silver grey of the sleeves, braid, narrow sash and collar. A black cloak hangs from his shoulders to make him look more imposing, and the violet reds and golden yellows of the furnishings impart a gentle warmth – the yellows being pale and the reds muted. This use of restrained colours for the ceremonial trappings is significant. When artists such as Rubens paint gold decorations or trimmings, they like to create a perfect illusion of the precious metal shining and glittering. Their aim is to outdo nature and disguise the fact that what is there is merely a layer of paint. Velázquez, on the other hand, is content merely to indicate the presence of the gold or silver, not to strive for a totally realistic effect. He never tries to make us forget that what we see is a pigment, mixed with oil and applied with a paint-brush. There is no glitter or sparkle. Yet this discreetly evocative approach is far more telling then the stridency of many other painters.

Shortly after he produced this distinguished and charming portrait, Velázquez painted a *Coronation of the Virgin* for the Queen's oratory in *81, 84* the Alcázar. It is a work that might be described as classical, in the sense that the composition is very clear and symmetrical, founded entirely on geometric patterns. The three figures frame an ellipse, within which a diamond shape is formed by the Virgin's body. She is seen in full-face, God the Father in three-quarters profile and Christ in almost full profile, but their two gazes converge on her and so do the two hands holding the crown. There are other works in Velázquez' canon which are as carefully composed but none which has such measured precision. Nowhere else is the geometric structure so evident or so scientifically calculated.

In the circumstances the influences for the picture, insofar as we know them, come as no great surprise. An engraving of *The Assumption* by Dürer has been mentioned in this connection, and of course the various *Coronations* of El Greco. But a comparison with El Greco at once indi- *86* cates how much better suited he was to religious art. It takes the temperament of a visionary to handle such themes with conviction, and an ability to conceive of a world quite different from the one which we inhabit.

84 *The Coronation of the Virgin* Detail of ill. 81

Of course, a Velázquez painting is never without its merits, and the attractive palette of reds and violets deserves to be mentioned. But in the last analysis *The Coronation of the Virgin* must be seen as one of those emotionless works which Velázquez was apt to produce when he was grappling with a subject that did not elicit a response from the core of his being.

It was a different matter entirely when Velázquez was asked to paint a portrait that engaged his interest: then all the depth and power of his

85 *Lady with a Fan* 1644–48

86 EL GRECO *The Coronation of the Virgin*

genius was fully deployed. A splendid instance of this is the portrait of
Philip IV of 1644, which was painted in rather unusual circumstances.
Since the start of the Catalan uprising in 1642, the King had been
obliged to spend some of his time with the troops engaged in fighting
the rebels. Knowing his presence was appreciated by the soldiers, and
hoping to raise their morale, he again left Madrid in 1644. Velázquez
accompanied him, and it was in Fraga, a small town between Saragossa
and Lerida, that he painted this portrait (and also *El Primo*). His working

162

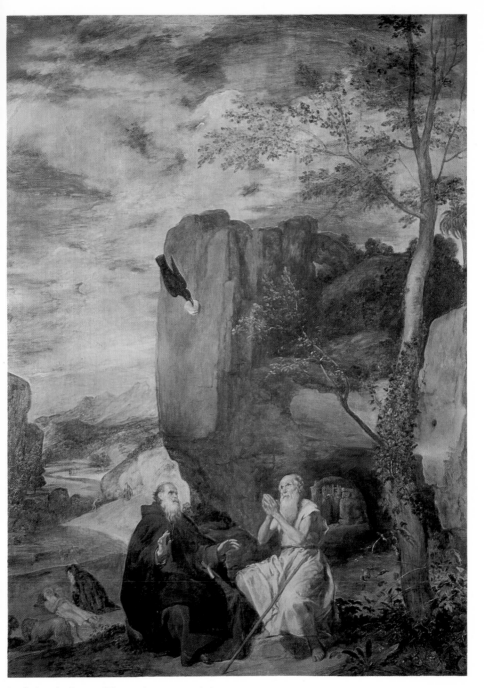

87 *Saint Anthony Abbot and Saint Paul the Hermit* 1640–60

conditions were far from ideal, his studio being no more than a small room with crumbling walls and no proper floor. And three sittings were all the King could spare him.

Philip IV wears the red and silver uniform of Commander-in-Chief of the Army, its alternating tones of bold and iridescent colour, brilliant yet discreetly opulent, giving the painter ample scope to display his marvellous feeling for colour. Not of course that a fine colour sense cannot be demonstrated with a palette of blacks and greys – Velázquez himself is the proof of that – but here he shows that he is quite as skilled at handling a range of brilliant colours, and does so to breathtaking effect. The other significant element in the picture, apart from the colours, is naturally the King's face. Compared with the portrait in the National Gallery, London, the features are more severe, the chin heavier and the expression more careworn.

That the King's expression should have changed is hardly surprising. Only a year after his reluctant dismissal of Olivares, Philip IV must have felt very isolated. In spite of his presence, the military situation in Catalonia had not improved, and it was no better elsewhere. The previous year, in Rocroi, a particularly severe defeat had been inflicted on the Spanish infantry by Condé's cavalry. With or without Olivares, the power of Spain continued its inexorable decline.

And before very long the King would be affected by events of a more personal nature. The Fraga portrait was intended for the Queen. Having neglected her for so long, Philip had begun to take notice of her again, even to show affection. He made her his confidante and appointed her as the leading figure of his government. Unfortunately she was not destined to enjoy her newly privileged position for very long: she died in October 1644, and her husband was greatly affected by his bereavement. Less than two years later he learned that his sister María had also died, in Vienna. Nor was this all. In January 1646, according to plan, Baltasar Carlos was betrothed to Princess Mariana of Austria, the match being intended to strengthen the ties between the Spanish kingdom and the Habsburg empire. But before the year was out Baltasar Carlos too was dead. Philip IV felt the loss with particular keenness because it deprived him not only of the son he loved but also of his heir. And there were at the same time further political setbacks to reckon with. In 1646, Spain's authority was shaken by a revolt in Sicily.

The following year there was a rebellion in Naples lasting several months. In 1648 the Peace of Westphalia brought the Thirty Years War to a close, but victory was won by the enemies of the Emperor, who were the enemies of Spain as well.

In 1644 Velázquez too suffered the loss of someone dear to him, the father-in-law for whom he felt such affection. There is a dearth of documentary evidence about Pachecho's death, and until 1960 it was believed not to have occurred until 1654. Velázquez continued all the time to fulfil his functions at court and to paint his pictures. It is true that if one adds up all the works he executed between 1640 and 1650, they number about twenty, compared with nearly forty for the previous decade. One might interpret this as evidence that Velázquez was spending a greater proportion of his time on his other duties. Was he perhaps asked to paint fewer portraits, or painted them more slowly? The numerous over-paintings in his canvases indicate that he was never entirely happy with his first attempts, in spite of the growing air of spontaneity in his work. A clue is perhaps to be found in a letter written by the ambassador of Modena, Fulvio Testi, to Duke Francesco d'Este. After Velázquez had finished the previously mentioned head-and-shoulders portrait of the Duke, Philip IV asked him to paint an equestrian portrait, a copy of which would be presented to the sitter.[55] Hence, in March 1639, Fulvio Testi wrote to tell the Duke of Modena that Velázquez was at work on the portrait 'which will be admirable'. His letter continues: 'But he has the fault of all great artists, that he can never complete a piece of work, and never tells the truth.'[56] (Presumably he means the truth about when the portrait will be ready.) Possibly his remark carries the implication that increasing demands on his time forced Velázquez to paint more and more slowly. It is a tempting explanation, except that the picture under discussion is a copy, and the task may well have been one that Velázquez found somewhat tedious. As ever with Velázquez, one can only speculate.

A further mystery is the identity of the *Lady with a Fan* (London, Wallace Collection). It has been suggested that she is Francisca, the artist's daughter and Mazo's wife, but again there is no real evidence to support this view. The date too is uncertain, the accepted period being somewhere between 1644 and 1648. We have already said that Velázquez' women are usually serious rather than pretty. They make no

85

88 *View of Saragossa* 1647

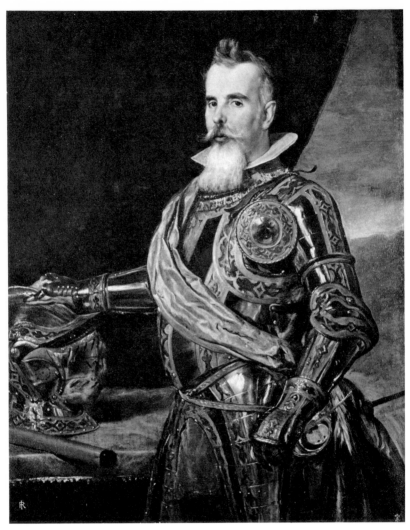

89 *Don Juan Francisco de Pimentel, Count of Benavente* 1644–48

effort to captivate or even to look particularly agreeable, they simply exist. This woman's oval face has a hint of melancholy about it, and the big eyes stare straight towards us. She looks rather splendid with her dark brown hair covered by a black mantilla, her olive green dress, pale grey gloves and purplish-blue fan, and the pale blue ribbon carefully knotted in a decorative flourish to embellish the rosary she carries. Her features are those of an individual but they are also characteristic of her race. Like certain of Goya's women, she is a superb example of Spanish womanhood.

It must have been at roughly the same time that Velázquez painted *Don Juan Francisco de Pimentel, Count of Benavente* (Madrid, Prado). *89* Because he was a member of a military family, all of whom had given valiant service to Spain, he is shown wearing full armour, with only his head left bare. The beard and hair are grey but the complexion is strikingly fresh and delicate. The hardness of the ochre and grey-green armour is in bold contrast to this delicacy of feature, but the one does not suffer at the expense of the other. El Greco's *Burial of the Count* *16* *of Orgaz* (Toledo, Santo Tomé) and Titian's *Philip II* (Madrid, Prado) *20* come irresistibly to mind; in all three pictures a resplendent suit of armour is a principal feature. But it is no surprise that the Velázquez contains fewer details and yet manages to be more 'realistic'. The mood of the painting is also less formal and grand, because the lighting is diffuse, more 'ordinary'.

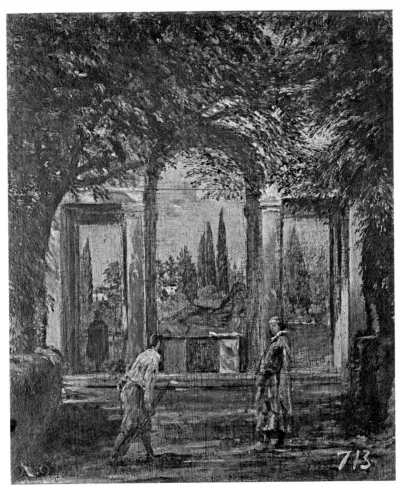

90 *Villa Medici in Rome* 1650?

Landscape painter

One can tell from the equestrian portraits that Velázquez had the makings of an excellent landscape painter, an opinion which is confirmed by one of his religious paintings, *Saint Anthony Abbot and Saint* 87 *Paul the Hermit* (Madrid, Prado). It is not an easy painting to date, and 1624, early in the 1640s and 1660 have all been suggested as possibilities. The two figures are shown seated in the foreground in front of a rock of imposing mass. The men are obviously meant to be tall but they are dwarfed by the rest of the picture and seem insignificant compared with the landscape. This is a familiar enough relationship between man and his natural environment, and was widely used by Joachim Patinir, for example, the sixteenth-century Flemish artist whose works Velázquez would have had the opportunity to study at the Escorial.

The picture has a number of other unusual features: Saint Anthony is shown in conversation with Saint Paul, but also in various scenes from the legend of his journey. In the background, he encounters a centaur; further towards us he meets a faun; and nearer still he is shown knocking at the door of the cavern in which Saint Paul lives. There is even a reference to events subsequent to the meeting of the Saints. In the middle ground, Saint Anthony kneels beside Saint Paul's corpse; he himself is too exhausted to bury the body so two lions have run to the scene ready to dig a grave.

By juxtaposing episodes set in different locations at different times, Velázquez is (once again) resorting to an archaic tradition. Medieval artists habitually used this device when they wanted to tell a complete story, but when the Renaissance adopted the idea of the single point of sight, the painters were forced to abandon that sort of narrative style. However Velázquez does not reject the artistic precepts of his own age out of hand. It does not occur to him to feign ignorance of perspective, and Saint Anthony's height, for example, varies according to where he is situated in space. And the landscape could never in fact be confused

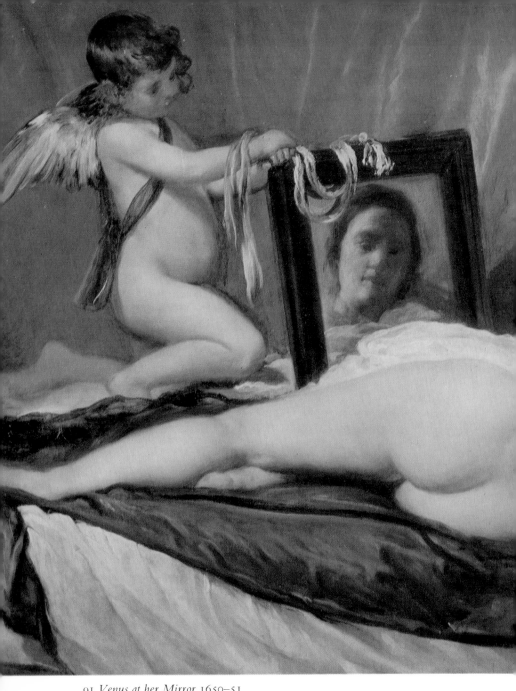

91 *Venus at her Mirror* 1650–51

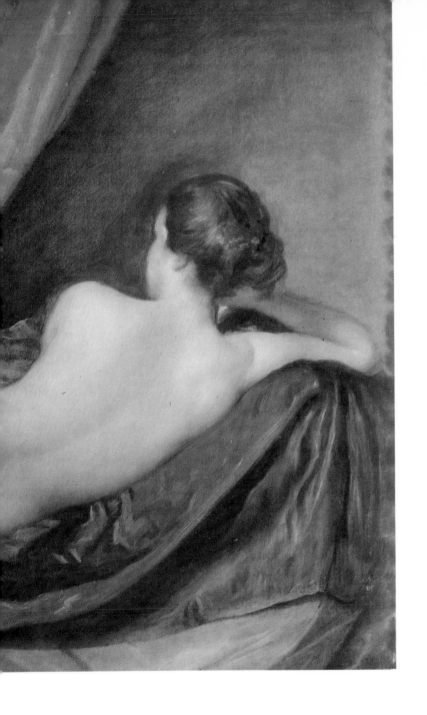

with one by Patinir – it seems less complex, far less of a panorama, and contains altogether fewer elements. Patinir belonged to an age in which the external world was still being 'discovered'. Delighted by the mere sight of rocks and plains, forests and rivers, the artists enjoyed combining them all together in one painting. Velázquez' landscape does however have its own sort of complexity. The mountains in the background look rather like the Sierra de Guadarrama, which had featured already in some of the earlier paintings; Velázquez has not simply reproduced the motif, however, even though it looks as though he has been more 'faithful' than the Flemish artist. The forms of objects, their colouring, and the light and atmosphere that envelop them, all have that seemingly realistic air that is characteristic of his painting.

It is worth noting in passing a feature of the picture which has nothing to do with the landscape, but which throws light on something else. Both Saint Paul and Saint Anthony appear fully clothed. In general the theme of the hermit was taken by the painters of the seventeenth century as the opportunity to paint either nudes or semi-nudes – old men's bodies shrivelled by age and the privations of their ascetic life, the action of the winds and desert sand, their skin withered and their muscles slack. Velázquez is content to show Saint Paul with one arm bared, and otherwise to concentrate on the bony hands of the two men. He must have been conscious that the nude was not his forte, and it is a decision one can only welcome as his palette is far more varied than would have been possible in a faithful anatomical study.

93, 94
88 Works in which the landscape plays as important a part as it does here are rare in Velázquez' canon. In the case of two of them, *The Royal Boar Hunt* (c. 1638?) and the *View of Saragossa* (1647), we must ask whether large sections should not be attributed to Mazo or one of the other assistants; if so, it would mean that Velázquez painted only the figures – or some of them at least, that being a further point of contention.

To do justice to the theme of a wild boar hunt it is obviously necessary to show all the detail of what is going on. In the centre of the picture (London, National Gallery) is an enclosure fenced in with long strips of canvas, looking rather like an arena. Men and animals confront each other on the flat terrain. Because it is a vast area it is shown as though from a distance, so that the objects and figures appear on a very reduced scale. The artist must also indicate that a hunt of this kind is as much a

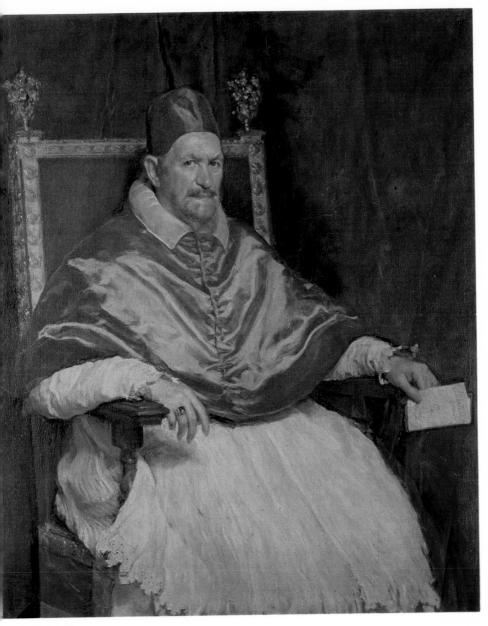

92 Innocent X 1650

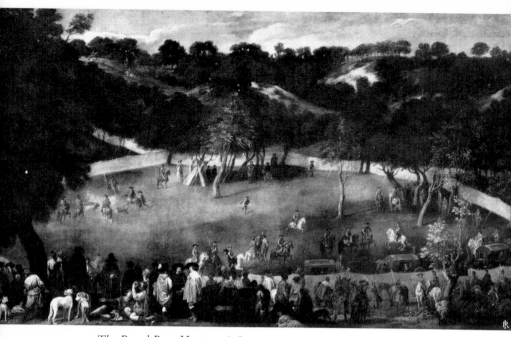

93 *The Royal Boar Hunt c.* 1638

spectacle as an activity, with as much appeal for spectators of all kinds as for the participants. Even the Queen (presumably) and her ladies are present, and the blue carriages in which they have made the journey are drawn up actually inside the enclosure. The others who are not taking part are outside the fence. There are many of them and they are distinguished by the diversity of their attitudes, costumes and social class. Servants rub shoulders with nobles, beggars with men of consequence. Although the figures are tiny, their silhouettes have been picked out with authority and skill. The same is true of the horses, mules and various breeds of dog, shown, like their masters, in a variety of attitudes. Variety too in the colours, bathed in the outdoor light and full of subtle shades, managing to be delicate and emphatic at one and the same time. Judging from the light and assured brushwork one would have no hesitation in recognizing the hand of Velázquez, but the

94 *The Royal Boar Hunt* Details

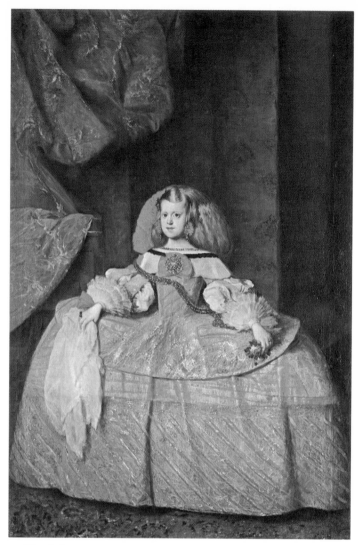

95 The Infanta Margarita 1659?

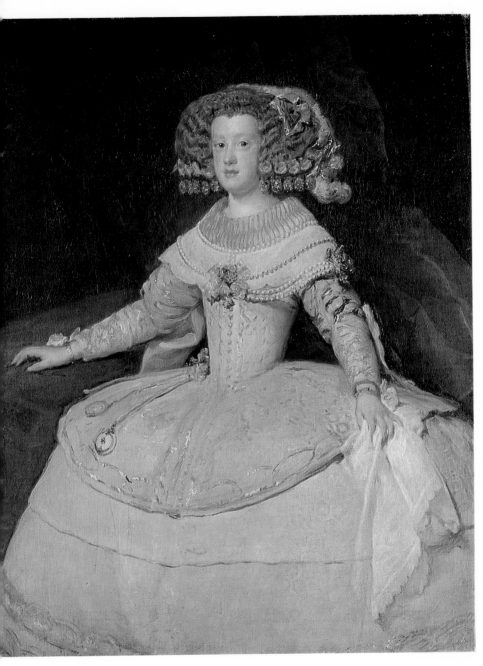

66 *The Infanta María Teresa c.* 1652

picture does reveal a taste for narrative and a felicity in the handling of anecdotal details that are usually lacking in his work. There are, for instance, the two men beating a stubborn mule, and the knot of people leaning over to inspect a wounded dog which is lying on the ground bleeding.

Within the enclosure some of the postures are rather stilted. In particular, Philip IV, sitting stiffly on his horse, shows an extraordinary degree of detachment for someone lowering a pronged pole at a pouncing boar. His upright bearing hardly reflects the quick reactions of the hunter; it is more the attitude a king might adopt for a ceremonial progress. Possibly Velázquez had to make him look like this in order to make it clear to an observer that he was in the presence of His Majesty the King, who remained calm and dignified even when he was out hunting. The fact that the figures of Philip IV and those around him are partially effaced does not make the matter any easier to resolve. The picture has suffered with the passage of time and is no more than a shadow of its former greatness. It remains something of an enigma. If one does not attribute to Velázquez the groups outside the fence, it is impossible to think of any other painter at court who could have handled them with such skill. Although Velázquez is not usually at ease in narrative passages, it is just possible that he was happier when dealing with figures on a smaller scale.

The landscape itself raises similar problems. There are a few trees inside the arena, and at the back a wild area of sandy hillsides covered with patches of woodland. It looks like the countryside to the north of Madrid. The fact that the landscape is in no way 'prettified' points to Velázquez, yet the handling is altogether too slack to be his work.

88, 97 The *View of Saragossa* (Madrid, Prado) again shows a crowd of people in the foreground: men and women, aristocrats and commoners, some standing and some sitting, alone or in groups, some looking across the Ebro to the town, others turned to face towards us. Once again the diversity of the attitudes is matched by the range of costumes and colours, reds, blues, greys and browns. The swarming brightly-coloured figures are boldly contrasted with the calm surface of the river and its dark grey-blue water.

Further contrasts are provided by the river and the town, and the town and the sky. The houses are built of brick, but the artist gives the

97 *View of Saragossa* Details of ill. 88

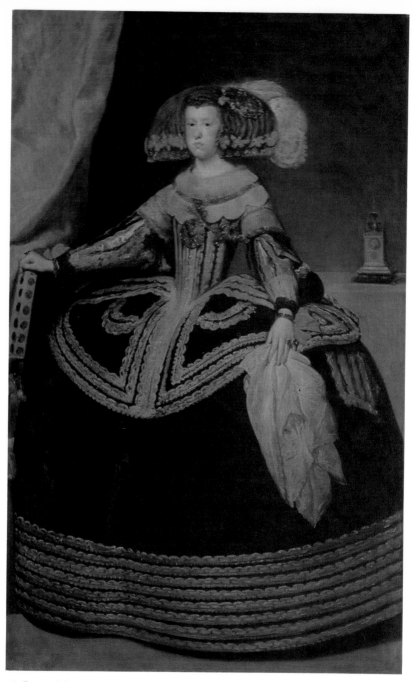

98 *Queen Mariana* 1652

homely colour an added distinction. The pearly greys of the sky are scumbled with faint touches of blue and orange. Horizontality is the keynote of the picture. True, there are verticals (the towers and some of the men in the foreground), and also the diagonals and curves of the two bridges, but the chief impression is of a wide flat expanse. The town itself has a sleepy air, in spite of the presence of people, horses and carriages. There is certainly nothing very distinctive about it, and it is not highlighted or dramatized in any way. Canaletto himself could hardly have been more objective. The *View of Saragossa* is at the opposite extreme from El Greco's *View of Toledo* (New York, Metropolitan Museum), which is heroic and ghostly, fascinating and unreal all at once. Here there is no attempt to transfigure reality. The light is not intense or jagged with lightning, it is soft and caressing, with more of the tenderness of Corot then the visionary emotional power of El Greco or Rembrandt. It reflects Velázquez' temperament – even if the picture was executed entirely or in large part by Mazo. An inscription in the bottom right-hand corner indicates that it was he who completed the painting in 1647, but this does not exclude some degree of participation by Velázquez. This particular view of the town is said to have been chosen by Baltasar Carlos when he accompanied the King to Saragossa.

Among the few drawings attributable to Velázquez (though on this subject there is a large measure of disagreement among specialists) is one landscape, a *View of Granada* (Madrid, Biblioteca Nacional). This *100* time the emphasis is not on a horizontal panorama, but on the squat mass of the cathedral, beside which the houses are all jumbled together, apparently almost flattened to the ground. The drawing would seem to date from the month of November (1648), and the light is therefore rather subdued – a pale sun dapples some parts of the buildings and casts diaphanous shadows over the rest. The line-drawing too is of great delicacy, and even the broader strokes are sensitively and suggestively traced. It would only be a slight exaggeration to describe the sketch as 'impressionistic'.

The ephithet is even more apt in the case of two small canvases, views *90, 101* of the *Villa Medici in Rome* (Madrid, Prado). There is no doubt at all that they were painted in Italy but, as Velázquez was there in 1629 and again twenty years later, the date of the paintings is far from certain.

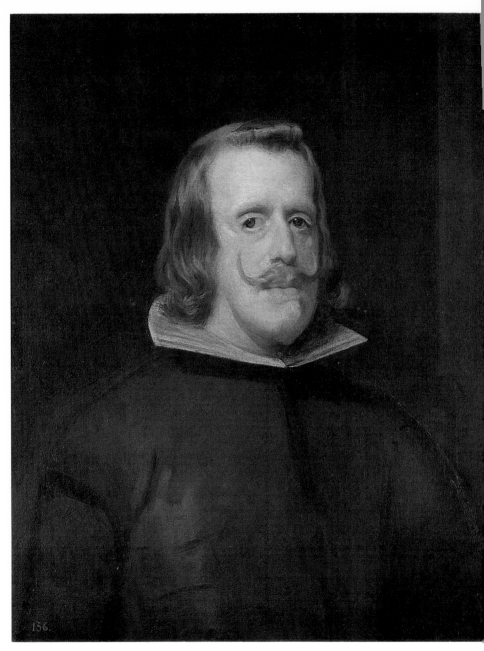

99 *Philip IV c.* 1656

100 *View of Granada*

Most of Velázquez' biographers believe he brought them back with
him after the second visit. He seems to have drawn them from life,
with a total respect for appearances and a faithful rendering of the light.
Hence, of course, the parallels with the Impressionists.

The motifs themselves are mundane. Although they include archi-
tectural structures and statues inspired by Graeco-Roman mythology,
they have absolutely nothing in common with those historical land-
scapes, frequently in a heroic vein, to which seventeenth-century

101 *Villa Medici in Rome* 1650?

artists who found themselves in Italy were so irresistibly drawn. In one of the pictures, all pretensions to architectural splendour are thoroughly deflated by the rough barrier of planks blocking up the main archway and embrasures on either side. On the top of the balustrade a young

186

woman is to be seen hanging out the washing. In this context, the statue set in a niche at the edge of the canvas looks like some left-over fragment of a bygone age.

We should not conclude from this that Velázquez is implicitly criticizing those who have allowed the artistic treasures of the past to fall into disrepair. As usual, he simply represents what he sees. He presents the contrast of the vigorously growing cypresses with the impermanent regularity of the man-made edifice. The one enduring feature common to both is the light, a flat light dimmed by the clouds in the sky.

In the other picture, architectural remains are used to embellish a pretty and peaceful spot, and the foliage of the trees permits a few rays of sunlight to filter through and play 'capriciously' over the stonework, splashing over the ground and the figures of the two men situated in the foreground. This interplay of light and shade resembles the effect in Renoir's *Le Moulin de la Galette* (Paris, Jeu de Paume). Even the handling has that allusive quality we find in the work of the Impressionists. We should however guard against seeing in Velázquez the direct precursor of the movement. There are three essential features of their style which we do not encounter in his work: a light, hot palette; the division of colours; and blue and green shadows. Although Velázquez was acutely sensitive to light, it did not in any way intoxicate his senses. But it must be admitted that these two pictures are unusual in several respects and seem much closer to us than most other seventeenth-century landscapes.

The second trip to Italy

When Velázquez returned to Italy in 1648 he went specifically to purchase works of art. The King, and he himself no doubt, wanted them not, this time, for the Buen Retiro but for the former royal palace, which was being refurbished. The duties assumed by Velázquez in 1647 made it his responsibility to oversee the renovations and the decoration of rooms converted or newly constructed. Believing that 'the King should not own paintings available to all and sundry', he informed Philip IV that, if he were granted permission to visit Rome and Venice, he would do everything in his power to secure the best works of Titian, Veronese, Bassano, Raphael and Parmigianino. 'There are few princes who possess paintings by these masters, and even fewer who possess them in the numbers His Majesty will acquire as the result of my diligence.'[57]

The above declaration was quoted by Jusepe Martínez, a friend, and therefore someone to whom Velázquez might well have repeated what he said. But is that a sufficient guarantee of authenticity? If Velázquez did say exactly that, then he spoke with some pride and clearly flattered himself on possessing a considerable expertise in the matter of buying pictures. Or he may have exaggerated in order to persuade the King of the necessity for making the trip, as there can be little doubt that he was eager to return to Italy.

On this occasion he was unable to sail from Barcelona because it was occupied by the French. Valencia, Alicante and Seville were out of the question because of plague. He therefore boarded ship instead at Málaga, arriving there in November 1648 (travelling probably by way of Granada, where he executed his drawing of the town). In 1629 he had made the journey in the company of Spínola; this time he was accompanied by a Spanish delegation led by the ambassador Don Jaime Manuel de Cárdenas, Duke of Nájera and Maqueda. They were on their way to Trent to meet Princess Mariana of Austria. She had

once been the intended wife of Baltasar Carlos and was now to be married instead to Philip IV, her uncle and the father of the man to whom she had been betrothed. At the end of 1648 the Princess was just fourteen years old and the King forty-four.

At that time Velázquez had no contact with the future Queen. He left Málaga in January and arrived in Genoa on 11 March 1649, and in Venice on 21 April. Once again he was accommodated by the Spanish ambassador, now the Marquis de la Fuente, who at once set about helping him in his search for paintings. If we are to believe the Venetian Marco Boschini, who includes the information in a poem published in 1660,[58] Velázquez bought while in Venice two Titians, two Veroneses and a Tintoretto, the latter being a sketch for his huge canvas *Paradise* which hangs in the main hall of the Doges' Palace. According again to Boschini, his enthusiasm for the painting was so great that he exclaimed: 'This picture alone would be enough to secure immortality for any painter; it seems to be the product of the whole of a man's lifetime.'[59]

Certainly Velázquez did not buy many pictures, even if one accepts Palomino's account, according to which he bought more than one Tintoretto and two Veroneses.[60] He must have discovered that in practice it was a more difficult task than he had led Philip IV to believe. A further point of uncertainty is whether he found these paintings in 1649 or not until a second visit to Venice in 1650–51. In all events he did not linger in the city of the Doges. By the end of May he was in Rome, having visited Parma, Modena, Bologna and possibly Florence on the way, Parma and Modena because he wanted to see the works of Correggio, the fresco of the *Assumption* in the cupola of Parma Cathedral,[61] and the painting known both as *Night* and *The Nativity*, which then belonged to Francesco d'Este, Duke of Modena. Madrid had coveted the painting for over ten years. Fulvio Testi, the ambassador of Modena at the Spanish court already referred to, had suggested in a letter to the Duke that he should bring it with him in 1638, although at that time it still belonged to an order of nuns and was in a chapel in Reggio. The Duke took no notice of his ambassador; he wanted the Correggio for himself, and two years later he obtained it. Velázquez' prompt arrival in Modena shows that the desire to possess the picture was as strong as ever, and this is substantiated by his subsequent

manoeuvres – there is some interesting documentary evidence about this, which will be quoted in due course.

Velázquez' stay in Rome was interrupted by a visit to Naples to obtain from the Viceroy, Count Oñate, the funds needed for his personal expenditure and for the purchase of pictures. But he was back by mid-June and remained in the Eternal City for over a year.

As well as paintings, he had promised to take back with him a number of sculptures, antique statues in particular. If he was unable to obtain the originals, he planned to buy replicas or moulds which could then be used to cast bronzes after he was back in Spain. Palomino says that he had thirty-two castings made, numerous Roman full-figure statues and busts and the head of Michelangelo's *Moses*.[62] Some of these pieces were very famous indeed, such as the *Laocoön*, *Apollo* and *Antinous* from the Belvedere; the *Hercules* and *Flora* in the Palazzo Farnese; the *Mars Standing*, *Hermaphrodite* and *Dying Gladiator* in the Villa Borghese; the *Wrestlers* in the Villa Medici; the *Mars Seated* and *Mercury* in the Villa Ludovisi; and *The Boy with the Thorn* on the Capitol. It would appear from this list that Velázquez shared the tastes of his age, but of course we do not know if he chose these works because they appealed to him personally or because they were the pieces that would be expected to figure in any representative collection of antique sculpture.

We do know – for certain this time – that Velázquez made contact with a number of contemporary Italian artists, notably the painters Pietro da Cortona and Salvator Rosa, and the sculptors Bernini and Algardi, who were highly respected. They represent that extrovert tradition of Baroque, full of extravagant gestures and the sort of illusionism Velázquez had never been attracted to, and indeed had firmly opposed in his own work. But sculptures by Algardi and Bernini were to be part of the royal collection, and although we have no proof that they were bought on Velázquez' recommendation, that may well have been the case. Even though he rejected the Baroque style in his own work, it is not impossible that he was capable of appreciating it in the work of others. Or it may be that his loyalty to the King was such that, when it came to making these purchases, he considered Philip IV's preferences rather than his own. And it was certainly because the King wanted to have Italian fresco painters at court that Velázquez tried to

tempt Pietro da Cortona to Madrid. He was then considered the best painter in Rome of large decorative church paintings, and when he declined the invitation Velázquez was obliged to turn to other lesser names. The two artists he found are barely remembered today, but at that time they were in considerable demand. They were Agostini Mitelli, from Bologna, and Angelo Michele Colonna, who came from Rovenna, near Lake Como. Among others, they had worked for the Duke of Modena, had decorated three rooms in the Pitti Palace in Florence, and had also received a number of commissions in Rome itself. On a previous occasion they had been approached to work in Madrid but had declined the offer. This time they seemed ready to go to Spain, or at least so they gave Velázquez to believe – as we learn from a letter written on 12 December 1650 to the Duke of Modena by Gennaro Poggi, one of his officials, who mentioned that he was displeased by the news.[63] In the event, the two artists decided against making the journey, at least for the immediate future. They did not go to Spain until eight years later when commissions in Italy were harder to come by.

We have little more information about Velázquez' informal contacts with other artists than we do for the first visit. But Boschini tells us he spent a day with Salvator Rosa, and that the following conversation took place. Rosa: 'What do you say of our Raphael? Now you have seen all the fine things Italy has to offer, do you too not think he is the best?' Velázquez: 'To tell the truth (for I like to be honest and sincere) I must admit that I do not like him at all.' Rosa: 'Then there can be no one in Italy who is to your taste, for we award him the crown.' Velázquez: 'It is in Venice that the fine things are to be found. In my view, there is the brush that has pride of place. It is Titian who carries the day.'[64]

Of course there is no proof that this is an accurate report of what was said, especially as Boschini wrote in rhymed verse. But it does express one basic truth, that as he developed Velázquez was increasingly drawn to purely pictorial painting. Raphael could not have meant the same to him then as he had in 1630, while Titian must have appealed to him more and more.

It may well have been out of a desire to measure himself against his two great predecessors that Velázquez determined to paint the portrait

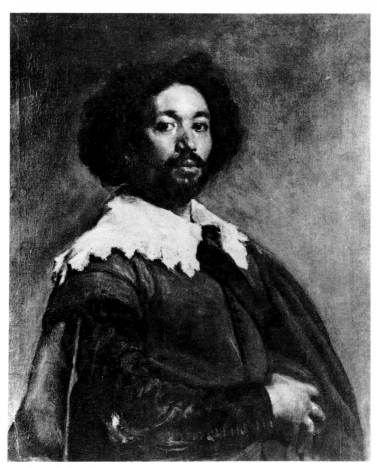

102 *Juan de Pareja* 1650

92 of *Pope Innocent X* (Rome, Galleria Doria-Pamphili), for both Raphael and Titian had painted celebrated portraits of the then reigning Popes. Certainly Velázquez was conscious of the importance of this work and as a form of preparation, what I would describe as a mustering of his *102* forces, he first painted *Juan de Pareja* (Longford Castle, Salisbury, Radnor Collection) – the mulatto assistant who had accompanied him to Italy. The painting was so much admired by the people who saw

it that it was put on public show at the Pantheon on 19 March 1650. It was exhibited together with a number of other pictures, but received particular acclaim because, in the words of one witness, 'it was the opinion of all the painters, of whatever nationality, that the rest was mere painting and this alone was truth'.[65] This triumph, following his election to the Academy of Saint Luke and admission to the ranks of the 'Virtuosi of the Pantheon', clearly encouraged Velázquez to pursue his principal task, the portrait of the Pope.

Innocent X was then seventy-five although he looks younger, prob- $92, 104$ ably because of his florid complexion. His face appears battered rather than lined. The expression is severe and suspicious, the eyes are steely, and the thin lips indicate a certain cruelty. Seated in his red and gold chair, elbows resting on its arms, he holds between the fingers of his right hand a sheet of paper bearing the words: *Alla San*ta *di N*ro *Sig*re | *Innocencio X*o | *Per* | *Diego de Silva* | *Velásquez de la Ca* | *mera di S. M*ta *Catt*ca. Velázquez does not let it be forgotten that it is the court painter to the King of Spain who is painting the pontiff.

There is a bronze statue of Innocent X by Algardi (Rome, Palazzo dei Conservatori), as well as sculptures by Bernini, including a marble head (Rome, Palazzo Doria). Algardi's Pope is more emaciated and apparently more preoccupied with spiritual matters, while Bernini gives him the dignity and serenity of an old man of imposing wisdom and calm. In reality he was an uncommunicative man who mistrusted other people. His contemporaries described him as excessively ugly; in particular, he did not have the fine bushy beard Bernini gave him. It is the Velázquez portrait that is accurate, the rest are idealized likenesses.

More revealing still is the comparison with similar works by Raphael and Titian. The former painted both *Julius II* and *Leo X with* 105 *Two Cardinals* (Florence, Uffizi). The latter painted a portrait of *Paul III*, also *Paul III with his Two Nephews* (Naples, Pinacoteca). In each 106 case it was the composition of the three figures that brought out the best in the artist – unsurprisingly so, as this was the formula that gave them scope to do more than merely emphasize the Pope's rank. The image is more relaxed, not nearly so stiff and formal; the pontiff is not sitting in state conducting an audience, he is in his office in conversation with his advisers, discussing a fine manuscript in the case of Leo X, and Church business in the case of Paul III. Titian even envisages some sort

of narrative: the Pope, a thin, bent old man, turns towards his nephew Ottavio Farnese, who is approaching with cat-like stealth and leans over to catch the Pope's question.

Nothing of this kind is possible in a picture which represents the Pope on his own. But in Raphael's *Julius II*, of which we possess only copies, and Titian's *Paul III*, the painter insists on the dignity and

103 *Innocent X* 1650

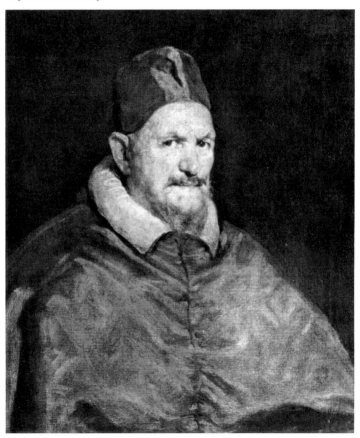

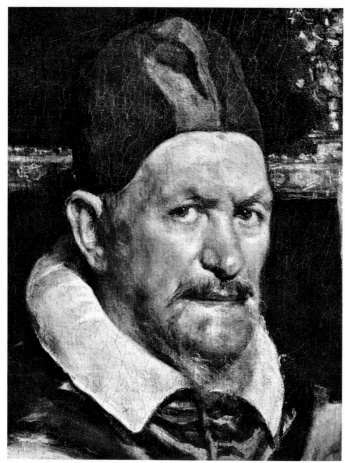

104 *Innocent X* Detail of ill. 92

spirituality of his model. This is particularly so in the case of the Titian which, while not concealing the stooped back, nevertheless shows Paul III seated in an attitude which gives him the imposing grandeur of a pyramid. The picture seems too narrow to contain his full majesty. Here too the eyes have a piercing gaze, watching us closely as though to intimidate us, but the face does not lack nobility. The hands are drawn with enormous sensitivity, the jagged contour of the

105 RAPHAEL *Leo X with Two Cardinals* 1517–19

body, tapering fingers echoed by the lightning strokes of the mozzetta. In short, Paul III is magnified by the art of Titian, while Velázquez' Innocent X remains exactly what he is. In the Titian we are conscious above all else that we are looking at a Pope, a man to be venerated. In the Velázquez what we see is a man of unprepossessing appearance, a

196

complex blend of reserve and obstinacy. To put it another way, truthfulness of characterization takes precedence over ecclesiastical rank.

The two dominant colours of the Velázquez are red and white. The white occurs in the collar and surplice and is picked up by the sheet of paper in the Pope's hand. Most of the rest of the picture is in red. Even

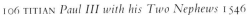
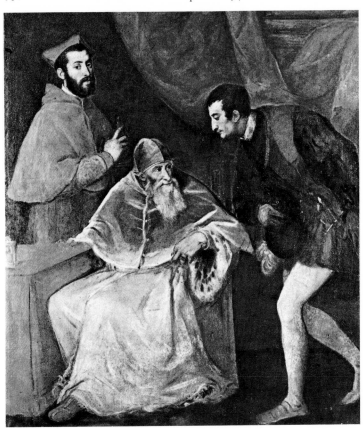

though the shades of colour range from the palest to the darkest, Velázquez in fact employs a very restricted palette – and yet the picture gives the impression of sumptuousness and formal splendour. The gold borders of the chair have a dual function: to make the throne stand out against the hangings at the back, and to introduce straight lines and angles into the composition, as a contrast to the twisting and broken lines elsewhere. Only the sheet of paper in the Pope's hand echoes discreetly the line of the chair-back.

Although the portrait is anything but flattering, Innocent X liked it very much and apparently sent the artist a sum of money in payment. Velázquez is said to have refused this on the grounds that he could accept fees only from his employer, the King. But he did accept a gold chain bearing a medallion of the Pope's head and agreed that the painting should be exhibited in the Pantheon, where it was even more widely acclaimed than his portrait of Pareja. As a result he was invited to paint further portraits, only three of which have survived: that of *Cardinal Camillo Astalli Pamphili*, adopted nephew of Innocent X (New York, The Hispanic Society of America); of *Monsignor Camillo Massimi*, the papal chamberlain (Wimborne, Dorset, Bankes Collection); and the *Portrait of the Unknown Man* (New York, private collection), believed by Auguste L. Mayer to be the Pope's barber.

91, 107, 108 It has been suggested that Velázquez did not confine himself to portraiture while in Rome, and that *Venus at her Mirror*, the so-called *Rokeby Venus* (London, National Gallery), also dates from this period. A number of art historians believe this is the case, although an inventory has recently been discovered which indicates that the painting was already in Madrid in June 1651, before Velázquez had returned to Spain.[66] It might have been sent on ahead from Rome, but it is equally possible that it was executed before Velázquez went to Italy. The reason a date of 1650–51 has been proposed is because of the picture's resemblance to certain works in Rome, notably the *Hermaphrodite* (lying down, seen from behind) of which Velázquez had commissioned a casting. Parallels have also been suggested with Michelangelo's bronze nudes on the ceiling of the Sistine Chapel. But of course parallels and similarities do not necessarily imply derivation. To discover, when investigating the sources of a painting, that it has affinities with other works, is not to say that they directly influenced the artist.

Surely Velázquez need not necessarily have borrowed the idea of painting a back view of a nude from some earlier painting? It might as easily have been suggested to him by the body of some live model. Some of these analyses make one wonder if the eminent scholars who expound them are not over-ready to believe that a painter always finds his inspiration in the work of other artists (or in philosophical texts) and never in life. They seem to fear that an artist will appear uneducated if they once accept that he may have responded quite straightforwardly to something he saw. They therefore attribute to him similar pre-occupations to their own (of the highest order, in their opinion), but which are in fact the interests of thinkers and literary men, and not of painters. And Velázquez was above all else a painter. He could not have imparted to his canvases their undisputed realism if he had been in the habit of relying exclusively on other people's work. This is not to say that he was indifferent to other artists, for he was a sophisticated painter and in no sense a primitive. But when he uses a particular device it does not necessarily mean that he borrowed it from someone else.

Velázquez was certainly familiar with the paintings of Venus by his idol, Titian, but they are nothing like the nude he himself painted. Her forms are slim and graceful rather than voluptuous. The modestly swelling hips curve into a slender and pliant waist. The arms are thin, the legs not at all heavy, and the body as a whole is sinuously drawn. Velázquez handles sensuality with restraint. He does not show Venus's bosom or her stomach. There is no exchange of glances between Venus and the Cupid holding the mirror. Each figure is alone, Venus especially, as the face reflected in the mirror seems not to belong to her. Distant and rather drowsy, it has none of the delicacy of feature one would expect from seeing the profile. This sort of inconsistency is something familiar in Velázquez, who was usually more interested in the faithful rendering of details than in the fidelity of the picture as a whole. One could legitimately say that what interested him here was not Venus but the female nude – certainly the Cupid was not added until later and it was not originally the painter's intention to represent mythological characters.[67] The use of myth seems to be a concession to the taste of an age which found the nude acceptable only when 'ennobled' by some such significance. But Velázquez does not make the woman's body approximate to some anonymous ideal of beauty; on

107 *Venus at her Mirror*
Detail of ill. 91

the contrary, it is strongly individualized, and it is this which gives it its discreet warmth and power to attract.

By showing the body stretched out on a grey-blue drapery, Veláz-quez brings out the full subtlety of the ivories and pale pinks of the skin, and he adds a purplish red curtain at the back to give warmth to an otherwise cool palette. This is not the muted splendour of a Titian or the exuberant sumptuosity of a Rubens, it is something more intimate, with a more direct and personal appeal to the senses.

In February 1650 the Duke El Infantado, the Spanish ambassador in Rome, was asked by Madrid to inform Velázquez that Philip IV was eager for his return and expected him by May or early June. Four more messages followed, the last in January 1651, but apparently Velázquez was not yet ready to think of departure. Was it the fact that his mission

was not yet accomplished that kept him there? Or the pictures he was painting? Or indeed the 'phlegmatic' temperament which the King in his letters urged him to 'bestir'? Or it may have been simply the pleasure he took in finding himself in surroundings where artists were permitted a way of life very different from his existence at the palace. Whatever the reasons, he did not forget the main purpose of his journey and in December 1650 returned to Modena, still hoping to purchase Correggio's *Night*. We know of his visit, and the guarded reception he received, from a letter written by Gennaro Poggi, the official at the Duke's court already referred to. The Duke was away when Velázquez arrived, so he announced that he would await his return. Poggi writes to Francesco d'Este: 'I doubt that he is remaining simply out of politeness, which is why his exaggerated courtesy did not appeal to me, though His Grace may think I am at fault in this. But it is a question of the pictures, and I am too much afraid that His Grace may lose one of his very finest. He asked me at once to show him all the paintings but I told him that, to my great regret, I was unable to do this as His Grace alone possessed keys to these rooms.'[68]

108 *Venus at her Mirror* Detail of ill. 91

Once again Velázquez was obliged to leave Modena without getting what he wanted. But his persistence in the matter is indicated by another letter addressed to the Duke by his ambassador in Madrid, Ottonelli, in January 1652. 'A few days ago, the painter Diego Velasco . . . told me that His Majesty would be extraordinarily delighted if Your Grace were to present him with a fine picture by Correggio.' Having made it clear that it was the *Night* that he was referring to, he went on: 'I told him that he would no doubt remember what I had said to him on this subject while we were waiting to board ship at Genoa . . ., namely, that I would write to Your Grace who, I had been told, was strongly desirous of meeting His Majesty's wishes. But the *Night* itself was not in question as Your Grace held it, so to speak, in trust, and had solemnly vowed never to let it leave his family. I had the impression that this gave Diego pause.'[69]

This episode is worth examining because it sheds some light at least on the personality of Velázquez. On this occasion he proves himself capable of being devious, stubborn and tenacious, but of course we do not know if he set so much store by getting what he wanted because that was his nature, or because he was spurred on by loyalty to Philip IV. Probably it is fair to accept that both motives played some part.

From Modena Velázquez travelled again to Venice, and here we lose track of him. After staying in Italy for a year longer than the King had planned, and after being recalled five times, he decided to return by way of France and even to spend some time in Paris. He had already procured the necessary travel documents but in the end decided against the journey because of the continuing hostilities between France and Spain – no doubt also because Philip IV would hardly have appreciated such a detour. He therefore sailed from Genoa and arrived in Barcelona, which by then had been retaken by Spanish troops.

The late portraits

On this occasion too Philip IV seems to have welcomed the return of his court painter, and there is nothing to indicate that he was angry with him for lingering in Italy. Velázquez may have been able to persuade him that his long absence was necessary in order to purchase all the works of art that had accompanied him back to Spain, or would follow in due course. In any case, soon after his return he was given another official position, that of Aposentador de palacio (Chamberlain of the Palace). There were five candidates for the post, one of whom had the support of all the members of the council of administration at the court, but the King nevertheless appointed Velázquez. His new functions included responsibility for all the royal apartments, cleaning and heating arrangements as well as furnishing and decorating. He also had to organize public festivities, tournaments, balls, masquerades and theatrical entertainments. When the court left Madrid it was up to him to arrange accommodation for the royal family and their entourage. And there were many other daily duties which made no demands on his particular skills. They would have been well within the powers of an ordinary administrator – more suitable for an accountant than an artist. Velázquez presumably wanted the position both because it was an honour and because it brought with it spacious accommodation in the Treasury, which was an annexe to the royal palace, as well as a substantial salary (even if that was not always paid). It is possible too that he accepted the nomination at the King's request, as a further proof of his loyalty. In all events it indicates the close ties, and probably friendship, that existed between Philip IV and Velázquez. No doubt it was initially Velázquez' reliability in artistic matters, in which he himself was interested, that made the King realize he could trust him completely. He had, after all, given excellent advice on the decoration of the Buen Retiro, the Torre de la Parada and more recently the Alcázar. And he had also been the means of enriching the royal collections with a series of magnificent works such as few monarchs possessed.

1654 saw the inauguration at the Escorial of the Pantheon, a sort of burial vault intended to house the remains of all the Kings of Spain since Charles V. It was the occasion for Philip IV to present to the monastery forty or so pictures, several of which had been acquired in England at the sale of the goods of the beheaded Charles I. Others came from Italy where the Viceroy of Naples had obtained them by virtual extortion. Velázquez was asked to display them in the sacristy and in a study room. No doubt the task appealed to him as the pictures included works by Titian, Tintoretto, Veronese and Raphael, Correggio, Caravaggio, Ribera, Rubens and van Dyck.

We may well ask what time Velázquez had left for painting. No doubt rather less than he would have liked, but still enough for him to paint the portraits and compositions that rank among his greatest works.

There was a new face at court on his return from Italy, that of Queen Mariana, whom Philip IV had married in October 1649. Velázquez did not paint her at once because she was about to give birth, and even after Princess Margarita was born, in 1651, she was unwell for several months. But in 1652 she sat for a huge portrait (Musée du Louvre, Paris). Here the face is not the most important feature – which is no particular loss as it is not especially attractive. At scarcely eighteen years of age this young woman looks proud, surly, obstinate, bad-tempered and utterly lacking in spontaneity. The symmetrical braids of her enormous wig, studded with jewels, bows and ostrich plumes, encase the face in a rigid frame which does nothing to improve it. The hair style was imposed by the dictates of fashion, as was the dress, which flattens the bosom into a tight bodice and billows out around the body, hiding it completely, so that not even a hint of the human form can be detected. It is hard to imagine a more extreme negation of femininity or a more ungainly appearance.

Nevertheless, if one studies the picture for a while, one is struck less by the ugliness of the attire than by the beauty of the picture, viewed as a piece of painting. Eventually one sees the wig as a variety of blond tints enriched with pinks and corals, the swelling skirt as a large area of black enlivened by the nuances, arabesques and rhythms stated in grey braid. Note how cleverly Velázquez prevents the Queen from becoming alienated, in compositional terms, from her surroundings. With the

98

expanse of formally draped red curtain on the one side and the red tablecloth on the other, she would stand out in stark isolation from her environment, were it not for the relationships established between the colours of certain of the details: the wig, the bows of coral ribbon at her wrists, the gold brooch and chains on the bodice echoed by the little gilt clock on the table. And the rectangular, upright clock restates the stiff attitude of the Queen, and also serves to block the observer's gaze, which would otherwise tend to lose itself somewhere at the back of the picture.

A *Philip IV Wearing Armour* (Madrid, Prado) has dimensions identical to the above picture. It could therefore have been intended as a companion piece, although today it is usually regarded as the work of a pupil. But the King continued to sit for his favourite painter. And, in purely psychological terms, no more remarkable likeness exists than a head-and-shoulders portrait dating from the early 1650s (Madrid, Prado). The features bear the marks of the life the King has led. Velázquez does not go out of his way to stress the lined and tired flesh, but nor does he try to conceal the fact that the chin is heavier, the lips have lost their thick sensual fullness, and the expression is now weary and rather dispirited. Yet it is not so much the individual features that reveal the man but the urgent, rather sickly light that flickers over the face. The costume is sombre and perfectly plain. There is nothing to indicate that this is a King. In another somewhat similar portrait the 99 insignia of the Order of the Golden Fleece are displayed on the tunic, together with a few discreet ornaments, but the general effect is still of sobriety. There are a number of copies of this apparently later portrait (*c.* 1656) but none is universally accepted as authentic. The canvas in the 109 National Gallery, London, a fine painting in any circumstances, is regarded by Allan Braham[70] as an original, while López-Rey[71] thinks it no more than a 'remarkable' piece of work by an unnamed pupil, who copied it from the *Philip IV* in the Prado.

In the other portraits he painted during the 1650s, Velázquez employed an altogether richer and more varied palette. His most frequent subjects were the two princesses living at court, the young Margarita and María Teresa, the sole survivor of the children born to Isabella of Bourbon. There is one portrait of María Teresa (New York, Lehmann Collection) that may have been painted in 1648, before Velázquez left

205

for Italy. This shows the head and shoulders only and could well represent a ten-year-old girl. But there can be no doubt that a second bust portrait (New York, Metropolitan Museum, Bache Collection) was painted after the artist's return, and the same holds true for another portrait in which a large part of her dress is included – probably the whole of the garment was once shown, but the canvas has been trimmed at top and bottom.

The first of these two works depicts a girl of about sixteen, her slightly plump face discreetly lit by a faint smile. The wig looks like the one worn by Queen Mariana, but is less top-heavy and clumsy.

96, 126 The full-length portrait (Vienna, Kunsthistorisches Museum) is in many respects similar, although the Princess's head is turned more towards the observer and the wig appears broader in consequence. Her dress too conforms to the fashion of the times but is not as stiff or austere as that worn by the Queen. The background is a dark green, with patches of lighter colour, and against this the soft greys and the pinks of the trimmings have a freshness and daintiness appropriate to the youth of the sitter.

110, 111 The earliest portrait of Princess Margarita (Vienna, Kunsthistorisches Museum) must date from 1654 or thereabouts. She is standing before a dark green curtain beside a table covered with a blue cloth; she wears a long pink silk dress richly embroidered with silver, with contrasting black cuffs and collar. The costume is of as fine a texture as the satiny skin of the face and the blond hair. On the table, where her right hand is resting, is a vase of flowers, not a sumptuous bouquet but a modest bunch, in keeping with the nature of the young child. As most of the flowers are blue (including two irises), they tone with the colour of the cloth on which the vase is standing. But there are two roses, one picking up the colour of the dress, the other echoing the blond hair. These two colours provide a note of warmth in a passage which would otherwise be dominated by cool tones.

Trailing on the table in front of the vase is a white flower. It is sketched with such economy that one might say it is no more than the ghost of a flower. Presumably Velázquez saw the need for a splash of white at this point but felt it unnecessary to represent the shape of the bloom more accurately – in other words, he reacted just like a modern painter. Even Manet has never been more elliptical in his painting. In

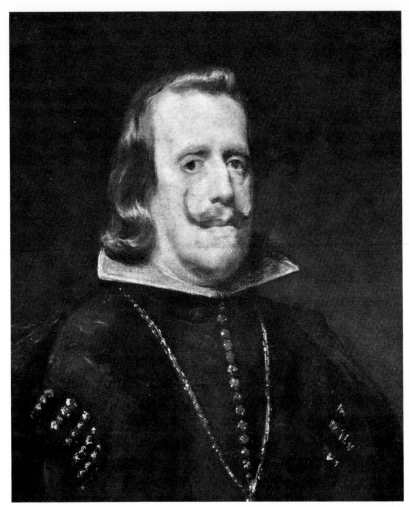

109 *Philip IV c.* 1656

the case of the *Old Woman Frying Eggs*, we saw how Velázquez 'placed' the objects in an almost Cubist spirit, but there he allowed the things to retain their own character, volume and substance; here we have vaguely suggestive patches of colour. The painting itself has become much freer and is now the prime consideration, just as it was in the art

110 *The Infanta Margarita
in a Pink Dress*
Detail

of the end of the nineteenth century, and is today. Yet there is nothing in the least casual about it: the flowers may be transformed but they do not cease to be real and alive, and one senses that they have been approached in the same mood of serious study as the early works. Not surprising therefore that this vase of flowers has such an exhilarating effect, making us want to look at it in isolation and relish its pictorial delights. And it is also a splendid complement to the Infanta, because it is full of delicacy and lyrical in spirit.

39 By comparison the 1632 portrait of *Prince Baltasar Carlos* seems rather stilted. Although the poses of the two children are similar, the portrait of the Princess has a naturalness and lightness of touch that is lacking in the earlier work, even though it too is painted with considerable freedom. And secondly, the silhouette of the Infanta is not as sharply

111 *The Infanta Margarita in a Pink Dress* 1654

112 *The Infanta Margarita* 1656

outlined as that of Baltasar Carlos: it is better integrated with its sur-
roundings, helped in large measure by the red and blue patterned carpet
spread over the floor.

112 Velázquez painted Margarita again in 1656 (Vienna, Kunsthistori-
sches Museum). Here too she is wearing a dress cut like the gowns of

113 *The Infanta Margarita* 1659

her mother and half-sister, María Teresa. But the bodice and farthingale are better proportioned and the arms are held symmetrically away from the body, making a more coherent ensemble. In no other portrait does Velázquez combine the large and small volumes of a dress with such eloquence. The strictness of the proportions is tempered by the alert

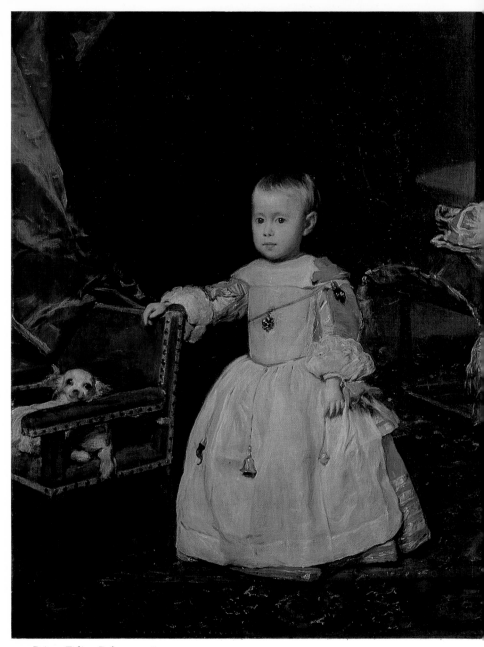

114 *Prince Felipe Próspero* 1659

115 *Las Meninas* Detail of ill. 118

and airy brushwork and the subtle use of colour. The dominant pale grey is a much fresher shade than in the portrait of María Teresa in the same museum, more luminous and even more glowingly alive.

113 Three years later the Princess again posed for Velázquez (Vienna, Kunsthistorisches Museum). This time she wears a blue velvet dress much more like the one worn by the Queen, except that there is not quite so much silver braid and it is more fluently drawn, and the puff sleeves are more rounded in shape. The effect is nothing like as stiff and severe as it was before. With its curving lines and iridescent materials, the picture has none of the mere application evident in the portrait of Mariana. By now Velázquez' skill has developed to the point where he is able to show the Princess holding something as clumsy as her big rectangular muff without in the least detracting from her girlish grace. He sets up a connection between the chestnut brown of the fur and the similar tones of the furniture in the background on the left. This furniture is shrouded in shadow so that its verticals and horizontals provide the discreetest of contrasts with the dominant curves of the human figure. The haziness of the background serves to place the emphasis on the Princess, but at the same time has a mysterious life of its own, which could not have been achieved if the objects had been either precisely delineated or excluded altogether, leaving an expanse of a single colour.

The finest portraits of the Infanta Margarita are found today in Vienna. They were sent there originally for a specific purpose, the Princess being the intended bride of Emperor Leopold I. He was eleven years older than she and the intention was that he would become acquainted with his future wife through the pictures, and so be able to follow her development even while she was still a child.

95 There is a further portrait of Margarita (Madrid, Prado) which raises a number of questions. It is generally held that Velázquez had a hand in it but was not the sole artist. Yet there is no denying that the dress, wider and bigger than ever, is sheer delight for any eye capable of appreciating its pictorial beauty. The greys and pinks are so subtly combined, juxtaposed with such accuracy and freedom, that it is hard to see who but Velázquez could have painted them.

What is particularly striking in this work is the curtain at the Infanta's side. The heavy material, the splendour of the draping, the gold embroidery picked out on the purple, combine to give an effect of

214

116 *Prince Felipe Próspero* Detail

positively imperial magnificence. There are two possible explanations: either the artist was making an allusion to the Infanta's future role, or this section of the picture was painted after she had become Empress (her marriage took place in December 1666). If the latter, the painting must have been completed after Velázquez' death.

Together with the portrait of the Infanta in a blue dress, the court of Madrid sent to the court of Vienna a portrait of a baby boy. This is *114, 116* Felipe Próspero (Vienna, Kunsthistorisches Museum), born 20 November 1657, and only two years old when he was painted by Velázquez.

117 *The Tapestry Weavers* or *The Fable of Arachne* 1657?

Blond and with a waxy complexion, his sickly constitution is immediately apparent – he in fact died towards the end of 1661. The greyish white pinafore, largely covering the pink gown trimmed with grey, accentuates the pallor of his skin and his air of fragility. The way his hand hangs limply over the chair-back again emphasizes his lack of strength. The child has none of the authoritative gestures and bearing

of Baltasar Carlos at about the same age. He is already tired of his young life and ready to return to the oblivion from which he had recently emerged. The expanses of red to either side of the Prince (the curtains, chair, cushion on the table and carpet) are also without lustre. They add a touch of warmth to the picture, but dominating it all is still that large pale surface area of the pinafore.

The white dog lying half hidden on the chair plays an analogous role to the dwarf in the portrait of Baltasar Carlos, although its significance is different. The alert little animal, so agile and playful, makes one even more conscious of the child's disadvantages. In addition, the dog's white coat picks up the colour of the pinafore in a passage where reds predominate, thus helping to stress the particular tint that best reflects the Prince's anaemic condition – which Velázquez' sense of honesty did not permit him to conceal. Once again the choice of palette is conditioned both by the reality that has to be conveyed and by the exigencies of compositional harmony. In other words, what at first sight appears to be no more than an anecdotal detail proves on closer examination to have a twofold validity, serving both life and art.

This sensitive and infinitely expressive work is almost certainly the last picture painted by Velázquez. It is also one of his most affecting and most admirable canvases.

The great compositions

None of Velázquez' works is more famous than the great painting of 1656 which was called *The Royal Family* in the seventeenth century, but is now more commonly known as *Las Meninas* or *The Maids-of-Honour* (Madrid, Prado). Two of these maids-of-honour appear in the picture, one on either side of the Infanta Margarita. One is sketching a curtsey, the other is kneeling and offering the Princess a red terra cotta pot on a gold plate. In spite of the formality of their attitudes there is nothing forced about the scene. Its spontaneity is emphasized by the presence of a lively young dwarf prodding a big sleepy dog with his foot. To one side of him is his female counterpart, who turns towards us her over-heavy face, ill-tempered and prematurely aged, making the Infanta's features look as luminous and pretty as a fairy tale. But Velázquez does not stress the contrast, any more than he does elsewhere. He simply states it. There is nothing of the Expressionist about Veláz-quez. He is well aware that it is possible to be profoundly moving even when speaking in a quiet voice, that a well-articulated whisper can have an effect as great as, or greater than, a violent outburst.

Much of the picture's power lies in its quality of silence. We are face to face with nine people, none of whom says a word – the only exception being the maid-of-honour dressed as a nun, who is addressing some subdued comment to her neighbour, the *guardadamas*. Even he does not appear to be listening, or at any rate his thoughts are elsewhere and he is looking away. Nearly all the others are facing in the same direction. At first we think we ourselves are the object of their attention (as in certain of the early works) but we soon realize that is not the cor-rect interpretation, either of the characters or of the picture as a whole. Their eyes are not turned towards us but towards Philip IV and Queen Mariana, whom we should imagine to be standing in the place we our-selves occupy. They are posing for Velázquez, who stands with his paintbrush in one hand and his palette in the other, in front of a huge

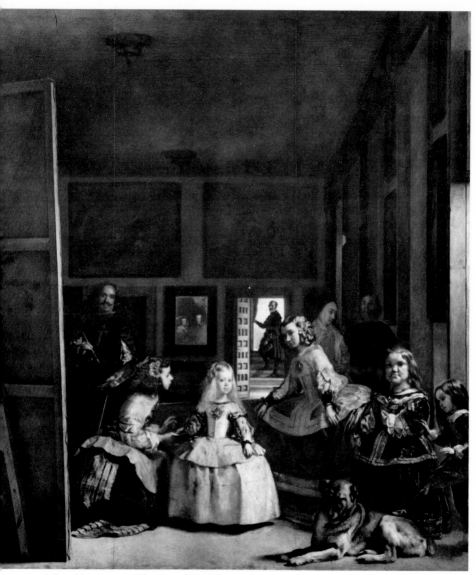

118 *Las Meninas* or *The Royal Family* 1656

canvas which we see only from the back. We would not know that he is painting a portrait of the royal couple (and in fact no such portrait has been discovered) if it were not for the mirror at the back of the room, in which the King and Queen are reflected. By a bold stroke, Velázquez reduces to a blurred reflection the very people who are the focus of all these eyes, the objects of attention, and the reason for the presence of all those we see assembled together in the picture. It is an ingenious device to give weight to the minor characters and turn into insubstantial ghosts the two who, in reality, occupied the dominant position.

True, the idea of using a mirror in a painting was not new. Jan van Eyck had employed the device in the *Arnolfini Marriage Group* (London, National Gallery), a picture which Velázquez must have known as it was then part of the royal collection in Madrid. In the van Eyck the mirror serves a dual function: it shows the backs of figures who would otherwise be visible only from the front, and it shows the area of the room in front of these figures, containing two other persons who have entered the room for some purpose that remains obscure. There are other works in which a mirror and a window are employed as a means of introducing an area of skyscape or a street scene into an interior. But the mirror is normally used to bring in some subject of purely secondary significance, which echoes the main theme of the picture. In *Las Meninas* the expressions on most of the faces, and indeed the whole composition, hinge on what is to us no more than an intangible reflection.

One might say that Velázquez hints at the existence of two kinds of reality, even two degrees of realism: that which exists only for the eyes to see and that which can be both seen and touched; an image which is pure illusion, and living beings whose bodies appear solid and firmly planted in space. And there is another variety of intangible image, apart from the mirror reflection. The upper section of the back wall is occupied by two large paintings. They are shrouded in shadow but it has been possible to identify them as copies of Rubens' *Pallas and Arachne* and Jordaens' *Apollo and Marsyas*. Here too there is illusion and reality, the realm of myth and the realm of painting; but the latter, although it refers, like the mirror image, to people and things with a purely visual existence, nevertheless presents a totally different appearance.

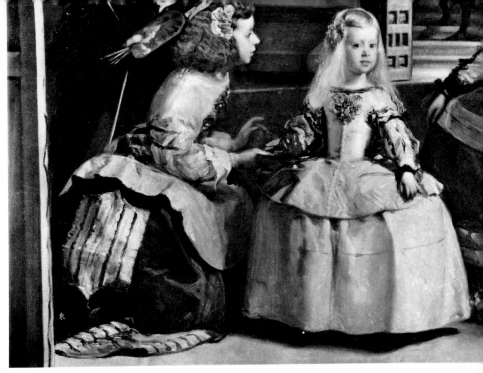

119 *Las Meninas* Detail of ill. 118

The two Flemish pictures are not there merely to provoke reactions and speculations of this order. And they do more than indicate the large number of works of art in the royal palace at Madrid (others can be seen between the windows and pilasters). The undeviating verticals and horizontals of their black frames provide a contrast to the gentle irregular curves developed in the figures of the foreground. More or less everything connected with the palace and its decor, the environment in other words, has a rigid and severe structure, while the human figures provide the fluidity and warmth (albeit understated) of life. For example, a curve can be traced sweeping down from the artist's head, across to the Infanta, back up to the curtseying maid-of-honour, on to the *guardadamas* and down again to meet the canvas edge beside the dwarf's head.

Velázquez does however mitigate the severity of the straight lines by shrouding the back of the apartment in shadow. This also prevents the vast, tall room from seeming too cold, and at the same time makes it contribute to the powerful mood of silence which emanates from the picture. Even at its brightest, the light is without intensity. It is a sort of blond colour, or more accurately perhaps ash blond or pale grey, slightly warmer in tone at the point where it enters the room. It is subtly changed as it brushes against people and objects. Its principal function is of course to illuminate the Infanta, lying like a dew on her face, hair and dress, flooding over her with gentle warmth. Velázquez, however, had not forgotten that he is painting an interior scene with a large cast of actors rather than the portrait of a single person, and this is still not the brightest area of light in the picture. Even with the help of the parallel lines drawn to a vanishing point on the right-hand wall, we would still find it hard to assess the room's depth, were it not for the open doorway at the back which reveals an area of yellowy-white light. This is the most brightly lit passage of the painting – it would in fact be too bright, almost like a hole in the picture, if Velázquez had not introduced in front of the aperture the figure of a man, his flattened silhouette standing out sharply against the glare. He is another *aposentador*, the Queen's Chamberlain, and Velázquez included him in the picture not – or so it would appear – because he was actually present at the relevant time, or even because he wanted to introduce another figure arrested in mid-movement, but in order to graduate the light he needed for his composition. First he needed to lighten the background, so as to dissolve the shadows veiling the objects and tending to destroy the sense of perspective. Then he needed to obtain two contradictory yet complementary effects: first, to convey the distance between the background and the foreground, and second, to show the connection between the two, or in other words, to make us conscious of space. The second effect he achieved by the distribution and quality of the light, the first by the reduced size of the man in the doorway.

The picture's unity does not depend solely on the use of light, the palette too plays an important part. Many of the colours are muted, so that the overall impression is of a variety of different shades and hues. The greys lighten or merge into yellows, or darken into blues and greens. They are exquisitely pretty but never insipid or anaemic.

120 *Las Meninas*
Detail of ill. 118

Quiveringly alive and perfectly judged, they allow the other colours to stand out with clarity but without overwhelming the rest. The problem of how to use the reds is neatly solved. Realizing that they must not be too emphatic, Velázquez diminishes their power, first by confining them to relatively small areas, so that they are not too dominant, and secondly by dispersing them in such a way that they balance each other and lead the eye from one figure to the next.

The lightness of the touch in this composition is not in itself surprising. It is the rule rather than the exception in the paintings Velázquez

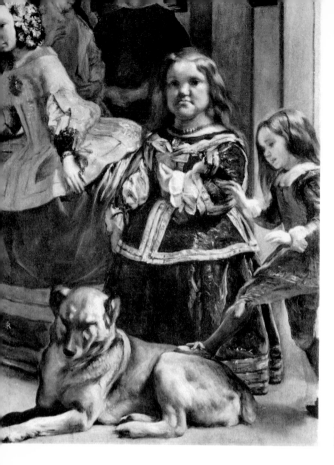

121 *Las Meninas*
Detail of ill. 118

executed towards the end of his life. Yet it deserves to be mentioned in this case because the canvas measures 318 × 276 cm. It could not therefore have been painted quickly, and the artist must have had to maintain over a period of weeks the verve and freshness that normally come only with spontaneity.

122 Together with all its other splendours, *Las Meninas* contains the only self-portrait of Velázquez which can be identified with certainty (although it was not the only one he painted, for there is documentary evidence that others existed, and in some cases we possess copies). It is interesting to see how he chooses to depict himself, what idea he wants us to have of him and his role. His general air, and especially his dress,

224

do not correspond at all to the image a painter normally likes to present of himself. One would be more inclined to think it is a courtier standing there. Long well-tended wavy hair frames the oval face, which becomes wider towards the chin; the two arcs of the moustache look, somehow, a trifle out of place. The expression is serious and alert, the eyes watchful. The mouth is melancholic, gloomy almost, but the upright bearing indicates that Velázquez was conscious of his own worth. No hint of ostentation however; dignity but not self-importance. The cross of the Order of Santiago, which is picked out in red on the black costume, cannot be of the same date as the rest of the picture as Velázquez had not been given the Order in 1656; it was awarded to him some three years later.

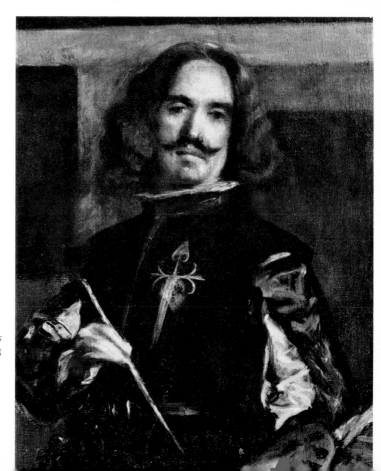

122 *Las Meninas*
Detail of ill. 118

It was shortly after he had finished *Las Meninas* (according to most accounts) that Velázquez embarked on another large-scale composition

117 known as *The Tapestry Weavers* (Madrid, Prado). It was damaged by the palace fire of 1734 and then added to on all four sides when it was restored – by as much as fifty centimetres at the top. The theme of the picture raises certain problems. Is it, as was long believed, a scene observed from life in a workroom of the tapestry factory of Santa Isabel in Madrid? Or is it *The Fable of Arachne*, which is the alternative title suggested by certain modern exegetists, who believe that it is the painting listed under that title in an inventory of 1664? If the latter, Velázquez must have taken his subject from Ovid's *Metamorphoses*, in which it is told how the Lydian woman Arachne was so skilled in the art of weaving that her reputation spread far and wide. Nymphs deserted the rivers and vineyards to come and admire her works. But she became proud and denied that she was the pupil of Pallas Athene, even announcing that she was not afraid to compete with the goddess herself. The goddess took offence and, disguised as an old woman, invited Arachne to beg forgiveness for her presumptuous words. But the Lydian woman was unyielding and repeated her defiant boast. Athene then threw off her disguise and revealed her divinity, and the contest began. The goddess chose to represent the fate of men who had dared to match themselves against the gods, while the workgirl depicted gods who had assumed the forms of human beings or animals in order to achieve their ends. Naturally Pallas Athene emerged the victor and, as the humiliated and enraged Arachne knotted a cord about her neck in order to hang herself, she turned her into a spider.

What does Velázquez make of this story? Among the five workers

123 in the foreground is an old woman at a spinning wheel. She, we are told,

124 is Athene in disguise. A younger woman with her back to us is winding wool, and we are asked to believe that this is Arachne. On a dais at the rear another woman and a person in a helmet are engaged in conversation, making animated gestures. Again Arachne and Athene – or so we are told. Behind them is a tapestry – but is it really behind them? Judging by the upper halves only of their bodies (all that is visible in the case of Athene), one would be inclined to think they actually form part of the tapestry; Arachne's feet, however, contradict this impression as they are clearly in front of it. According to López-Rey,[72] the tapestry

depicts *The Rape of Europa*, after the Titian then in the possession of the Spanish King (and today in the Gardner Museum, Boston). It is a plausible theory, judging by the few details that can be made out. And *The Rape of Europa* was certainly one of the subjects chosen by Arachne to prove that in certain circumstances the gods were obliged to take human form in order to get what they wanted.

There remain the three women in contemporary dress, who are plainly in front of the tapestry. These, we are told, represent the Lydians admiring the work of their compatriot. Or another interpretation is that, together with Arachne, they personify the four arts: music (hence the viola de gamba on the left); painting (Arachne); sculpture and architecture. And so on. The picture has aroused much speculation, and in the final analysis it tells us nothing. Velázquez has apparently chosen not to present us with a story that is decipherable in all respects: he prefers to leave us uncertain about the position and even reality of the two background figures (the two who have been identified by some with Athene and Arachne). This tendency to set up a confusion between palpable reality and painted illusion is something we have previously had occasion to note in Velázquez' work.

We know too that when Velázquez represented a mythological theme he liked to transpose it into an everyday setting. And it is always what an artist does with his subject that is more significant than the choice of subject itself. However one interprets this scene, it contains many passages, and in particular the workroom in the foreground, of a realistic character. It is not surprising that the work has been regarded as a genre picture – and indeed those who have taken this view have understood rather better than most the nature of Velázquez' concerns.

It goes without saying that the mood of the picture is quite different from that of *Las Meninas*. With these working women there are no formal poses, just the basic movements appropriate to their craft. No reverential silence, instead the humming of the wheel and the sound of words being exchanged. Instead of the lofty proportions and severe articulation of a palace apartment, the bare, dark and gloomy walls of a workroom. Only the niche at the back is brightly lit so that the colours of the tapestry stand out. The 'poetic' atmosphere of the area where the finished work of art invites admiration provides a contrast to the prosaic nature of the workplace itself. There is a similar opposition in the

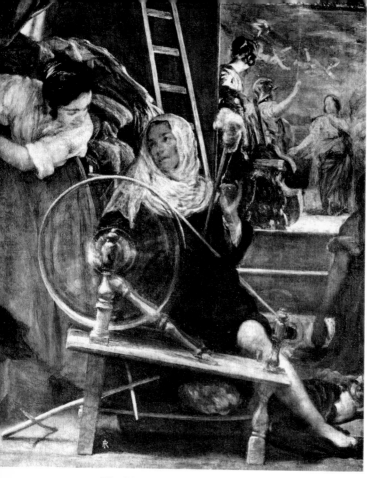

123 *The Tapestry Weavers* Detail of ill. 117

characters. While the weavers are sitting upright or bent over their work, according to their tasks, and neither their faces or garments are in any way glamorized, the women on the dais have all the elegance of the idle rich. It is immediately apparent to which class each group of women belongs. But there is no reason to believe that Velázquez is deliberately contrasting the situation of the working women with that of the aristocracy in order to make a point about social equality. Once he painted fools and cripples, now he chooses to paint this scene. For

him it is simply another facet of life, which he considers with his habitual sympathy and seriousness.

Once again the contrasts between foreground and background do nothing to detract from the pictorial unity. There are enough patches of brightness in the clothes of the workers to balance the luminescence of the tapestry, which in turn contains enough pink and blue to link up with the women at their tasks. But the shades of colour in the niche are pale and ethereal, while the workroom is dominated by reds, blue-green and black. For the weavers near to us Velázquez employs a more or less straightforwardly descriptive approach, but his handling of the

124 *The Tapestry Weavers* Detail of ill. 117

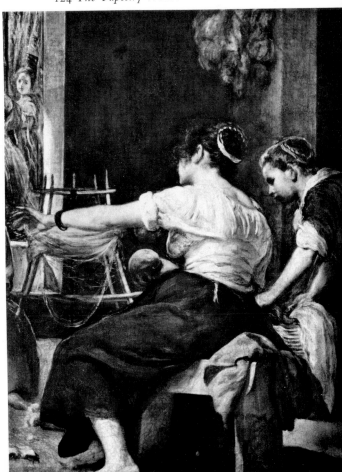

background is merely allusive. Instead of modelling the bodies he is content to evoke them with trails of colour along which the light flows and glistens. Once again the parallel with Impressionism is irresistible.

Throughout the composition the light is less static than in *Las Meninas*, the gestures and movements more numerous. Arms are raised or reach in opposite directions; bodies lean over, or turn to one side, showing torsions which have been compared to the work of Michelangelo. There are many curving lines, a sinuous bending of nearly every contour, and innumerable folds in the garments. One might almost call the style Baroque. Of all Velázquez' works it is this one which best justifies that epithet. But it must again be emphasized that Velázquez was not an artist who gave way to wild impulses. he always knew exactly what effect he wanted to achieve.

125 *Mercury and Argus c.* 1659

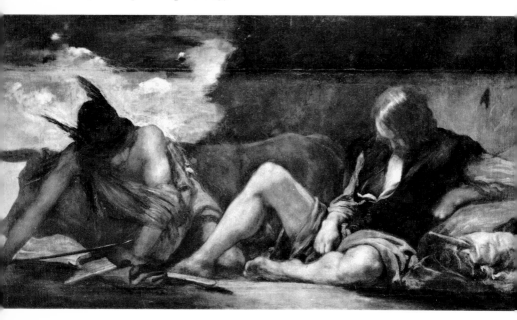

In or about 1639 he painted for the Hall of Mirrors in the Alcázar four pictures which are based, without any possibility of doubt, on mythological themes: *Apollo Slaying Marsyas*, *Psyche and Cupid*, *Venus and Adonis* and *Mercury and Argus*. All except the last (Madrid, Prado) *125* were lost in the palace fire of 1734. As one would expect, the mythological figures have become ordinary people. Argus is just a herdsman who has fallen into a deep slumber, uncomfortably propped up rather than reclining at ease. Mercury is some kind of brigand moving stealthily towards him, holding in one hand the sword with which he plans to slay him. Io, changed into a cow, could not be more indifferent to the proceedings if she were made of clay. The evening sky emits no more than a feeble glow of light. The colours too are sombre, greys and browns, and a sort of purplish drapery over Mercury's shoulder. It is not a work which fully engaged Velázquez, and it is far from having the poetry and pictorial enchantment of *Las Meninas*, *The Tapestry Weavers* or the late portraits.

A final assessment

It was no easy matter for Velázquez to obtain the cross of the Order of Santiago, which he wears in *Las Meninas*. Philip IV wanted him to have it but it was still necessary for the Chapter of the Order to investigate his case and establish that he fulfilled all the conditions for entry. Velázquez had to call witnesses to testify that his blood was pure, which in practice meant that he had no Moorish or Jewish blood; that his ancestors were members of the nobility and, as far back as his grandparents' generation, had never been engaged in business or practised a 'vile profession'; and finally, that he himself had never painted for financial gain. Strictly speaking, no one could deny that he had executed portraits which had been paid for by private clients. Nevertheless his fellow artists Zurbarán, Alonso Cano and Nardi swore that he had never received a fee except from the King and had never painted except for the King's pleasure. The investigation opened in June 1658 and went on for several months. Finally, after hearing over one hundred witnesses, the Chapter reached the verdict that Velázquez had failed to establish his noble descent on the maternal side. Philip IV was obliged to apply to the Pope for a special dispensation in the matter, and it was not until November 1659 that the artist was granted the right to wear the insignia of the Order of Santiago.

There is no doubt that Velázquez longed for this particular decoration, implying as it did official recognition of his nobility. While in Rome, after painting the portrait of Innocent X, he had begged the Pope to intervene on his behalf and secure for him a Spanish military order. We might deduce from this, as Ortega y Gasset does,[73] that Velázquez' overriding concern, throughout his career, had always been to rank among the nobility. In fact there is no evidence to support this view. All we know for certain is that he coveted the Order, in the same way as he had welcomed his increasingly elevated position at court.

Was it because these various promotions were an honour? And if so, did he desire honour for its own sake, or did he think it worth having only because he knew it mattered to others, and that his palace functions would ensure him a consideration he could never win through his painting? We are simply not in a position to judge. All we can say is that in the only painting based on a scene observed at the palace, and in which he himself appears (*Las Meninas*), he represents himself as an artist, brush in hand; this would seem to indicate that it was this role which mattered to him most; but on the other hand we know that he fulfilled his other duties in a conscientious manner, like the responsible court official he also was.

The last knowledge we have of him is in connection with his duties as Chamberlain. The Infanta María Teresa was to be married to Louis XIV of France, and it was planned that the couple should be united on the Isle of Pheasants on the River Bidassoa, not far from the French frontier. Velázquez was given the task of making the travelling arrangements for Philip IV and all his entourage. It was a journey of twenty stages, which meant that he had to find accommodation for everyone twenty times over. He set out in advance of the King on 7 April 1660, carried on a litter, and arrived at the island three weeks later. He then had to decorate the hall in which the Princess would be given in marriage to Louis XIV, and also the adjoining rooms (having brought with him from Madrid for this purpose a number of tapestries to hang on the walls). The ceremony took place on 7 June. Velázquez was present, and Palomino describes his delight, and also the elegance and nobility with which he distinguished himself.[74]

The following day the party left again for Madrid, arriving on 26 June after a further journey of twenty days. Velázquez' family had particular cause to welcome his return as a rumour had reached them that he was dead. Certainly he was tired but felt in good health, as he wrote in an otherwise unimportant letter of 3 July. But on 31 July he was attacked by a fever, sickness set in, and the doctors summoned by Philip IV rapidly reached the conclusion that they were powerless to help. The end came on 6 August in the early afternoon. Velázquez was just over sixty-one years old when he died. Wearing the robes of the Order he had so coveted, he was placed in his coffin and buried at the Parish Church of San Juan Bautista in Madrid, in the presence of

representatives of the court and nobility. Eight days later his wife died as well, his faithful and discreet companion for the major part of his life, and she was buried at his side.

It was as Chamberlain of the Palace and Knight of the Order of Santiago that Velázquez was honoured at his death. But it is of course as a painter that he is viewed by posterity. Many have regretted that the two roles, artist and courtier, were necessary to him, that he was content to give to the one role time and energy we might wish had been spent in creative activity. That at least is one's initial reaction as one learns in what circumstances he led his life and produced his paintings. But there is another aspect to it. Velázquez' responsibilities at the palace did free him from other obligations which might easily have been less conducive to his art and his particular kind of genius. Undeniably the court was a place where his talent could flourish. Indeed we should recognize that in seventeenth-century Spain it was the only place where it could flourish. Velázquez' sole master was the King, who trusted him, so that he was in effect his own master. He may not have been free to paint what he wanted, but he was free to paint how he wanted. There was no need to take into account the reactions of clients or the exigencies of reputation. We have seen how Velázquez is quick to take offence when jealous men try to denigrate his work, but he is not fundamentally troubled, and certainly does not allow himself to be deflected from his chosen course.

Astonishingly enough, it is in precisely the genre that imposes the most constraints, namely portraiture, that he appears most free. He does not evade the constraints. As we have seen, his style is respectful and his aim was always fidelity to life. He respects too the personalities of his sitters. He never makes use of them to express his own feelings. Nor does he attempt to lay bare their souls, in the fashion of the Expressionists. One is tempted to say that he approaches his task with detachment – except that it is, on reflection, more a sense of discretion that makes him refrain from delving more deeply. It would be quite wrong to think that he is indifferent to the humanity of his sitters. The

103, 51, 72 76, 24, 56 portraits of Pope Innocent X and Olivares, some of the jesters, the *Boy of Vallecas*, and the pictures of the Infante Don Carlos and Philip IV as an older man, are very revealing indeed and repay a leisurely examination. Velázquez does not make the psychological complexity of his

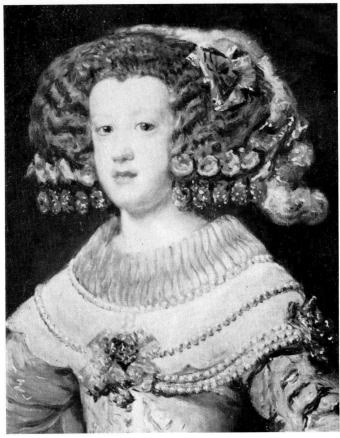

126 *The Infanta María Teresa* Detail of ill. 96

characters explicit, but he allows it to be glimpsed. He rejects both sentimentality and melodrama out of hand.

There are many traps in wait for the painter of official portraits: pomposity in the presentation; the worldly elegance of the costumes; the emptiness that lies beneath the mask of respectability or prettiness; flattery or special pleading; the attempt to establish complicity with the observer. Velázquez avoids all these pitfalls. He depicts beautiful materials and richly decorated garments, but his paintings never appear frivolous. Nor are they ever affected or insipid, even though some of

his works are delicate in the extreme. The portraits indicate an attitude of deference but never the least hint of obsequiousness – further proof of Velázquez' nobility of mind, if not of birth. Even in Seville he was dignified and serious, and remained so throughout his career. We must also recognize in him one of the most aristocratic of painters, not because he painted Kings and Queens, Infantes and Infantas, but because of his distinguished and discriminating sensibility. Life at court may have provided the conditions for this sensibility to develop, but it certainly did not create it.

Velázquez shows equal restraint in his handling of light. He gives many examples of his ability to deploy light with the maximum of expressive power, but he is not one of those artists who use violent or deliberately enigmatic effects in order to give their subjects a more unusual, mysterious or demonic appearance. No one can have had less interest than he did in seeking after effect for its own sake, or made less use of striking presentations in order to seem original. Certainly he possessed a high order of compositional skill, but he was at pains to conceal his art and tried to give his painting that natural quality which seems to emerge from the randomness of life rather than the conscious will of the artist.

In trying to achieve an air of objectivity, Velázquez is simply putting into practice the style most suited to his particular genius. It is always apparent that contact with the real world, and the need to give a faithful account of it, lends him wings, while the need to use his imagination merely hampers him – imagination, that is, in the modern sense of the term, meaning the faculty of conjuring up images. There is another sort of imagination of a pictorial order which Velázquez possessed in the highest degree, and which consists in inventing harmonies of colours and forms, and embodying them in what might be termed 'symbols'.

There are painters who define objects with precision, enclosing them in rigid contours. They do not actually employ a formula for painting, say, an eye or a hand, but the forms are so concisely drawn that they come near to being that. In his early days Velázquez adopted a similar approach. In the first of the court portraits a precisely drawn line delineates the eyes and mouth, and the flesh is rounded out firmly under a taut skin. Then, in the mid-thirties, the lines and volumes become blurred, and the paint is used less consistently. The new freedom is more

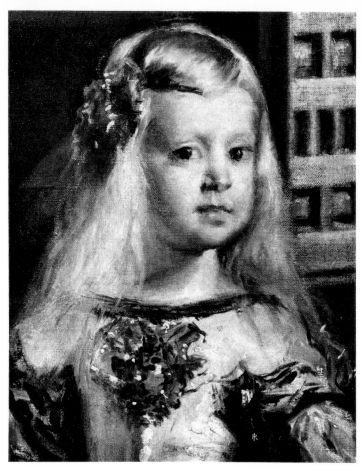

127 *Las Meninas* Detail of ill. 117

apparent in the hair and clothes than in the faces. Whenever Velázquez paints a dress, a ribbon, a head of hair or a hat, he reinverts his style, makes use of new 'symbols'. They are so allusive and traced with such élan that they would be impossible to repeat. Between one work and the next they have nothing in common but their dazzling evocative power. Seen from close to, they look approximate and arbitrary, but from a distance they are perfectly judged. They have a dual function, both suggesting the objects themselves and acting as a calligraphy.

Of course, no great painter, not even a so-called Realist, represents reality 'as it is', but a reality that is metamorphosed and probably enriched in the transformation. But Velázquez, more than any other painter, takes us out of the world of objects and into the world of painting, inviting us to discover its objective delights, never to be confused with those of the external world. When we examine one of his paintings we should not, therefore, dwell too much on the theme or the content of the picture. Of course *Las Meninas* can be read as a representational image, and it can for example be said that the Infanta Margarita has the finest, silkiest hair imaginable, but we should also note that the blond colour is rendered in a grey-yellow so filmy and subtle as to be positively miraculous. In the same way, the jewels and ribbons decorating the dresses are both renderings of what the painter saw actually before his eyes, and they are also composites of coloured blobs and palpitating strokes of the brush.

Sometimes it is sufficient to consider an artist's palette purely in terms of colours and harmonies. In the works painted by Velázquez after 1630 it is also necessary to consider the handling. He uses strokes that are light yet firm, inspirational yet supremely controlled, to impart lustre and life to his painting. And we should guard against seeing the brushwork as a purely technical aspect of creativity: it does not merely record the activity of the artist's hand, it also embodies his sensibility and vision. The brushwork here is of an allusive nature which indicates that, for Velázquez, objects were ultimately no more than visual phenomena, to be viewed from a point somewhere in the distance. Even in his early works, where he tended to lay stress on the size of objects, he rarely showed any familiarity towards what he was painting. Life at the palace reinforced this tendency. There one was expected to keep one's distance – and Velázquez' brushwork shows how literally he learned that lesson. His portraits too, and in particular the later ones, force the observer to stand some distance away in order to obtain the full effect of the hair styles, costumes, etc., to see objects and not just patches of colour and passages of paint. Though these too repay study, as we then realize that the effects produced by these patches of pigment, flourishes and scrawls are little short of miraculous. If the word magic had not been devalued, it would perfectly describe this transformation of reality by a radical blend of discretion and enchantment.

Chronology

Notes

Short Bibliography

List of Illustrations

Index

Chronology

1599 Birth in Seville of Diego Rodríguez de Silva y Velázquez; baptized there on 6 June. Between 1601 and 1617 his parents, Juan Rodríguez de Silva and Jerónima Velázquez, have six more children, five boys and a girl.
Birth of van Dyck.

1600 Rubens goes to Italy and stays for eight years.
Birth of Claude Gelée (Claude Lorraine).

1601 Birth of Alonso Cano.

1602 Birth in Seville of Juana de Miranda, daughter of Francisco Pachecho and later the wife of Velázquez.

1603 Rubens visits Spain for the first time.
Shakespeare writes *Hamlet*.
Birth of Elisabeth of Bourbon, daughter of Henry IV of France and Marie de Médicis, later the wife of Philip IV, and Queen Isabella of Spain.

1604 Cervantes finishes *Don Quixote*, and the first part is published in the following year.

1605 Birth in Valladolid of the future Philip IV.

1606 Birth in Valladolid of the Infanta María, sister of Philip IV.
Birth of Rembrandt.
Birth of Corneille.

1607 Birth in Madrid of the Infante Don Carlos, brother of Philip IV.

1608 Rubens leaves Italy and returns to Antwerp.

1609 A twelve-year truce is concluded between Spain and Holland, who have been at war for the past thirty years.
Philip III begins the expulsion of the Moriscos from Spain.

1610 Velázquez enters the studio of Francisco Pachecho (1564–1644) as his pupil. Probably he has previously worked for some time under Francisco Herrera the Elder (before 1600–1657?).
Death of Caravaggio (born 1573).
Death of Henry IV of France, who is succeeded by Louis XIII. Marie de Médicis becomes regent.
Galileo publishes *Siderius Nuncius*.

1611 Pachecho signs a contract with Velázquez' father to teach Velázquez painting for a period of six years, starting 1 December 1610.
Pachecho visits Toledo and meets El Greco.

1612 Having painted the *Raising of the Cross* in the previous year, Rubens finishes his *Descent from the Cross*, both works being destined for Antwerp Cathedral.

1613 Francisco de Zurbarán (born 1598) comes to Seville to study painting under Pedro Díaz de Villanueva. He stays there until 1616, meets Velázquez and becomes his friend.
Cervantes publishes his *Novelas Ejemplares*.
Birth of La Rochefoucauld.
Valentin de Boullogne (born 1591) takes up residence in Rome.

1614 El Greco dies in Toledo.

1615 The Count of Olivares is invited to the court of Philip III as Gentleman of the Bedchamber to Philip, his son and heir.
Marriage of the future Philip IV to Elisabeth (Isabella) of Bourbon, daughter of Henry IV of France.
Marriage of the Infanta Anna, Philip's sister, to King Louis XIII of France.

1616 Alonso Cano becomes a pupil of Pachecho.
Death of Cervantes.
Death of Shakespeare.
The Church forbids Galileo to teach that the earth revolves around the sun.

1617 Having completed his apprenticeship, Velázquez is examined by Pachecho and Juan de Uceda and is admitted into the Sevillian Guild of Saint Luke.
Zurbarán leaves Seville and takes up residence at Llerena in Estremadura.
Birth of Murillo.

1618 Velázquez marries Pachecho's daughter. He paints the *Old Woman Frying Eggs*.
Ferdinand II becomes Emperor.
Start of the Thirty Years War, in which Spain later joins forces with the Emperor. Their principal opponents are the Swedish, under the command of Gustavus Adolphus, and France, governed at first by Richelieu, then by Mazarin.

1619 Birth of Francisca, Velázquez' first daughter. He paints *The Adoration of the Magi*.
The Infante Fernando becomes a cardinal and Archbishop of Toledo.

1620 Velázquez paints the portraits of *The Priest Cristóbal Suárez de Ribera* and *Mother Jerónima de la Fuente*.

Georges de la Tour (born 1593) takes up residence in Lunéville.

1621 Birth of Ignacia, Velázquez' second daughter, who dies sometime before 1634.

Death of Philip III and accession to the throne of Philip IV, who appoints Olivares as his Prime Minister.

Resumption of hostilities between Spain and Holland.

Death of Archduke Albert, governor of the Spanish Netherlands, who is succeeded by his wife Archduchess Isabella.

1622 Velázquez goes to Madrid, hoping to be appointed as court painter. He is unsuccessful but paints the portrait of the poet Luis de Góngora (born 1561). After visiting the Escorial and, probably, Toledo he goes back to Seville.

Birth of Valdés Leal.

Birth of Molière.

Rubens goes to Paris to plan his Marie de Médicis cycle of paintings, now in the Louvre.

Richelieu is made a cardinal.

1623 At the invitation of Olivares, Velázquez returns to Madrid. On 30 August he finishes his *Portrait of Philip IV* and on 6 October is appointed court painter. He installs himself permanently in Madrid, together with his family.

Velázquez paints the portrait (now lost) of the future King Charles I of England, who had visited the court in connection with his projected marriage with the Infanta María.

Birth of Pascal.

Cardinal Barberini is elected Pope. He takes the name Urban VIII.

1624 Velázquez paints full-length portraits of Philip IV and Olivares.

Death of Luis Tristán (born 1586?).

Poussin (born 1594) takes up residence in Rome.

Richelieu becomes prime minister.

1625 Velázquez paints a second full-length portrait of Olivares.

The Spanish forces, commanded by Spínola, force the Dutch to surrender the town of Breda.

The English are repulsed in the attempt to take Cadiz.

Wallenstein is given command of the Emperor's armies.

1626 The Dutch found New Amsterdam (the future New York).

1627 Philip IV arranges a contest between the artists Carducho, Caxesi, Nardi and Velázquez, the theme chosen being *The Expulsion of the*

Moriscos. A jury consisting of Mayno and Crescenzi designate Velázquez the winner. His painting is now lost.

Velázquez is named Usher of the Royal Bedchamber, his first duty as a court official.

At about this time he paints a further full-length portrait of Philip IV, and also the portrait of the Infante Don Carlos.

Death of Sánchez Cotán (born 1560).

After two previous visits to Italy, Claude Lorraine takes up permanent resident in Rome.

Death of Góngora.

1628 Rubens arrives in Madrid in August and stays until April 1629. Although undertaking a diplomatic mission he also paints numerous pictures. Velázquez has some contact with him.

Death of Francisco Ribalta (born 1565).

1629 On 10 August Velázquez departs for Italy. He boards ship at Barcelona and makes the voyage in the company of General Ambrosio Spínola. Arriving in Genoa on 19 September he goes immediately to Venice, where he remains for several months. He then goes on to Rome (by way of Ferrara and Bologna).

Zurbarán takes up residence in Seville and receives a number of major commissions from monasteries.

In April, the Infanta María marries by proxy the King of Hungary, the future Emperor Ferdinand III.

On 10 October, the birth in Madrid of Crown Prince Baltasar Carlos, first son of Philip IV and Isabella of Bourbon.

Descartes settles in Holland, where he remains for twenty years.

1630 Velázquez still in Rome. He paints *Joseph's Coat* and *The Forge of Vulcan.* Towards the end of the year he travels to Naples, where he meets Ribera and paints the portrait of the Infanta María, who has left Spain in order to join her husband. She is in Naples from 13 August until 18 December.

In Madrid, work is started on the construction of a new royal palace, the Buen Retiro, which has to be decorated with pictures.

1631 In January Velázquez returns to Spain. He paints his first portrait of Baltasar Carlos.

Rembrandt takes up residence in Amsterdam.

Richelieu signs a treaty with Gustavus Adolphus of Sweden, taking his side in the war with the Emperor.

1632 Velázquez paints his second portrait of Baltasar Carlos.

Rembrandt paints *The Anatomy Lesson of Dr Tulp.*

Death in Rome of Valentin de Boullogne.

Birth of Vermeer.

Birth of Spinoza.

Death of the Infante Don Carlos.

Philip IV sends an army to Germany to assist the Emperor against the Swedish.

The troops of Gustavus Adolphus are victorious at Lützen, but he himself is killed.

1633 Velázquez' daughter Francisca marries the painter Juan Bautista del Mazo (1612?–1667), one of her father's assistants (needed because he could not paint single-handed all the many portraits required at the court).

Carducho publishes his *Diálogos de la pintura*, in which he attacks Velázquez.

Bernini (1598–1680) completes his canopy for St Peter's in Rome.

Death of Lope de Vega (born 1562).

Death of the Archduchess Isabella, governor of the Spanish Netherlands. The Archduchess is later succeeded by the Cardinal-Infante Fernando.

1634 **(–1635)** Velázquez paints *The Surrender of Breda* for the Hall of Realms at the Buen Retiro. He hands over to his son-in-law Mazo his duties as Usher of the Royal Bedchamber.

Zurbarán is summoned to the court and paints *The Labours of Hercules* and two historical compositions (of which only *The Defence of Cadiz* survives). Like a number of other pictures by different artists these were intended for the Hall of Realms at the Buen Retiro.

The Cardinal-Infante Fernando wins a victory against the Swedish at Nördlingen.

In celebration of this victory Rubens paints *The Meeting of the Cardinal-Infante Fernando and the King of Hungary at Nördlingen*.

The Cardinal-Infante Fernando enters Brussels.

1635 At about this time Velázquez paints his equestrian portraits of Philip IV, Baltasar Carlos and Olivares, all intended for the Buen Retiro, also his portraits of the King, Prince, and Cardinal-Infante in hunting costume, for the Torre de la Parada.

From June 1635 until January 1636 the sculptor Montañés is in Madrid, working on his bust of Philip IV.

Van Dyck paints his *Portrait of Charles I of England*.

1636 Velázquez is appointed Gentleman of the Wardrobe.

Corneille writes *Le Cid*.

1637 Death of the Emperor Ferdinand II. Accession of Ferdinand III, brother-in-law to Philip IV.

Descartes publishes his *Discours de la Méthode*.

1638 Francesco d'Este, Duke of Modena, is in Madrid on an official visit and is twice painted by Velázquez. One of the pictures is an equestrian portrait, and Velázquez does not finish the copy that is requested until 1639. Both the original and the copy are now lost.

Birth on 20 September of the Infanta María Teresa.

Alonso Cano takes up residence in Madrid.

Claude Lorraine paints his *Seaport*; Poussin paints *Moses Saved from the Waters*.

1639 Velázquez paints his second portrait of the clown Calabazas.

Pietro da Cortona (1596–1669) finishes his fresco of *The Glory of Urban VIII* which decorates one of the ceilings of the Palazzo Barberini.

Birth of Racine.

1640 Velázquez paints *Aesop, Menippus* and *Mars*.

Barcelona and Portugal rise against Spain.

Poussin returns to France.

Death of Rubens.

1641 Death of van Dyck.

Death of the Cardinal-Infante Fernando.

1642 Rembrandt paints his *Night Watch*.

Poussin goes back to Rome.

Death of Guido Reni (born 1575).

Death of Galileo (born 1564).

Birth of Isaac Newton.

The French take Perpignan and enter Catalonia. Death of Richelieu. He is succeeded by Mazarin.

1643 Velázquez is appointed Gentleman of the Royal Bedchamber (without official duties) and also becomes Superintendent of the Works of the Palace.

Philip IV dismisses Olivares.

Condé defeats the Spanish forces at Rocroi.

Death of Louis XIII and accession to the French throne of Louis XIV. His mother Anna of Austria, sister to Philip IV, is made regent.

1644 Velázquez accompanies Philip IV to Aragon and paints his portrait at Fraga. He also paints the dwarf El Primo.

Death of Pachecho.

Death of Queen Isabella.

Death of María, wife of the Emperor Ferdinand III and sister of Philip IV.

Death of Pope Urban VIII. He is succeeded by Cardinal Pamphili, who takes the name Innocent X.

1645 Death of Olivares.

1646 Velázquez is promoted to Gentleman of the Wardrobe (with official duties).

Death of Baltasar Carlos a few months after his betrothal to Mariana of Austria.

Uprising against Spain in Naples.

Birth of Leibnitz.

1647 Velázquez is given the additional post of Inspector and Treasurer for Works in the Pieza Ochavada. He claims the salary owing to him for the past two years.

Bernini finishes his *Ecstasy of Saint Theresa* for Santa Maria della Vittoria in Rome.

Revolt against Spain in Sicily.

Philip IV signs the Treaty of Münster with the Dutch, recognizing Holland as an independent power.

1648 Velázquez complains that he has not received his salary for 1630–34, nor any payment for pictures executed between 1628 and 1640. In November he leaves Madrid to return to Italy, where he plans to purchase works of art for the royal palace. He boards ship at Malaga.

The Treaty of Westphalia brings the Thirty Years War to a close.

Death of Louis Le Nain (born *c.* 1593).

Poussin paints *Eliezer and Rebecca* and *The Burial of Phocion*.

1649 Velázquez boards ship at Malaga in January and arrives in Genoa in March. He is in Venice by April and in Rome by the end of May. His stops on the way include Parma, Modena, Bologna and possibly Florence. Apart from a short trip to Naples he remains in Rome for over a year.

Death of Juan Bautista Mayno (born 1578).

In October Philip IV marries his fifteen-year-old niece, Mariana of Austria, formerly betrothed to Baltasar Carlos.

King Charles I of England is beheaded.

1650 Velázquez prolongs his stay in Rome even though the King sends a message to say that he is expected back in May or June. He paints a number of portraits, notably that of Pope Innocent X. He also purchases sculptures, especially antique statues. He meets Italian artists, such as Algardi, Bernini, Salvator Rosa, Pietro da Cortona, Colonna

and Mitelli. He tries to persuade the last three to go to Madrid because Philip IV wants Italian fresco-painters to work at the court. In November Velázquez again goes to Modena and tries to obtain, for the King, Correggio's *Night*, which is in the possession of Duke Francesco d'Este.

Algardi finishes his relief of *Leo X and Attila* for St Peter's in Rome.

Death of Descartes (born 1596).

1651 Velázquez returns to Venice, having promised to bring back pictures from there. He plans to go to Paris but in the end boards ship at Genoa, arriving back in Spain in June.

Birth on 12 July of the Infanta Margarita, daughter of Philip IV and Queen Mariana.

Bernini finishes his *Fountain of the Four Rivers* for the Piazza Navona in Rome.

1652 Velázquez paints Queen Mariana. He is promoted to Chamberlain of the Palace.

Death of Ribera.

Death of Georges de la Tour.

1653 Rembrandt executes his engraving *The Three Crosses*.

1654 Velázquez paints his first portrait of the Infanta Margarita (wearing a pink dress). He is given the task of hanging forty pictures presented by Philip IV to the Escorial.

1655 Rembrandt paints the *Slaughtered Ox*.

1656 Velázquez paints *Las Meninas* and a second portrait of the Infanta Margarita (wearing a light-coloured dress).

Rembrandt is declared a bankrupt.

Pascal publishes *Les Lettres Provinciales*.

1657 Velázquez paints *The Tapestry Weavers* (?).

Birth on 28 December of Felipe Próspero, son of Philip IV.

To raise money for payment of his creditors, a first sale of Rembrandt's possessions is held in December.

1658 Philip IV decides to make Velázquez a Knight of the Order of Santiago. The Chapter of the Order holds an investigation in order to establish his noble descent.

Zurbarán and Alonso Cano, who both live in Madrid, give evidence on Velázquez' behalf.

In the Battle of the Dunes (near Dunkirk), the Spanish are defeated by the French under the command of Turenne.

1659 Velázquez paints the portraits of Felipe Próspero and Princess Margarita (wearing a blue dress). His noble descent not having been

satisfactorily established, a papal dispensation in the matter is sought by Philip IV. On 28 November Velázquez is invested with the insignia of the Order.

Mazarin forces Spain to accept the Treaty of the Pyrenees.

1660 Velázquez organizes the journey of Philip IV and his entourage to the Isle of Pheasants (near the frontier with France); there the Infanta María Teresa is given in marriage to Louis XIV on 7 June. Velázquez arrives back in Madrid on 26 June, falls ill on 31 July and dies on 6 August. On 7 August he is buried in the Church of San Juan Bautista in Madrid. His wife dies eight days later and is buried at his side.

Notes

1 Cf. *Tout l'œuvre peint de Veláz-quez*, Paris, Flammarion, 1969, p. 12. The phrase occurs in a letter written from Madrid to H. Fantin-Latour in 1865.

2 Francisco Pachecho, *El arte de la pintura*. Quoted in Carl Justi, *Diego Velázquez und sein Jahr-hundert*, Zürich, Phaidon-Verlag, 1933, p. 161. All subsequent quotations from Justi are taken from this book, the page number referring to the Phaidon-Verlag edition. This monograph, which first appeared in 1888, remains one of the best works on Velázquez. Although it has been corrected on certain points by more recent research, it is still well worth studying, both because of its high standard of scholarship and because of its author's perceptiveness and fine style.

3 Quoted in Justi, 1933, p. 126.

4 Quoted in Justi, 1933, p. 127.

5 Quoted in Justi, 1933, p. 127.

6 Quoted in Justi, 1933, p. 127.

7 Quoted in Justi, 1933, p. 127.

8 Justi, 1933, p. 128.

9 The first detailed published biography of Velázquez is by the painter Antonio Palomino Velasco in his *Museo pictórico III*, Madrid, 1724.

10 Quoted in Justi, 1933, p. 130.

11 Quoted in Justi, 1933, p. 137.

12 *Velázquez. A catalogue raisonné of his œuvre with an introductory study by José López-Rey*, London, Faber and Faber, 1963.

13 López-Rey, 1963, pp. 32–33.

14 Allan Braham, *Velázquez*, London, Publications Department National Gallery, 1972, pp. 7–13.

15 Quoted in *Tout l'œuvre peint de Velázquez*, op. cit., p. 12; and in Justi, 1933, p. 137.

16 José Ortega y Gasset, *Velázquez*, Berne, Iris Verlag, 1943, p. 16.

17 Quoted in Justi, 1933, p. 167.

18 Justi, 1933, p. 206.

19 Justi, 1933, p. 197.

20 López-Rey, 1963, pl. 443.

21 López-Rey, 1963, pp. 37–38.

22 López-Rey, 1963, pl. 445.

23 Quoted in Justi, 1933, p. 209.

24 Quoted in Gregorio Marañon, *Olivarès*, German edition, Munich, Georg D. Callwey, 1939, p. 106.

25 Quoted in Marañon, 1939, p. 107.

26 Quoted in Justi, 1933, p. 236.

27 Quoted in Justi, 1933, p. 236.
28 Quoted in Justi, 1933, p. 237.
29 Quoted in Justi, 1933, p. 238.
30 Justi, 1933, p. 240.
31 Quoted in Justi, 1933, p. 244.
32 Quoted in Justi, 1933, p. 246.
33 Quoted in Justi, 1933, p. 246.
34 Justi, 1933, p. 261.
35 Ortega y Gasset, 1943, p. 20.
36 Quoted in Justi, 1933, pp. 272–73.
37 Quoted in Justi, 1933, p. 274.
38 Quoted in Justi, 1933, p. 297.
39 Justi, 1933, p. 311.
40 Quoted in Justi, 1933, p. 312.
41 Quoted in Justi, 1933, p. 319; and in Paul Guimard, Les Peintres espagnols, Paris, Le Livre de Poche, 1967, p. 226.
42 Quoted in Justi, 1933, p. 323.
43 Braham, 1972, pp. 18–26.
44 Adopting the Andalusian spelling, the artist always used the signature 'Velasquez'.
45 López-Rey, 1963, p. 58.
46 Marañon, 1939, p. 248.
47 Marañon, 1939, p. 248.
48 Tout l'œuvre peint de Velázquez, op. cit., p. 96.
49 This engraving was used as an illustration for the Quadrins de la Bible, published in 1553 in Lyons, and produced in a Spanish edition in the same year. Cf. Jean Adhémar, Velázquez, son temps, son influence, Paris, Arts et Métiers Graphiques, 1963, p. 147.
50 Justi, 1933, p. 693.
51 Eugène Dabit, Les Maîtres de la peinture espagnole, Paris, Gallimard, 1937, p. 113.
52 There is a fourth painting of a dwarf, standing proudly beside a big dog (Madrid, Prado), but this is no longer attributed to Velázquez.
53 Justi, 1933, p. 328.
54 Justi, 1933, p. 328.
55 Both these works appear to have been destroyed.
56 Quoted in Justi, 1933, p. 508.
57 Quoted in Justi, 1933, p. 544.
58 Quoted in Justi, 1933, p. 551.
59 Quoted in Justi, 1933, p. 551.
60 Quoted in Justi, 1933, p. 551.
61 López-Rey, 1963, p. 95.
62 Quoted in Justi, 1933, pp. 582–83.
63 Quoted in Justi, 1933, p. 592.
64 Quoted in Justi, 1933, p. 566.
65 Quoted in Justi, 1933, p. 570.
66 Neil MacLaren, The Spanish School, second edition revised by Allan Braham, London, The National Gallery, 1970, pp. 125 and 127.
67 MacLaren, 1970, p. 125–29.
68 Quoted in Justi, 1933, p. 592.
69 Quoted in Justi, 1933, p. 594.
70 Braham, 1972, pp. 37–44.
71 López-Rey, 1963, pp. 219–20.
72 López-Rey, 1963, p. 90.
73 Ortega y Gasset, 1943, p. 11.
74 Quoted in Justi, 1933, p. 744.

Short Bibliography

FRANCISCO PACHECHO, *Arte de la pintura*, Seville, 1649.

ANTONIO PALOMINO DE CASTRO Y VELASCO, *El Museo pictórico y escala óptica*, Madrid, 1715–24 (vol. III).

WILLIAM STIRLING, *Velázquez and his works*, London, 1855.

GREGORIO CRUZADA VILLAAMIL, *Anales de la vida y de las obras de Diego de Silva Velázquez*, Madrid, 1885.

CARL JUSTI, *Diego Velázquez und sein Jahrhundert*, Bonn, 1888.

AURELIANO DE BERUETE, *Velázquez*, Paris, 1898.

AUGUSTE BRÉAL, *Velasquez*, Paris, 1919.

AUGUST LIEBMANN MAYER, *Velazquez*, Berlin, 1924.

JUAN ALLENDE SALAZAR, *Velázquez*, Stuttgart, 1925.

AUGUST LIEBMANN MAYER, *Velazquez. A catalogue raisonné of the pictures and drawings,* London, 1936.

EUGÈNE DABIT, *Les Maîtres de la peinture espagnole. Le Greco – Velázquez,* Paris, 1937.

ENRIQUE LAFUENTE FERRARI, *Velázquez, introduction and catalogue*, London, 1943.

JOSÉ ORTEGA Y GASSET, *Velázquez*, Berne, 1943.

LÉON-PAUL FARGUE, *Velázquez*, Paris, 1946.

BERNARDINO DE PANTORBA, *Velázquez*, Madrid, 1946.

ELIZABETH DU GUÉ TRAPIER, *Velázquez*, New York, 1948.

JOSÉ ORTEGA Y GASSET, *Papeles sobre Velázquez y Goya*, Madrid, 1950.

ENRIQUE LAFUENTE FERRARI, *Velázquez*, Geneva, 1960.

XAVIER DE SALAS, *Velázquez*, London, 1962.

JOSÉ LÓPEZ-REY, *Velázquez. A catalogue raisonné of his œuvre with an introductory study*, London, 1963.

Velázquez, son temps, son influence – Proceedings of a symposium held at the Casa Velázquez in 1960. Paris, 1963.

JUAN ANTONIO GAYA NUÑO, *Bibliografía crítica y antológica de Velázquez*, Madrid, 1963.

JOSÉ CAMÓN AZNAR, *Velázquez*, Madrid, 1964.

YVES BOTTINEAU and P. M. BARDI, *Tout l'œuvre peint de Velázquez*, Paris, 1969.

ALLAN BRAHAM, *Velázquez*, London, 1972.

List of Illustrations

PHOTOGRAPHIC CREDITS

Bulloz: 208, 210, 215, 235; Corvina, Budapest: 17; Giraudon: 13, 28, 29, 59, 60, 67, 83, 84, 85, 91, 92, 93, 97, 100, 102, 103, 104, 106, 112, 113, 115, 124, 125, 129, 131, 137, 145, 149, 151, 153, 162, 166, 167, 168, 176, 177, 181, 186, 195, 207, 221, 223, 224, 225, 228, 229, 237; Manso, Madrid: 38, 49, 58, 70, 72, 99, 105, 109, 134, 135, 138, 140, 141, 143, 146, 152, 163; Marzari, Italy: 147, 175; Mas, Barcelona: 15, 27, 30, 44, 45, 95, 117, 123, 185, 192, 194, 200, 201, 211, 230; Meyer, Vienna: 150, 179, 209, 212; National Gallery of Scotland, Edinburgh: 19; Roger-Viollet: 36, 51, 113, 125, 136, 160, 216; Wallace Collection, London: 90, 161; Wellington Museum, London: 22, 23.

Index